REMOTE VIEWING

REMOTE VIEWING

(INVENTED WORLDS IN RECENT PAINTING AND DRAWING)

ELISABETH SUSSMAN

with essays by Caroline A. Jones and Katy Siegel
a story by Ben Marcus
and contributions by Tina Kukielski and Elizabeth M. Grady

Whitney Museum of American Art
Distributed by Harry N. Abrams, Inc., New York

This catalogue was published on the occasion of the exhibition *Remote Viewing (Invented Worlds in Recent Painting and Drawing)*, at the Whitney Museum of American Art, New York, June 2–October 9, 2005.

Support for *Remote Viewing (Invented Worlds in Recent Painting and Drawing)* was provided by The Broad Art Foundation, The Andrew J. and Christine C. Hall Foundation, and Margaret and Daniel Loeb.

Whitney Museum of American Art
945 Madison Avenue at 75th Street
New York, NY 10021
www.whitney.org

Cover: The artists in their studios (photographs by Jerry L. Thompson);
front: Steve DiBenedetto, *Dose*, 1999 (detail); back, clockwise from top left: Carroll Dunham, *Untitled*, 2003 (detail);
Terry Winters, *Display Linkage*, 2005 (detail); Franz Ackermann, *Icecream*, 2003 (detail); Ati Maier, *West*, 2004 (detail)

The Immanuel Kant quotation on page 81 is from *Critique of Aesthetic Judgment* (1790), § 53.

The Robert Smithson quotation on page 90 is from *Robert Smithson: The Collected Writings*,
edited by Jack Flam (Berkeley: University of California Press, 1996), 322, 323.

Library of Congress Cataloging-in-Publication Data
Remote viewing : invented worlds in recent painting / edited by Elisabeth Sussman ;
with essays by Caroline A. Jones and Katy Siegel.-- 1st ed.
p. cm.
"This catalogue was published on the occasion of the exhibition Remote viewing: invented worlds in recent painting and drawing.
The exhibition was organized by the Whitney Museum of American Art, New York.
Whitney Museum of American Art June 2, 2005-October, 2005"--T.p. verso.
Includes bibliographical references and index.
ISBN 0-87427-148-7 (hardcover (flexibound)
1. Painting, Modern--21st century--Themes, motives--Exhibitions. 2. Drawing--21st century--
Themes, motives--Exhibitions. I. Sussman, Elisabeth, 1939- II. Jones, Caroline A. III. Siegel, Katy. IV. Whitney Museum of American Art.
ND196.2.R46 2005
759.07'074'7471--dc22
2005005624

Distributed by:

Harry N. Abrams, Inc.
100 Fifth Avenue, New York, NY 10011
www.abramsbooks.com
Abrams is a subsidiary of
LA MARTINIÈRE

CONTENTS

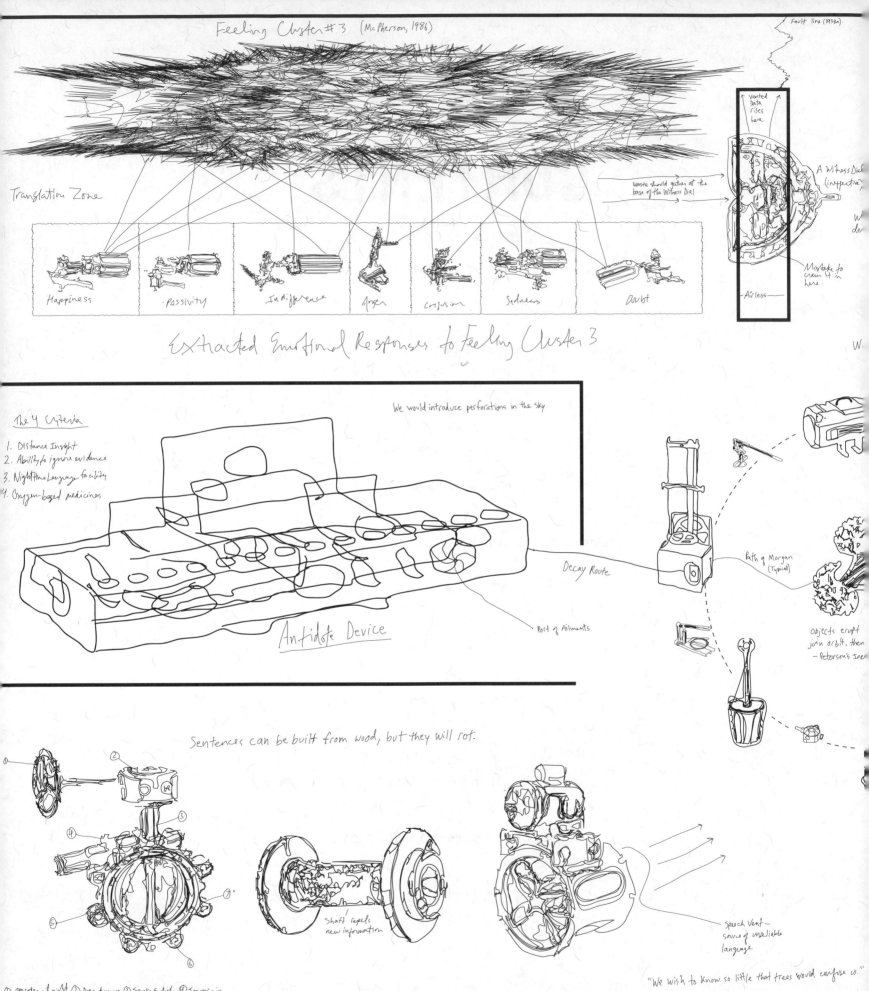

Feeling Cluster #3 (McPherson, 1986)

Fault line (1938a)

vented data rises here.

A Witness Dial (inspective)

Waste should gather at the base of the Witness Dial

Mistake to cram it in here.

Airless

Translation Zone

| Happiness | Passivity | Indifference | Anger | Confusion | Sadness | Doubt |

Extracted Emotional Responses to Feeling Cluster 3

The 4 Criteria

1. Distance Insight
2. Ability to ignore evidence
3. Nighttime Language facility
4. Oxygen-based medicines

We would introduce perforations in the sky

Decay Route

Path of Morgan (Typical)

Antidote Device

Port of Ailments

objects erupt, join orbit, then
— Peterson's Inev

Sentences can be built from wood, but they will rot.

Shaft repels new information

Speech Vent — source of unreliable language

"We wish to know so little that trees would confuse us."

① Operates at night ② Does damage ③ Speaks English ④ Ignores air
⑤ Has two-grained filter ⑥ Submits information directly into soil

ARTISTS
IN THE EXHIBITION

ACKNOWLEDGMENTS

Remote Viewing is an exhibition that has so depended on teamwork that I hesitate to claim it as solely my own curatorial project. Adam D. Weinberg, Alice Pratt Brown Director of the Whitney, provided the challenge and support that encourages the best curatorial efforts. All the members of the Whitney's curatorial staff provided input, advice, and critique as the project advanced, offering suggestions of artists and helping me to discover what the thesis of the exhibition was.

Much of the spirit of *Remote Viewing* has emerged from my discussions with artists Franz Ackermann, Steve DiBenedetto, Carroll Dunham, Ati Maier, Julie Mehretu, Matthew Ritchie, Alexander Ross, and Terry Winters. They welcomed me into their studios and helped me to define the exhibition as it was taking shape. I am very grateful for the excellent works that we selected together and for the new work that many have made for this occasion.

The lenders to *Remote Viewing* have been generous in parting with their works. Their enthusiasm for the artists in their collections and for gathering the artists into this group has been very gratifying. Similarly, I would like to thank the many individuals at the artists' galleries who have assisted us in identifying and tracking down the works.

A remarkable team of people has been instrumental in bringing *Remote Viewing* into actuality. I would like to thank my two assistants, Elizabeth M. Grady, curatorial assistant, and Tina Kukielski, senior curatorial assistant, for their help every step of the way, for their curatorial vision, and for their insightful and eloquent writing on the artists in the exhibition. This book would not be complete without the comprehensive artist chronologies and bibliographies compiled by interns Ash Anderson and Julie McKim in collaboration with my assistants. Caroline A. Jones and Katy Siegel have written essays that beautifully illuminate these eight artists and the context in which they work. Ben Marcus has not only written a wonderful piece of fiction for the catalogue, but has also contributed a work for the Whitney galleries that is his own verbal and visual map of the exhibition.

All of the writers have been brilliantly edited by Jennifer Liese, who was unstinting in her determination to bring clarity and verve to our work.

Yolanda Cuomo has entirely reinvented her role as "designer" of the catalogue and exhibition, creating a book and exhibition plan of enormous excitement that we have all been proud to work on. Kristi Norgaard has, as always, ably assisted Cuomo. At the Whitney, Rachel de W. Wixom, head of publications and new media, and Thea Hetzner have dedicated themselves to the project with real enthusiasm. Jerry L. Thompson has exceeded all expectations in his stunning studio photographs of the artists in the exhibition, which add so much to the catalogue.

The Whitney staff has been a true joy to work with, and we are grateful to many people who, unfortunately, have to be thanked in a list. They are: Donna De Salvo, associate director for programs and curator, permanent collection; Christy Putnam, associate director for exhibitions and collections management; Suzanne Quigley, head registrar; Joelle LaFerrara, assistant registrar; Joshua Rosenblatt, head preparator, and the installation team; Mark Steigelman, manager, design and construction; Carol Mancusi-Ungaro, associate director for conservation and research; Pia Gottschaller, associate conservator of painting; Susan Courtemanche, development consultant; Randy Alexander, director of major gifts; Bette Rice, director of corporate partnerships; Kimberly Goldsteen, director of special events; Adrienne Edwards, director of foundation and government relations; Jan Rothschild, associate director for communications and marketing; Stephen Soba, communications officer; Raina Lampkins-Fielder, associate director, Helena Rubinstein Chair for Education; Frank Smigiel, manager, adult programs; Kathryn Potts, head of museum interpretation; Anita Duquette, manager, rights and reproductions; Makiko Ushiba, manager, graphic design; Vickie Leung, production manager; Jennifer MacNair, associate editor; and Arianne Gelardin, publications assistant.

—Elisabeth Sussman
Curator and Sondra Gilman Curator of Photography

FOREWORD

Adam D. Weinberg, Alice Pratt Brown Director

As "the artists' museum," the Whitney Museum of American Art has always cultivated its unparalleled connection with artists in the United States. This relationship, embodied by the Biennial exhibitions, is equally evident in *Remote Viewing (Invented Worlds in Recent Painting and Drawing)*, which continues a tradition of group exhibitions that take the pulse of an artistic moment to reveal tendencies vital to a number of artists. Important and memorable exhibitions of this type include *Anti-Illusion* (1969), *New Image Painting* (1978), *Mind over Matter* (1990), and *Black Male* (1994).

The eight remarkable artists brought together by *Remote Viewing*—Franz Ackermann, Steve DiBenedetto, Carroll Dunham, Ati Maier, Julie Mehretu, Matthew Ritchie, Alexander Ross, and Terry Winters—immerse themselves in the vigor and power of painting and drawing. They create dynamic renditions of what might be thought of collectively as early-twenty-first-century "invented worlds." Cosmic, urban, visceral—yet strangely detached—these works bring to life new imagery, combining a devotion to drawing and a vibrant painterliness with a conviction not often seen in art of the last twenty years. The painters in *Remote Viewing* are heirs to a great tradition. Their mentors include painters as diverse as Giorgio Morandi, Cy Twombly, Brice Marden, and Sigmar Polke. Paradoxically, in this digital century the possibilities of the hand and the power of the imagination appear to be a new frontier. Looking more to the future than the past, the work in the exhibition, which ranges from miniature paintings to large, embracing environments, and from process-related sketches to highly finished drawings, emerges from a multitude of sources, including electromagnetic and televisual imaging and the paintings of Caravaggio. These eight artists invent, appropriate, and hybridize to create works of art that will entice and absorb everyone who comes before them.

It is also significant to note that the artists in *Remote Viewing* themselves exemplify a condition of many contemporary artists. As curator Elisabeth Sussman points out in her introductory text, the work of these artists is not a statement about or connected to a particular geographic location. They are in fact supranational expressions. In recognition of this, *Remote Viewing*, like many Whitney exhibitions to come, is not limited to American

artists. (This inclusiveness traces its origins to the early days of the Museum, when artists such as Picasso, Braque, and Rousseau were featured in exhibitions.) Franz Ackermann is neither American nor based in the United States, while three other artists, Ati Maier, Julie Mehretu, and Matthew Ritchie, were born abroad. Artists today are increasingly connected by shared ideas as much by, if not more than, physical and national boundaries. This exhibition reflects such peregrinations of artistic thought and practice. After all, it is the nature of artists to break boundaries.

Group exhibitions based on affinities are difficult to accomplish. They can never be comprehensive: More artists are omitted from such an exhibition than can possibly be included. And they can never be irreproachably definitive, as the curator is in the midstream of artistic events, and any reading, even the most informed, is necessarily provisional. Elisabeth Sussman is a keen and thoughtful observer of contemporary art who has never been averse to risk. Taking on this exhibition with both circumspection and gusto, she has again shown herself to be a versatile and expansive curator. I would also like to acknowledge the authors for sharing in this venture. Together, Caroline A. Jones, Ben Marcus, and Katy Siegel offer a rich compendium of thinking on this topic. The catalogue has benefited immensely from the labors and dedication of Tina Kukielski, senior curatorial assistant, and Elizabeth M. Grady, curatorial assistant, both of whom also contributed perceptive texts. Rachel de W. Wixom, head of publications and new media, brought together the efforts of everyone involved with grace and skill.

We are extremely grateful to all of the individuals and institutions that so selflessly lent works to *Remote Viewing*. This exhibition would not have been possible without the generous financial support of the Broad Art Foundation, the Andrew J. and Christine C. Hall Foundation, and Margaret and Daniel Loeb.

A timely and adventurous exploration of the art of our time, *Remote Viewing* embodies both the Whitney's commitment to contemporary artists and its desire to mark the territory of certain directions and tendencies at the time of their occurrence. We are grateful to all who participated in its creation.

INTRODUCTION

Elisabeth Sussman

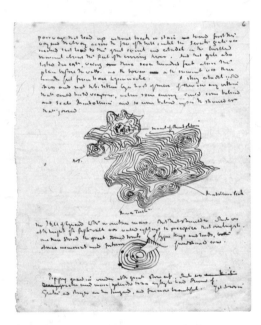

Topographical view of Minas Tirith, from JRR Tolkien's
The Lord of the Rings
Ink on paper, 9 1/3 x 7 3/8 in. (23.7 x 18.7 cm)
<small>MARQUETTE UNIVERSITY, MILWAUKEE</small>

Remote Viewing is an exhibition of recent painting and drawing by Franz Ackermann, Steve DiBenedetto, Carroll Dunham, Ati Maier, Julie Mehretu, Matthew Ritchie, Alexander Ross, and Terry Winters. All of these artists are inventors of new worlds that exist somewhere between representation and abstraction. Some of them work in one direction, beginning with information and breaking it down into abstraction. Others work in the other, beginning with abstraction, then breaking it down, and by so doing, finding information. Either way, it is the process of painting and drawing between these two poles that allows for their remarkable invention.

I'll turn to the choice of the title *Remote Viewing* later. First, a few words on what is meant by the exhibition's subtitle: *Invented Worlds in Recent Painting and Drawing*. *Invented Worlds* conjures up the expectation of a narrative sort of painting. It has a science-fiction tone, suggesting that these paintings might be reimaginings of an alternate universe, a futuristic society, a postatomic landscape. We might also think of sci-fi films or of the Surrealists Yves Tanguy, Max Ernst, or Roberto Matta. Or *Invented Worlds* could refer directly to literary sources, like Jonathan Swift's *Gulliver's Travels* or the sagas that inspired JRR Tolkien's *The Lord of the Rings*. At the same time, *Invented Worlds* could hint at something imaginary, only of the mind, a vision. There are all kinds of "visions" to contend with in poetry, literature, and religious writing. Accounts of how new worlds came into being through the use of opium, mescaline, and acid can be found in writing all the way from Samuel Coleridge to Henri Michaux. There is also a visual tradition of "expanded consciousness" running from Tibetan painting to William Blake to, again, Michaux, not to mention the psychedelic graphics of posters and albums from the 1960s.

But these models of invented worlds must be brought up to date if they are to be relevant to the eight painters in this exhibition. What is it that makes these artists' invented worlds new? I would argue that it is the coexistence of abundant information—visual and literary, hallucinogenic, from the past or the present—with a huge amount of data:

scientific theory, technological models, maps, mass-media quotes. This information and this data make strange bedfellows, many in fact meeting on the bed/canvas for the very first time. And they don't lie down—rather, in this art, vast amounts of information and data stand up and demand to be reckoned with.

The other part of the subtitle, *Recent Painting and Drawing*, seems straightforward enough. But is it? In the early twenty-first century, painting and drawing may seem like quaint anomalies relative to film, video, and the computer, whose technological capacities make it possible to invent worlds beyond our wildest imaginations. But while it doesn't employ it per se, the work in this exhibition is not blind to technology: In the terrain of the invented world, the digital, the scan, and the satellite view loom large. Painting and drawing, as they go about their two-way process of filtering representation and abstraction to register the mind in the hand that invents the new world, are a means of controlling information, opening it to both precision and chaos.

Just as the artists in this exhibition invent worlds, so too have I, the curator who brought the eight together. There is no material history that irrefutably links these artists—no common teachers, schools, or exhibitions that lead to a "school of" or "neo-whatever" designation. It is true, however, that all of the artists in this exhibition, with the exception of Ackermann, keep studios in New York. But there's no attempt to describe a latter-day New York School or a "New York style." Shared geography does not alone make this an obvious group. Furthermore, these artists all travel and exhibit widely. Ackermann's trips to many cities are integral to his work. Mehretu, born in Ethiopia, Ritchie, born in England, and Maier, born in Germany, happen to have settled into New York studios, but they do not erase the traces of their past homes in their work. Further complicating the matter, New York as an art world is today uncontainable as a single entity. Where once, even as recently as the late 1960s, the artists' world existed entirely "downtown," below Twenty-third Street, it now stretches to Harlem in the north and to the boroughs, particularly

Brooklyn, with communities, galleries, and artists' bars accordingly dispersed. Thus the idea that the artists in this exhibition could invent worlds from some shared, contained, knowable place (let's call it New York) is untenable. The New York art world is itself a fantasy, one not unlike the New York in Paul Auster's *City of Glass*. The place—New York—exists, but it is real and unreal; there are signs of familiarity, but they never quite come into focus.

Beginning then with this invented New York, we can now plot some sort of sociological grid or network along the lines of Pierre Bourdieu's diagrams of culture, a kind of art world where everyone and everything is somehow connected. As it turns out, many of the artists in *Remote Viewing* have been fans of each other's work for a long time. In the process of curating the exhibition, I discovered that Ritchie had interviewed Dunham, that Ross had worked in a studio in the same building as Winters, that Dunham, DiBenedetto, and Ritchie had studios near each other, that Winters collected Ackermann's work, and that Mehretu and Ritchie had exhibited in the same shows, as had several of the others. Looking at these relationships, I realized that all had been established through the 1990s and into the beginning of the next decade. But because Winters and Dunham both began working in New York in the late 1970s, the ties between these artists in fact extend back a full twenty-five years.

What are the stylistic affinities between Winters and Dunham? It could be argued that each developed a way of painting abstraction while maintaining a representational base. Ritchie, in an interview with Dunham, recalled that critic and artist Ronald Jones had located Dunham and Winters within a long history of abstract painting that had remained decisively abstract, ignoring all evidence of figuration. Ritchie goes on to write, "It seems clear now that that's kind of irrelevant as a description."[1] In fact, Dunham and Winters marked the beginning of something entirely new— an approach in which the membrane between abstraction and representation was no longer impermeable.

Ritchie, understandably, reads Dunham in a way that reflects his own enterprise: as abstraction that absorbs or generates a narrative. To make his point about Dunham, in 2002 Ritchie drew a diagram titled *Carroll Dunham's Condition*. Dunham's "condition," as drawn by Ritchie, is a system of overlapping circles that contain subjects or bodies of

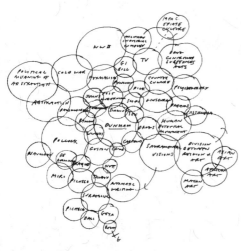

Matthew Ritchie, *Carroll Dunham's Condition*, 2002
Ink on polypropylene vellum, 8 1/2 x 11 in. (21.6 x 27.9 cm)
<small>COLLECTION OF THE ARTIST</small>

information, categories of interest Ritchie arrived at after many years of knowing Dunham. In the drawing, each of the subjects appears in its own circle, and all of the overlapping circles constitute a topography of the brain. Here is a sample of some of the subjects Ritchie identifies: POLITICAL MEANING OF ABSTRACTION; COLD WAR; WW II; MILITARY/INDUSTRIAL COMPLEX; ABSTRACTION; FORMALISM; GI BILL; TV; 19TH CENTURY OPIATE CULTURE; AUTOMATIC WRITING; SACRAMENTAL VISIONS; DIVISION BETWEEN RELIGION AND ART; ASIAN ART; MAYAN ART; AFRICAN ART.

That diagram, published in the catalogue accompanying Dunham's 2002 exhibition at the New Museum of Contemporary Art, New York, dovetails with the rise of Ackermann, Maier, Mehretu, Ross, and Ritchie himself, artists whose painting absorbs information, projects spaces, and at the same time remains in some sense abstract. In our network, we can link them to the combination of figuration and abstraction in DiBenedetto's work of the 1990s, as well as to Dunham's and Winters's evolution from the 1990s to the present.

Let's now move on to a less reliable set of coordinates: how this work looks. If all of the artists in *Remote Viewing* are interested in information, what does this information look like? If there are invented worlds, what do they have in common? If there are narratives, even figures, do they resemble one another? In a formal and perhaps superficial sense the work in this exhibition does share certain characteristics. The grid and geometric order, for instance, are frequently replaced by the vortex or by a circular way of organizing space, and for the most part color is intense (none of David Batchelor's chromophobia here). But the work also diverges. Winters and Mehretu have morphed all of their sources of visual information into forms and gestures that generate structure but retain little identifiable residual information. Ross's work appears simultaneously abstract and referential. At the other extreme are artists quite invested in information and narrative. Ritchie evokes a recombinant epic. Ackermann's mental maps and wall drawings are replete with the atmosphere of the urban *dérive* and transcontinental experience. Maier, on the other hand, switches from channel to channel and space to space to suggest the mental and visual concentration of the virtual. Dunham's recognizable "character" (an everyman who mysteriously emerged in the 1990s, some apparent but obscure herald of the situation

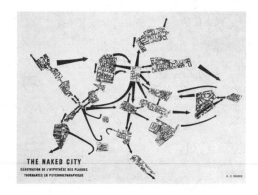

Guy Debord, *The Naked City*, 1957
Map, 33 x 47 1/2 in. (83.8 x 120.7 cm)
COLLECTION OF PAUL-HERVÉ PARSY

described as "Dunham's condition") is, in the series of works shown in this exhibition, cut, fragmented, expanded, and absorbed into the surface of the painting. DiBenedetto mines a group of recurrent circular images that, like Dunham's character, merge into a rich field of color, line, and painterly passages.

Despite stylistic similarities—immediately evident when these artists' works are seen together—I would encourage viewers not to stop at easy associations. Each artist's work is installed in a separate space for a reason: so that the viewer can enter each particular environment, physically and imaginatively, in full. For it is not so much the style, but the particular and unique information artists engage that distinguishes their work.

Several months ago I talked with Ritchie and Ben Marcus, who invented a world in his contribution to this catalogue, about how all of the artists in this exhibition might be united. They suggested that intuitive organizational structures may come closer to the nature of this group than the Bourdieu-inspired sociogram or the art-historical riff. They further proposed that once these artists were gathered together, there might be a story or fiction imposed on them that would be completely fantastic but still preserve a rational structure. This new narrative could link artist A to artist B, artist B to artist C, and so on. Another world would then emerge, more fiction than fact, but perhaps seemingly sensible. Marcus will in fact tell that possible story—through labels and diagrams accompanying this exhibition. He has produced such narratives, parallel but unconnected, around the work of both Ritchie and Winters in the past. (Selections from the Marcus-Winters collaboration *Turbulence Skins* [2004] are in this exhibition.)

Back to the coinage of *Remote Viewing*, which is the remnant of another possible curatorial story about this show and these artists that will never be told in full. I don't take credit for engaging the expression; it was in fact Ritchie's suggestion. The title is an adaptation of a term used to describe the psychics, known as "remote viewers," who were recruited by intelligence organizations within the U.S. government during the 1960s, their clairvoyant abilities called upon to report on places or things they had never seen. Perhaps in a post-9/11 world, where standard intelligence fails and films predict real situations, "remote viewing" is not so wacky as it sounds. Am I arguing that these eight artists, inventors of worlds, might be remote viewers, surrogate navigators of the unimaginable? Remotely, yes.

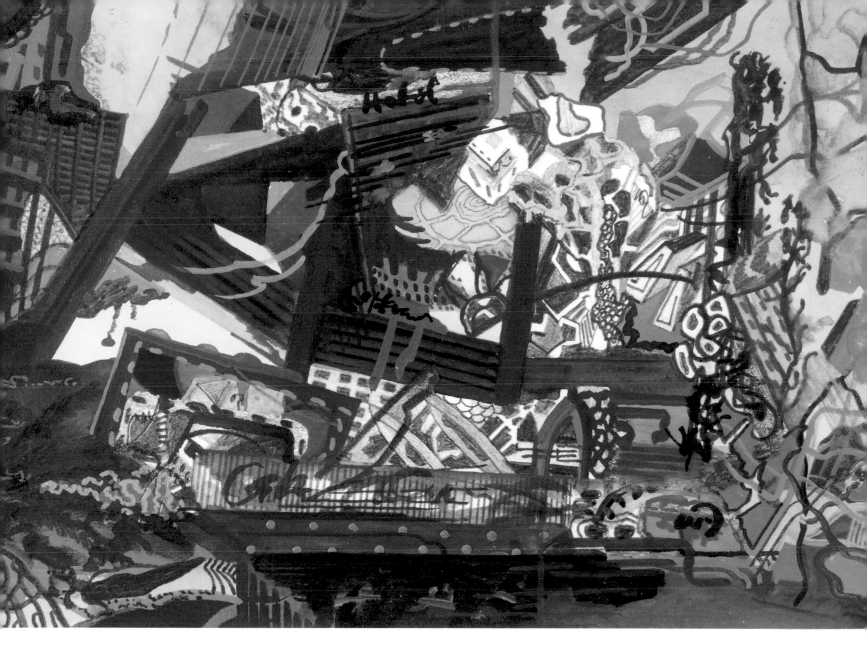

FRANZ ACKERMANN

dreamed-out myth • pleasure and adventure

Previous pages: Franz Ackermann, *Icecream,* **2003**
Watercolor on paper, 5 1/8 x 7 1/2 in. (13 x 19 cm)
Courtesy Gavin Brown's Enterprise, New York

Left: Franz Ackermann, *Inside the bullet,* **2001**
Mixed media on paper, 12 x 14 3/4 in. (30.5 x 37.5 cm)
Collection of Oliver Barker

less romantic realities•all-consuming

Since visiting Hong Kong on a fellowship just after finishing his studies at the Hochschule für Bildende Kunst in Hamburg in 1991, Franz Ackermann has made travel the point of departure for his work, drawing imagery from extensive journeys to such diverse destinations as Bangkok and São Paulo, Minneapolis and Zurich. The Berlin-based artist's installations generally include wall murals, postcard-size drawings that he calls mental maps (such as *Icecream* [2003]), and his large *evasion* paintings, along with tourism posters and a variety of other travel-related items. The contrast between the pleasure and adventure promised by the tourism industry and the less romantic realities of travel are at the heart of Ackermann's concerns. His project's ends are clearly political, critiquing the effects and countereffects of tourism and globalization, but his means are subjective: Linking recollections of the places he has been to his own emotional state and perceptions, Ackermann presents a delicate and nuanced train of thought, which he configures by layering past and present, the real and the reimagined.

Because the intersection between experience and memory provides such fruitful ground for Ackermann, it is hardly surprising that he incorporates temporal and spatial disjuncture into his process. While traveling, he wanders, absorbing visual impressions that he later translates into small drawings or large paintings, working in his hotel room, studio, or at the sites of installations. Past experience is filtered through the screen of memory while current or very recent experience is allowed to intrude, creating new associations. And just as agglomerations of bits of map or architecture gather in concentrated spots, the texture sometimes varies, with thick blobs and painterly swirls of shiny color collecting on the work's surface. Painting for Ackermann, then, is the physical realization of the layering of impressions through the language and structure of the application of paint to canvas, not a simple quotation of places visited and sights seen.

The Situationist International, a group of artists, writers, and architects whose aim it was to challenge late capitalism through radical intervention, is an evident precedent for Ackermann. In particular, he is intrigued by their notion of psychogeography and the practice of *dérives*, chance wanderings through the city of Paris undertaken in the 1950s that resulted in intuitive maps of thought rather than practical maps of city streets. Ackermann takes *dérives* from a local to a global scale, rearranging the geography of the world according to his own experience of it. For example, in *The Runway* (2004), a work on paper from his recent exhibition at Gavin Brown's Enterprise, we find trails resembling footprints or a highway divider line connecting fragments of architecture and landscape and forming some of the most easily recognizable but most puzzling elements in the image. Although the categories of reference—say buildings or rocks—are clear, the locations to

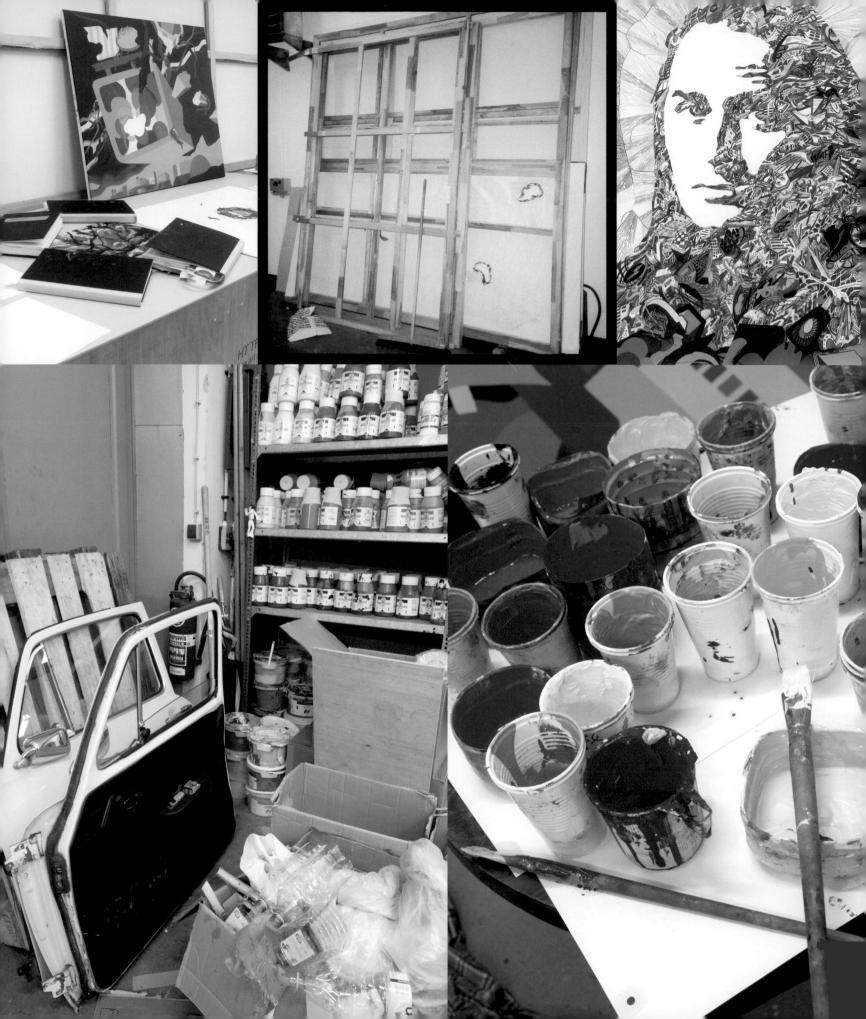

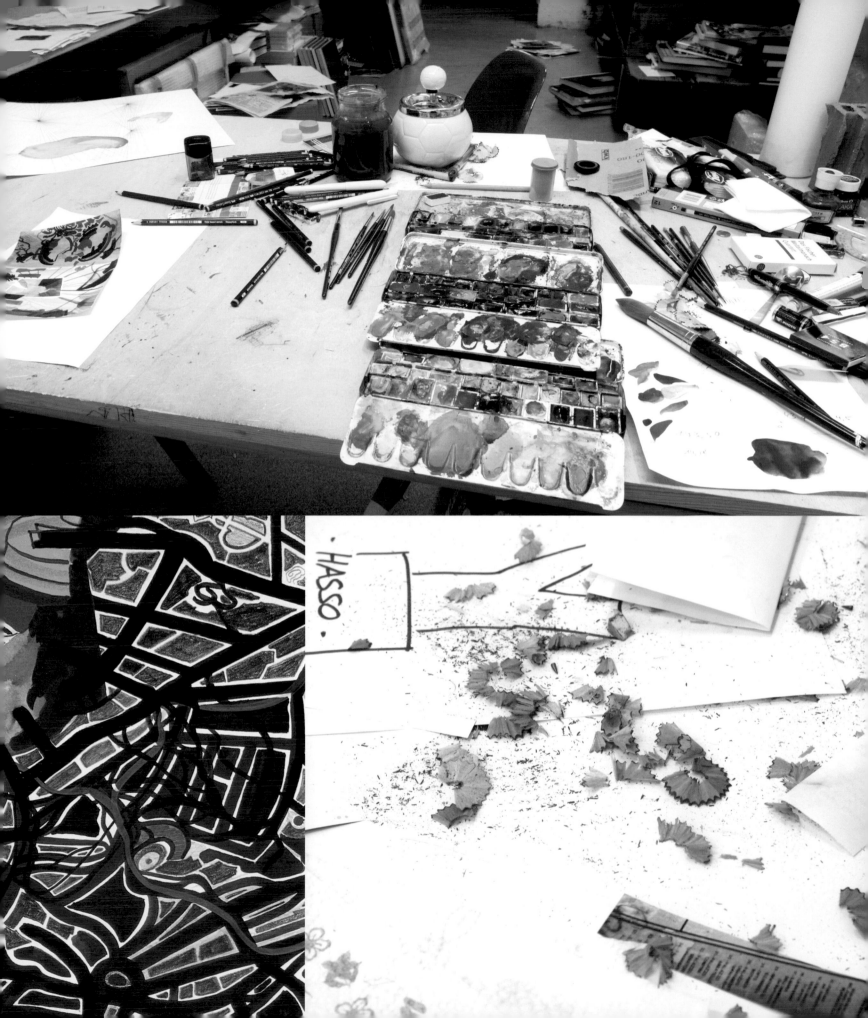

Franz Ackermann, *Untitled (evasion I)*, 1996
Oil on canvas, 110 1/4 x 114 1/8 in. (280 x 290 cm)
Collection of Dominique Lévy and Dorothy Berwin

which they refer are not, creating an eerie impression of dislocation not unlike that of coming across the homogeneous, interchangeable architecture of tourist hotels that look the same whether in Latin America or the South Pacific.

Ackermann expands on the Situationist exercise not only by traveling beyond his home turf, but by collecting and engaging tourist-bureau advertising and lifestyle marketing. The posters in the bureaus' shop windows, promising sunny, pristine beaches and exotic sights, guarantee happiness. But of course this vision is ideological and ultimately false. Ackermann sees it as a highly visible symptom and tool of the economic imperialism of globalization. "As for example with the Crusades, mass tourism characterizes an epoch which for me has its own stylistic concept," he has said. "It conquers territories, makes countries disappear or occupies them."[1] Indeed, the tourism industry projects an absurdly utopian vision, where life's stress and environmental distress are made to seem equally remote. "All this can be yours"—for a price. And therein lurks the lie in the capitalist promise of freedom and abundance: that consumption is good for everyone and accessible to all. We know that underprivileged locals are behind the palm trees, but to acknowledge their plight could transform a lighthearted vacation into neocolonialist exploitation.

An unusually large format makes the artificiality of these ideological images all the more apparent. In addition to appropriating publicity images, Ackermann makes paintings as large as billboards, using their scale and supporting armature to command the same attention as a roadside placard. But when the viewer is confronted with these enormous works, the impulse is not to "drive by," taking their consumerist message in at a glance. The works' explosive, near-psychedelic color and wild, almost violent, graphic impact make this impossible. Rather the format works in tandem with the visual punch associated with ad graphics—clarity, saturated colors, and strong tonal contrasts—to ask of the viewer not only a deep engagement with the work itself, but a broader critique of the genre to which it refers.

Ackermann's environments evoke a viewing experience that mirrors, in a sense, the artist's way of working. We become tourists ourselves, wanderers in his mindscape, cartographers of our *own* mental maps of *his* process, as we use our memories and expectations to decipher his topography. Instead of journeying to a set destination, we escape into another universe, one composed of constellations of mnemonic and personal associations. Ackermann says, "One has the need for change and fulfills it through travel. I thematize that in my oil paintings. It is not an invasion, rather one flees from a territory."[2] The experience he seeks in his studio is the one he offers to the viewer—a release from the everyday. Yet this flight into pure subjectivity is problematized by Ackermann's engagement with the theme of economic and cultural globalization. Offering us a brand of nonexploitative escapism that may itself be relatively free of invasive economic imperialism, he nonetheless forces us to acknowledge its existence. For Ackermann, with the freedom to escape reality as one experiences his art comes the responsibility to return to it when one leaves the gallery.

—*Elizabeth M. Grady*

dreamed-out myth•pleasure and adventure

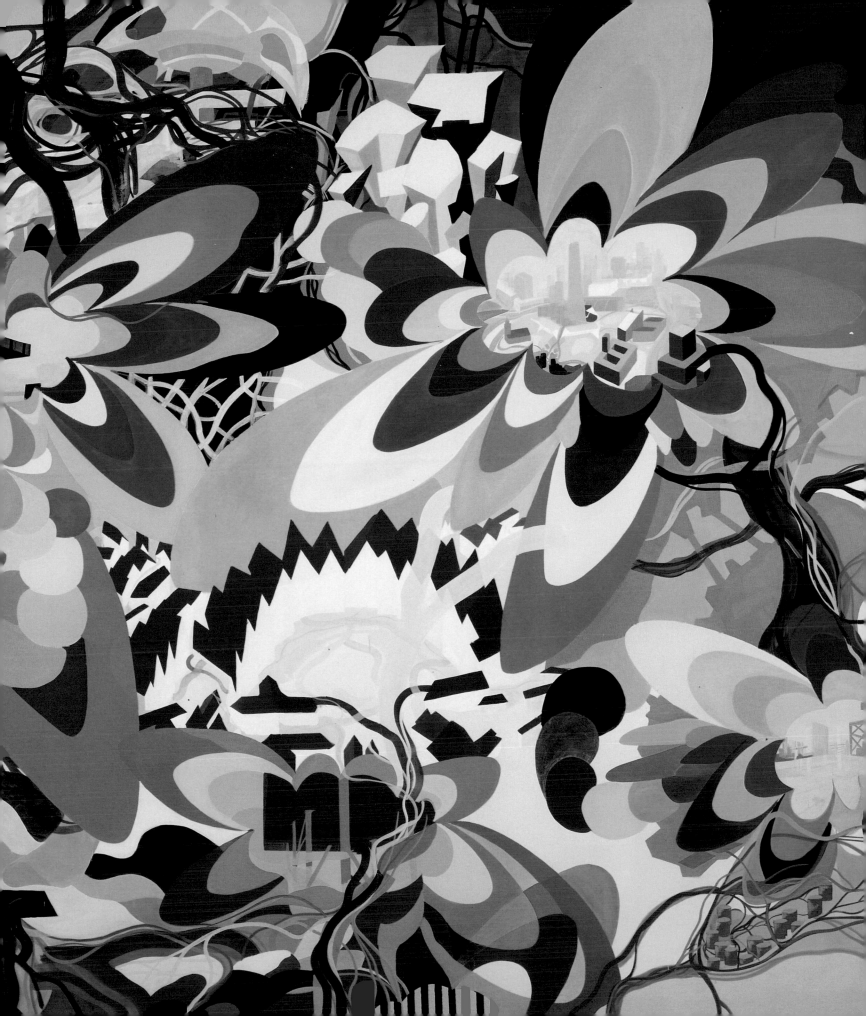

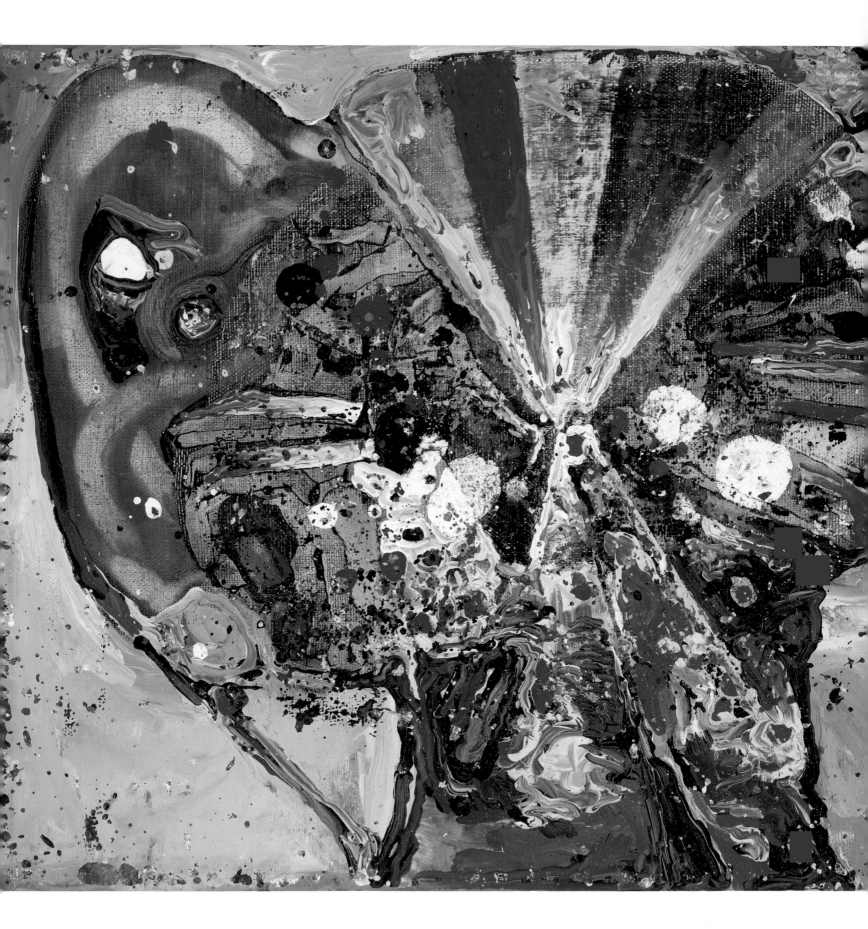

STEVE DiBENEDETTO

cavernous•kaleidoscopic vision•ghostly•submerged

Steve DiBenedetto concocts topsy-turvy underworlds that disturb almost as much as they enchant. In his paintings and drawings, swirls, tendrils, lattices, and vortices crisscross, interweave, sever, and re-form, resulting in a kaleidoscopic vision of a deep unconscious in apparent distress. Cavernous beds of polychromatic crystalline forms are juxtaposed against neighboring webs of thick, opaque paint. Radiant color wheels churn in and around rainbow-laden blue and yellow skies, suggesting a fantastical landscape right out of *The Wizard of Oz*. Are these topographic studies of the interiors of caves? Renderings of microscopic life-forms from another planet? Or do they represent sound waves bouncing in an echo chamber?

They may be any or all of these. Rather than refer to a defined system or set of systems, DiBenedetto simulates multiple realities native to various levels of human consciousness, as titles like *New Amnesia* (2001), *Afterland* (2001–03), and *Burnt Out and Glad* (2002) suggest. At times evocative of dreams, at others of drug-induced hallucinations, DiBenedetto's semiabstractions are agitated by formal elements pushing, pulling, and twisting in opposition to each other. We never know which element will submerge or reemerge from this tension, but one thing is sure: It will encapsulate a vision never before seen—one that has unexpectedly "tumbled into existence," as the artist puts it.[1]

DiBenedetto's artistic practice echoes the complexity of his imagery. Portions of his canvases are painstakingly painted and repainted over the course of several years. In some works, the gestural application of paint in drips and splashes suggests an Abstract-Expressionist quality uncommon among his contemporaries. But

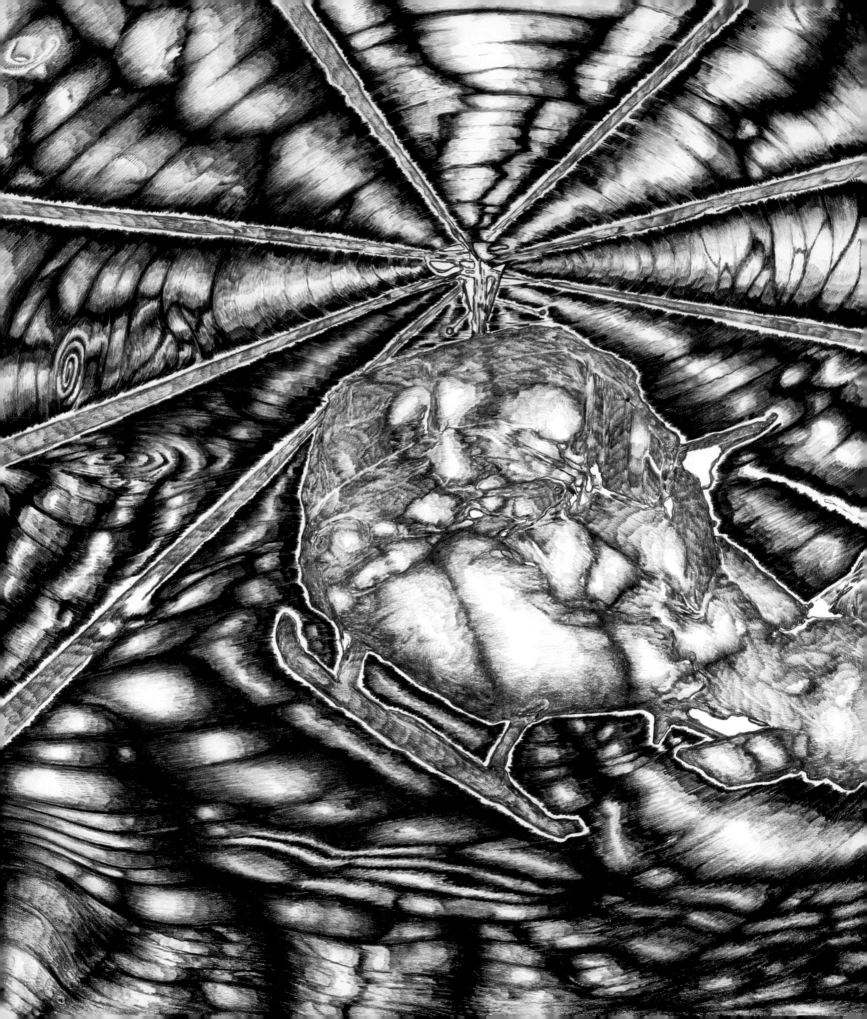

Previous pages: Steve DiBenedetto, *Dose*, 1999
Oil on canvas, 11 x 14 in. (27.9 x 35.6 cm)
Collection of Daniel and Brooke Neidich; courtesy
Derek Eller Gallery, New York

Left: Steve DiBenedetto, *Darkopter*, 2004
Colored pencil on paper, 22 1/2 x 30 1/8 in. (57.2 x 76.5 cm)
The Judith Rothschild Foundation, New York;
Contemporary Drawings Collection

this invention is then counteracted by tight composition. As the artist admits, "For me, painting is a combative process." Despite the battle, DiBenedetto creates panoptic cohesion in each and every canvas, intertwining his centralized imagery with radiating extensions of expressive forms.

Another cohering force in DiBenedetto's work is the use of recurring motifs. His iconography develops out of an ongoing interest in paranormal phenomena partly inspired by Steven Spielberg's 1977 sci-fi film *Close Encounters of the Third Kind*, which he remembers seeing as an art student in his late teens. UFOs entered into DiBenedetto's artistic vocabulary fifteen years later, and he continues to incorporate outer-space imagery into his work while also seeking out new motifs. In the past five years he has settled on a refined set of subjects, including octopi, helicopters, and Ferris wheels. While these share a radial quality, they each bear different and sometimes quirky meanings in the artist's iconography.

DiBenedetto's interest in octopi stems from his readings of Terence McKenna, an occult ethnobotanist and drug enthusiast who saw the octopus as an advanced species for its ability to communicate emotion by changing color. Ferris wheels, on the other hand, speak to the artist's interest in "instruments of disorientation" and reflect the centrifugal and chaotic movement that recurs in much of his work. Among all of DiBenedetto's icons, helicopters possess the most complex modern technological and spiritual lineage. In the drawing *Darkopter* (2004), DiBenedetto uses small, iterant strokes of indigo colored pencil to create a ghostly rendering of a hovering helicopter whose whirling propeller blades dissect the marbleized sky above. On closer inspection, the bulbous head of the aircraft can be identified as that of the famous Bell Model 47 helicopter. Invented in 1946 by scientist, engineer, and theorist Arthur M. Young for the Bell Aircraft Corporation, the Model 47 was a feat of modern design. Despite great success, following his helicopter's commercial release Young abandoned the aircraft business to pursue his long-standing spiritual quest to understand human consciousness. Young, like McKenna but without the

27

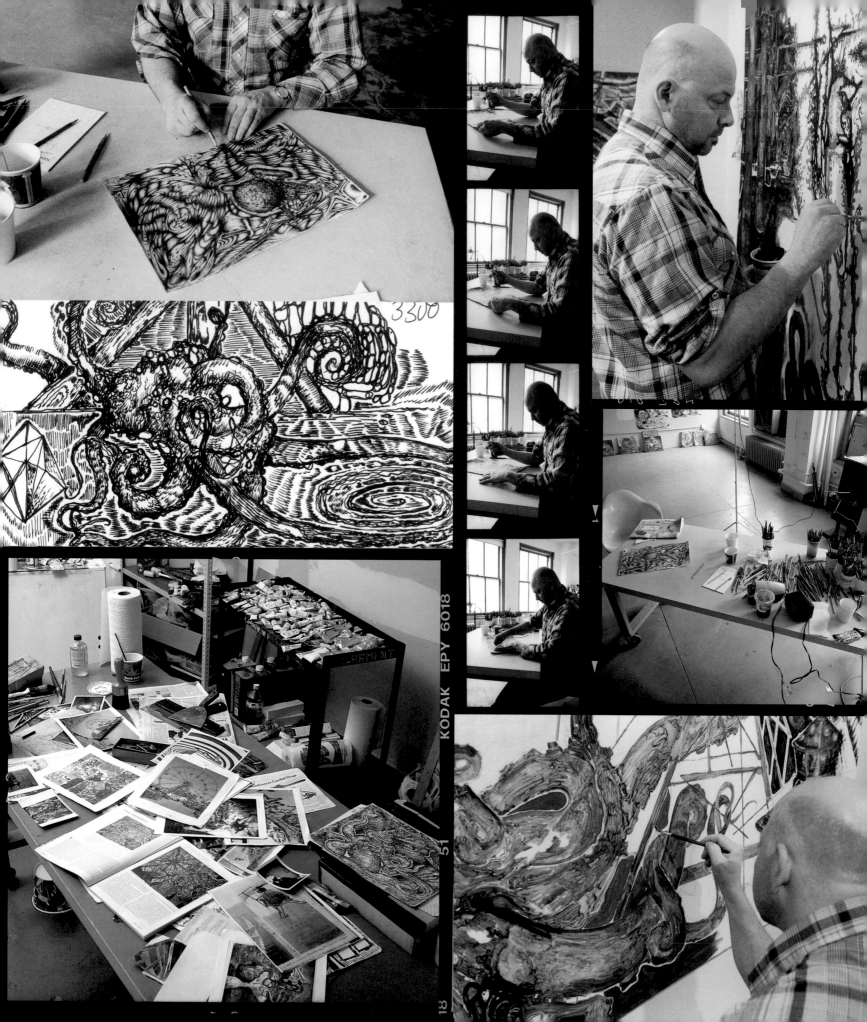

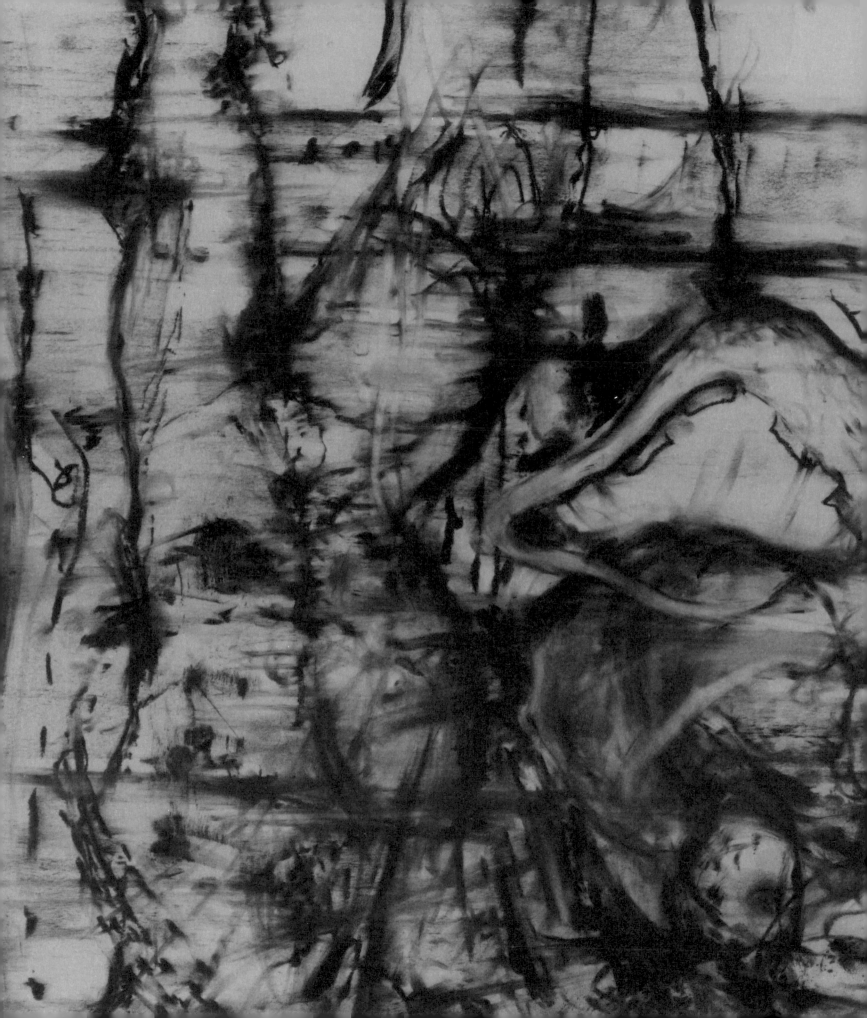

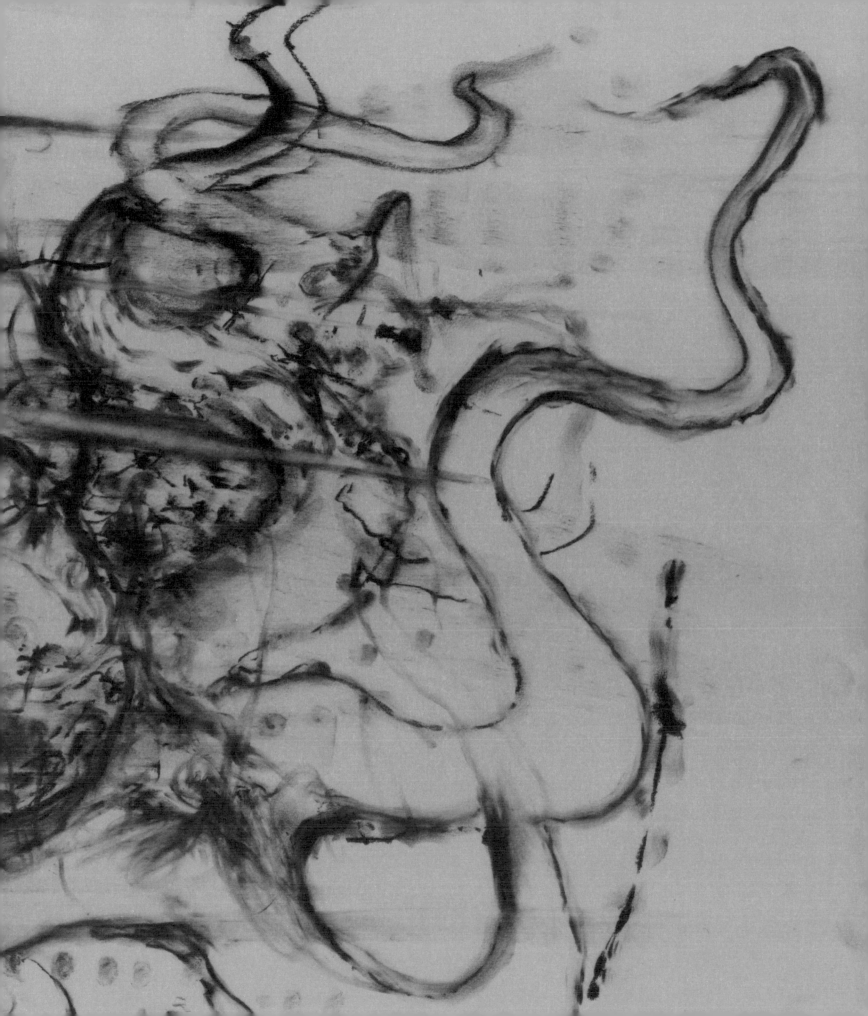

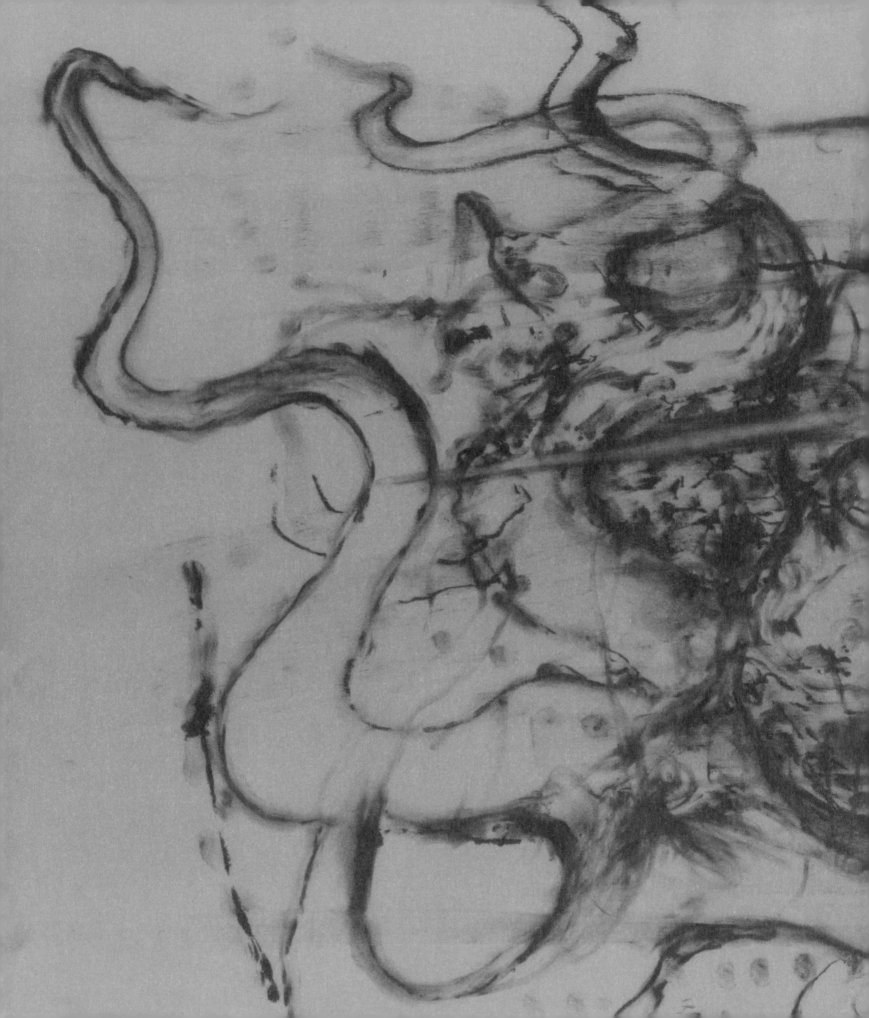

Steve DiBenedetto, *Breakup*, 2003–04
Oil on canvas, 48 x 60 in. (121.9 x 152.4 cm)
Private collection; courtesy Nolan/Eckman Gallery, New York

assistance of mind-expanding drugs, sought to make theoretical connections between lucid reality and unexplainable phenomena. By simulating an illusory mindscape, DiBenedetto, like these philosophers, deconstructs the barriers between abstract thoughts and conventional means of interpretation, offering a whole new mode of perception.

In the painting *Breakup* (2003–04), DiBenedetto likewise includes a helicopter, but this time he builds it up with heavily worked layers of impasto. He positions it just below the horizon line, moving in on a gnarly mess of octopus tentacles set against a pie-shaped color wheel and dipping into a crystalline blue sea. The depicted space is as likely to be situated high above the ground as it is to be set deep in an underwater cave. A dark background engulfs the helicopter's halo of radiating light, signaling the blackness either of a night sky or of the ocean's depths. *Breakup*, as the title suggests, obfuscates interpretation by fracturing our fragile perceptions of space. Whether this is a paradisiacal vision of the land of Oz or its antithesis, an unsettling netherworld, is not clear. DiBenedetto says he wants to give us a "greater sense of place in the big picture." And he does: He gives a big picture of a place where reality cohabits with and wages war against fantasy, a place caught between heaven and hell and enlivened in our minds.

—*Tina Kukielski*

tumbled into existence•radiating light•kaleidoscopic vision•ghostly

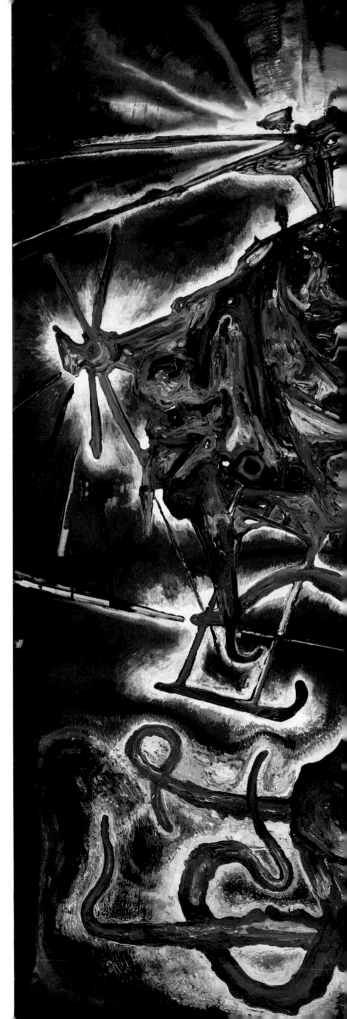

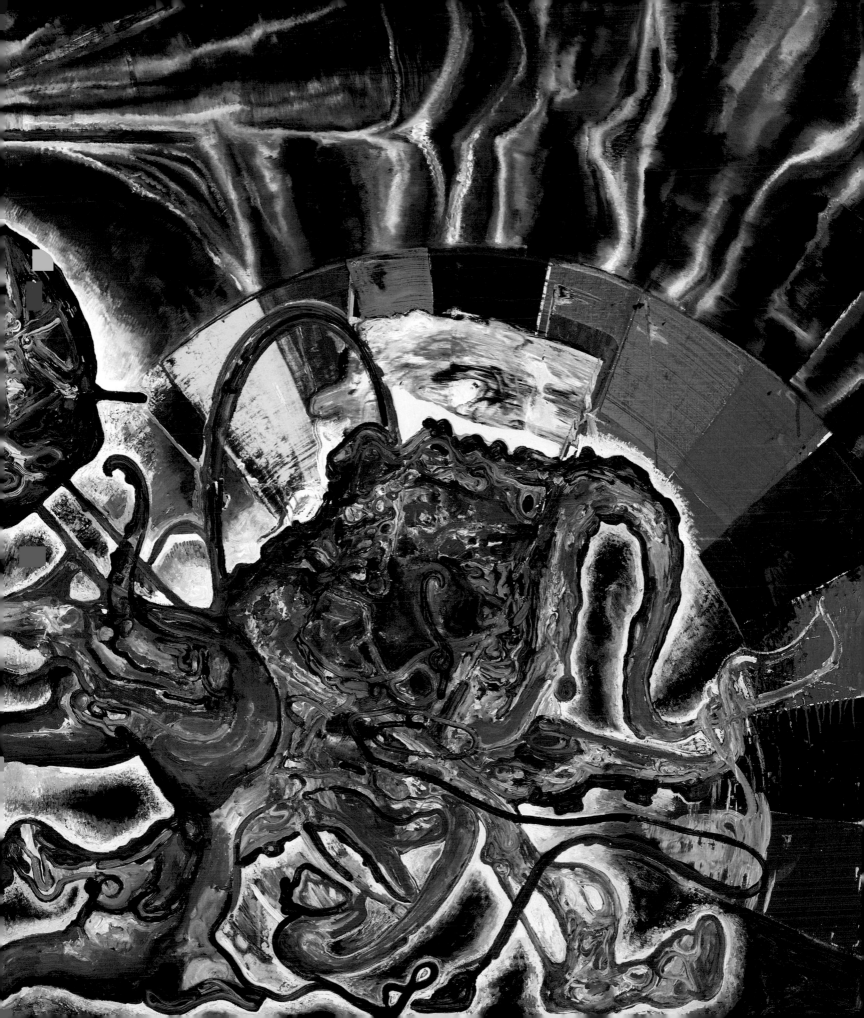

CARROLL DUNHAM

Over the past three decades Carroll Dunham has experimented broadly with form and content, ranging from large-scale canvases of rotating planetary bodies to suites of portraiture of a recurring male subject to small, ink-and-graphite doodles of dense, abstracted landscapes. While testifying to remarkably expansive ingenuity, the stylistic peculiarity of his semiabstract paintings and drawings and their unique iconography constitute a signature style that is instantly recognizable. The bubblegum pinks and black outlines, the square-headed, eyeless figures, the expressive orifices and protrusions—all reappear again and again in Dunham's work, proving that this artist is nothing less than the creator of a fully realized ulterior universe.

Bringing his universe to life, Dunham engages its inhabitants in a host of vehement feuds, primal pleasures, and assorted eccentricities, employing an artistic vocabulary rich in three of pop culture's mainstays: cartoons, pornography, and violence. In *Green Planet* (1996–97), one in a series of nearly monochromatic canvases, for instance, pairs of eyeless, rectilinear creatures emerge from the circumference of a chartreuse planet, tickling and prodding each other with their penis-noses, their mouths agape and baring big, angry teeth. Expressive green and black smears and drips add to the sense of aggression that plagues this planet and its surrounding atmosphere. Imagine a paint-strewn battlefield locked in stalemate where the best hope for a cease-fire is a nihilistic explosion.

Dunham's menacing cast of cartoonish characters first appeared in his work in the mid-1990s. More recently this crew has been replaced by a recurring alter ego, again eyeless and penis-nosed, but now dressed in a suit with a starched white collar and a

Previous pages: Carroll Dunham, *Green Planet*, 1996–97
Mixed media on canvas, 84 x 66 in. (213.4 x 167.6 cm)
Collection of Rachel and Jean-Pierre Lehmann

Above: Carroll Dunham, *Mesokingdom Fourteen (Edge of Night)*, 2002
Mixed media on canvas, 96 x 93 in. (243.8 x 236.2 cm)
Collection of Phil Schrager, Omaha

Right: Carroll Dunham, *Untitled*, 2003 (detail)
Ink and graphite on paper, thirteen parts, dimensions variable
Collection of the artist; courtesy Nolan/Eckman Gallery, New York

black top hat. Like a displaced nomad or Don Quixote himself, the blind figure scuttles ceaselessly through the desolate, wintry landscape of the *Mesokingdom* series (2001–02). Here we glimpse the figure's itinerancy as it plays out across multiple canvases that function like comic strips or animation cells. Pieces of narrative string together from painting to painting, but despite Dunham's scrupulous dating of his work, the sequences skip from one dislocated place to the next like cinematic jump-cuts. Dunham acknowledges this disconnect: "When you look at paintings, you can run the narrative in your mind—forward, backward, sideways."[1] The multidirectional abandon of Dunham's narratives provides a secondary layer of provocation: Now that you're acquainted with the bizarre caricatures waging wars at the surface, there's the utterly disorienting sense of time to grapple with beneath.

Lending some measure of coherence to these disruptions, Dunham's palette has gradually conformed to a set of representational color-coding: the pinks are skin/feminine, the blues are water/masculine, the whites are teeth, and the blacks are the outlines. This system serves as a guide to recent works including the series *Particular Aspects*

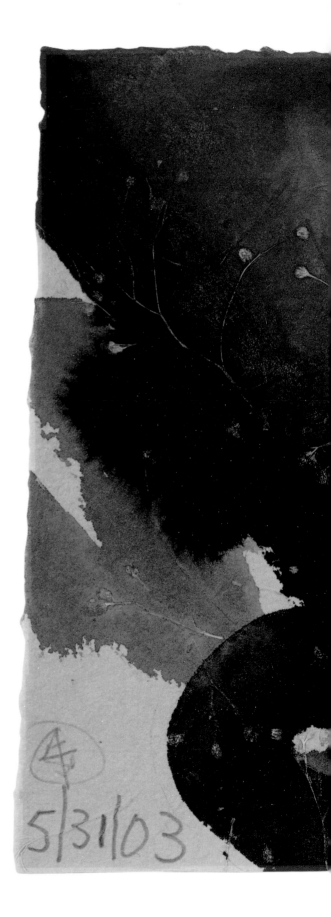

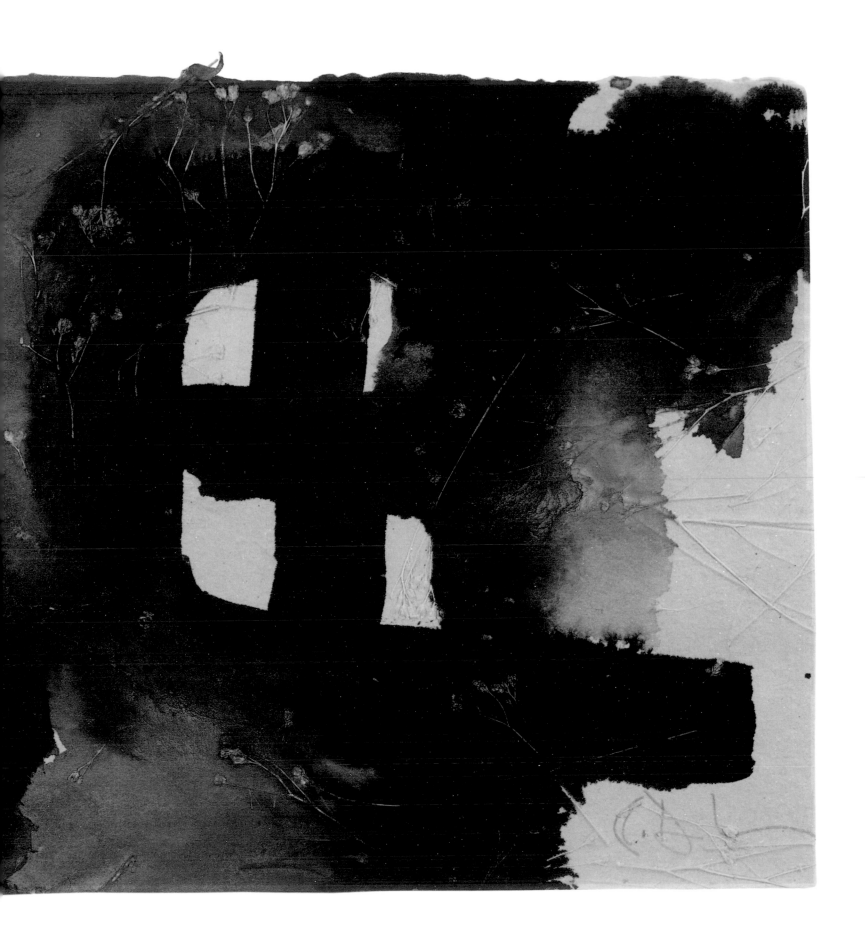

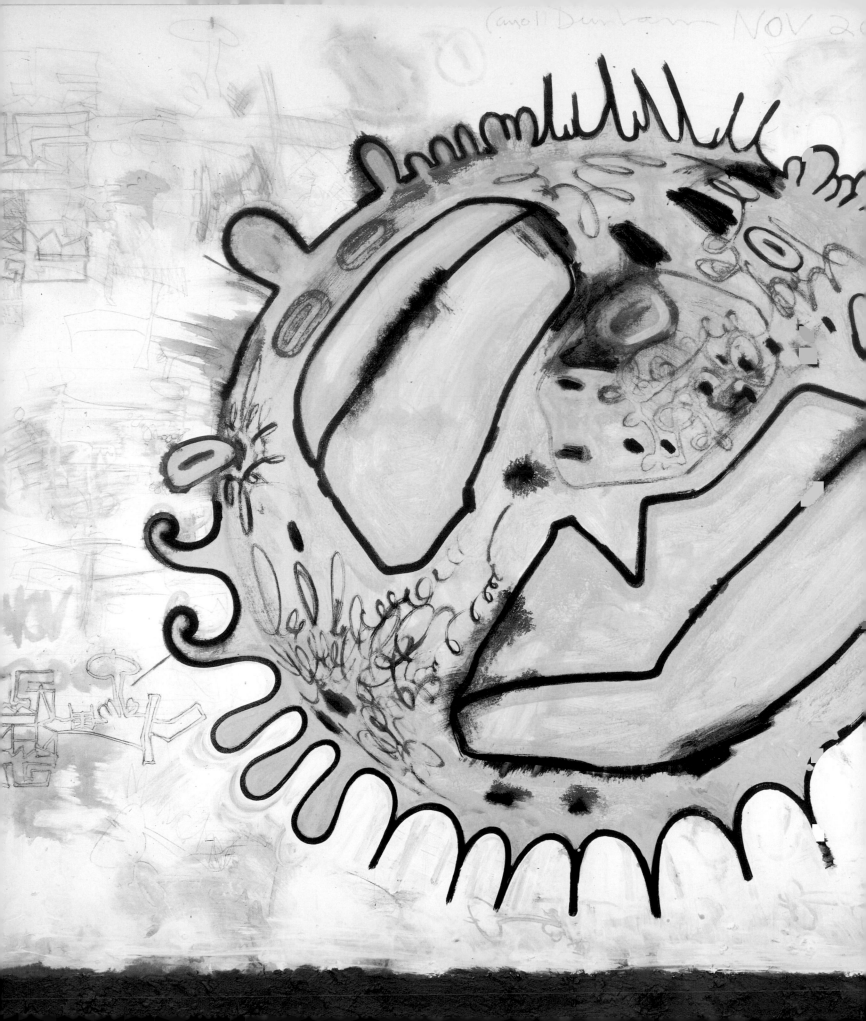

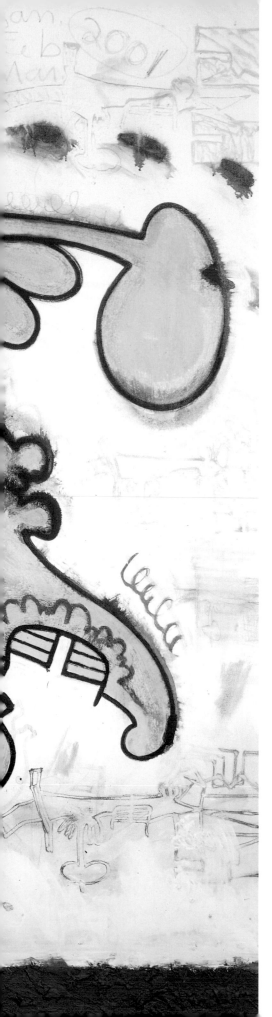

Carroll Dunham, *Solar Eruption*, 2000–01
Mixed media on canvas, 84 x 100 in. (213.4 x 254 cm)
Collection of Sally and John Van Doren; courtesy
Greenberg Van Doren Gallery, New York

(2003–04) and *Rotation/Ocean* (2004), in which Dunham has favored extreme compositional reduction, zooming in on the head, teeth, nose, neck, or chest of his male subject, and in some cases rotating the composition at one-quarter turns. Dunham calls this new attention to detail "reductivism from hell"[2] and says it stems from a growing interest in unveiling his subject's most banal or sometimes uncouth characteristics. At its most extreme, as in the case of close-ups of splotchy penis-nose protrusions, the inspection becomes almost explicitly sexual.

Throughout his career Dunham has complemented his paintings with suites of drawings that explore the workability of specific ideas. Take his 2003 untitled series of thirteen ink-and-graphite drawings on pink paper embedded with dried flowers. Here, the forms begin to lose their cartoonish quality; mixed with water, the black ink bleeds across the paper, blurring sharp outlines, gathering in pools around the floral impressions. The forms become so abstract that they morph into self-invented landscapes. Despite this loosening up, however, there is still an undeniable rigidity in the repetition of the initial marks across all thirteen sheets.

Though we might trace an evolution toward abstraction in Dunham's recent work, in fact it still resonates with all of the figurative wars that came before. The artist has observed that "abstractions are contaminated by subject matter."[3] But no matter how he might stretch and distort what he calls his "trains of thought" through experiments in scale, time, or place, his subject matter remains, as if he were intuitively bound to the painted world he describes as "bellicose." And so for Dunham, every turn of the paintbrush, pencil, or pen is an engagement between subject and intuition, as he wrestles to master contamination and distill it for our mind's eye. At times what Dunham reveals through this act of creation is splendid, at others it is grotesque. Regardless, it's indubitable that we're on the brink of some celestial eruption, so let's just hope for the best.

—*Tina Kukielski*

tickling and prodding•black smears

ATI MAIER

"I just don't like to make political art," says Berlin-born Ati Maier.[1] But as titles like *Drop Your Gun* suggest, the sentiment and subjects of some of her work bespeak a sense of pacifist escapism that at least nods toward the political. In this 2004 painting, rainbow-striped highways levitate and zip across an abstracted landscape. A florid grid emerges from the mouth of a giant, prismatic disco ball, and white cumulus clouds, billows of smoke, and snow-capped mountains butt up against starry blue solar systems. Octagonal shapes layered on and behind these elements are like peepholes to another dimension, housing undiscovered planets, odd species of birds, cartoonish astronauts, and anachronistic video-game characters. Is this mere child's play? Science fiction? Perhaps it's somewhere in between: a fantastical dreamworld devoid of earthly dangers and open to an unreserved sense of possibility.

In Maier's paintings, whirling and exploding clouds of celestial matter expand, contract, and finally morph into something resembling cyber networks. But whether her images are literal representations of outer space or a virtual simulation of infinite three-dimensionality is difficult to decipher. Fusing both, she employs microcosmic and macrocosmic vocabularies, superimposing their seemingly incongruous systems in dizzying feats of composition. In *More* (2004), for instance, supernovas flaring light-years away pulse menacingly around, over, and under jewel-like circles. In *Le Vent Nous Portera* (2003), swirling white galaxies rotate around kaleidoscopic black holes, their planets resisting gravitational force via compositional tension. In both works, low-resolution, pixilated forms gather in rows, echoing across the backgrounds like color bars on a television monitor or rudimentary digital animation on a computer screen.

That this vast expanse—from sky to screen—is traversed via humble media and on a very small scale makes Maier's project all the more impressive. The artist applies layers of inks mixed with wood stain to square sheets of thin, manila-

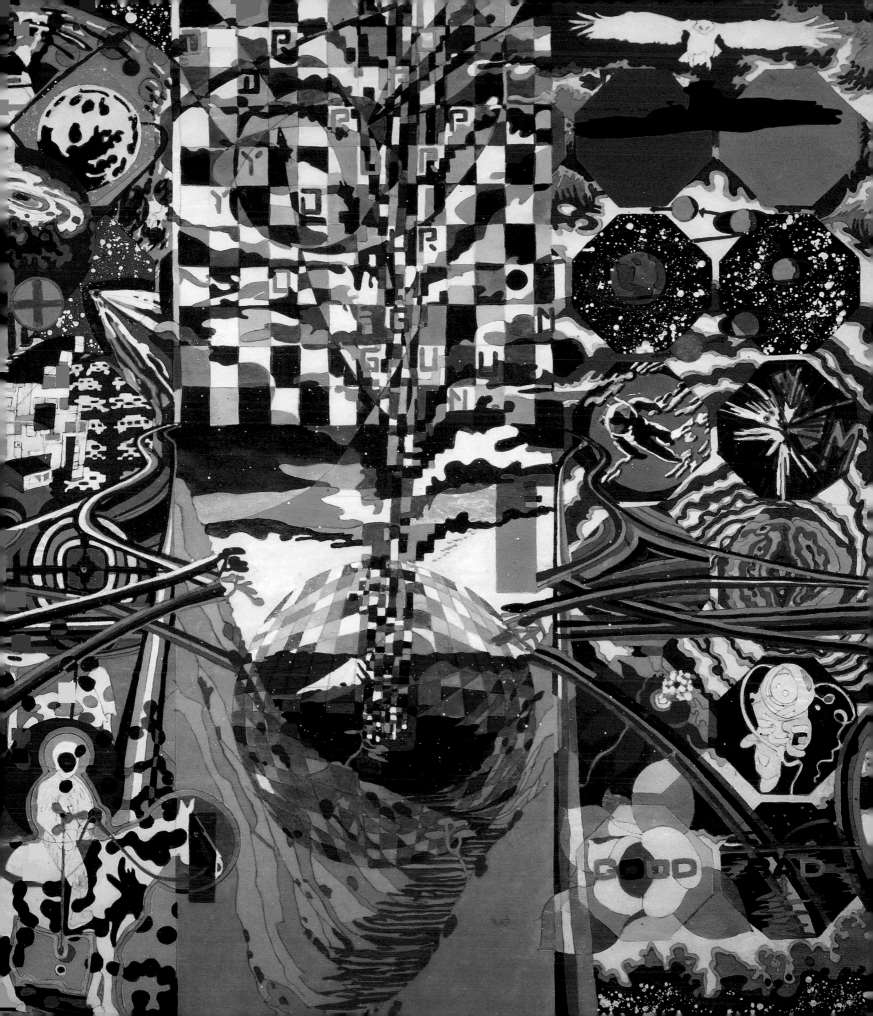

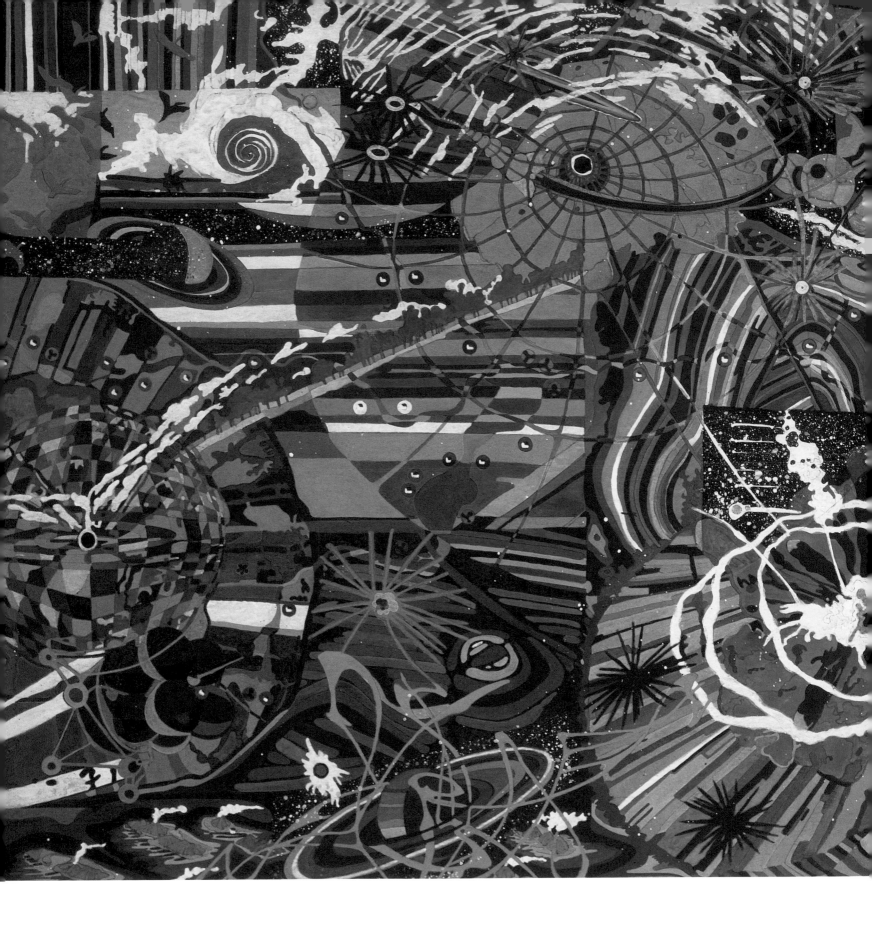

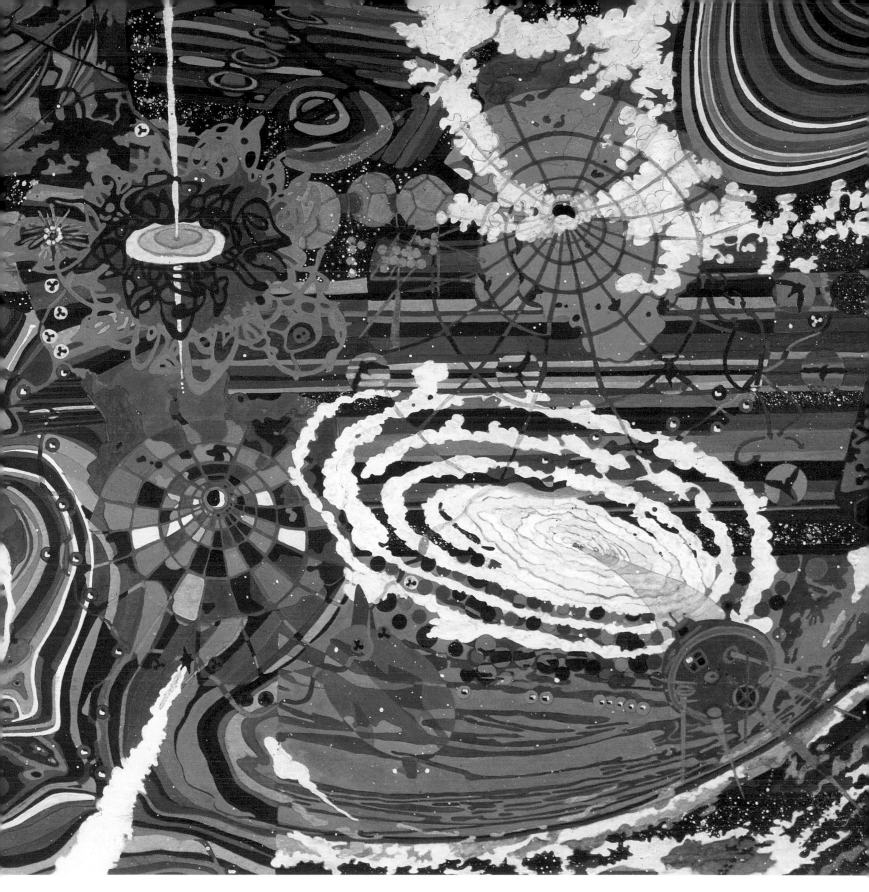

Previous pages: Ati Maier, *Drop Your Gun*, 2004
Ink and wood stain on paper, 23 5/8 x 23 5/8 in. (60 x 60 cm)
Geraldine Bergmeier Collection, Halle/Saale, Germany; on permanent
loan to Museum der bildenden Künste Leipzig, Leipzig

Above: Ati Maier, *Le Vent Nous Portera*, 2003
Ink and wood stain on paper, 23 5/8 x 47 1/4 in. (60 x 120 cm)
Private collection

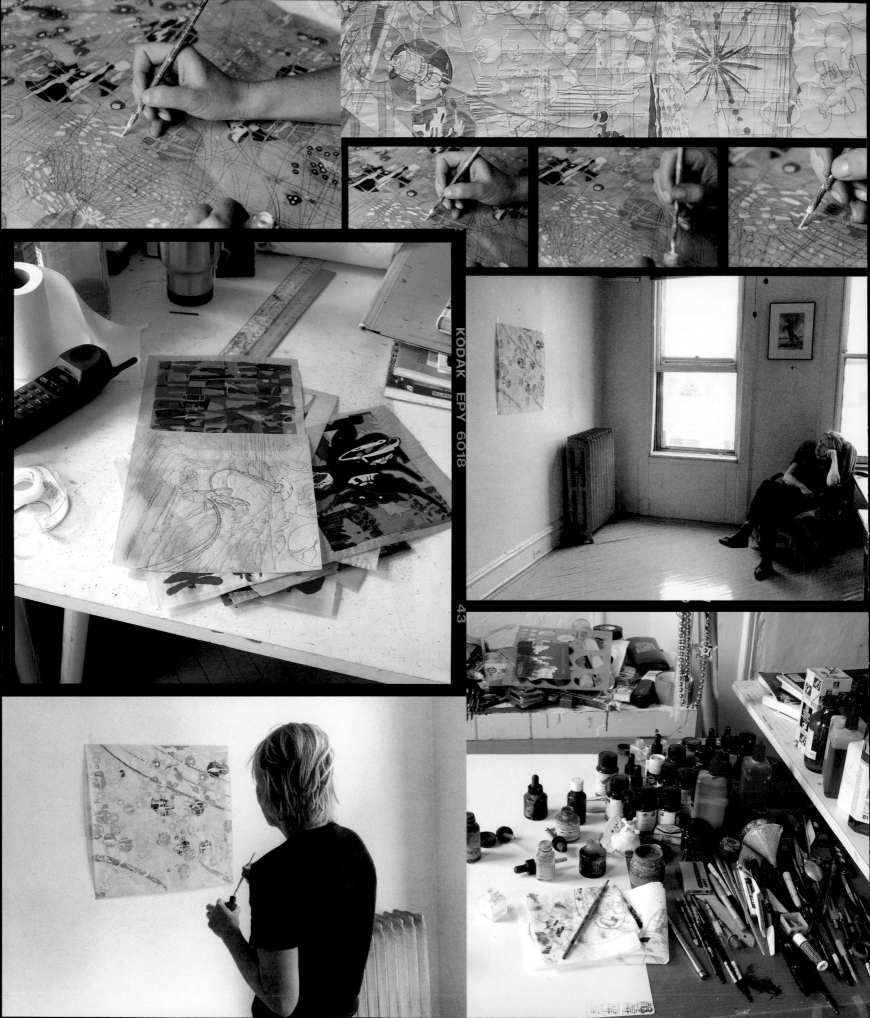

43

DIE WOLKE DER UNWISSEN
Zwird für immer BE

+ THE LAST

FOR HIS MUSIC THESE SHALL BE

SO IT YOU + YOU + YOU
+ 1 + 1 + 1

LIFE

PAC-A

PAC-A

SEIN - @

MORE MUSIK

ALL - THIS - TIME

SUPERGALACTIC LOVER

STAND - BYE
FREQUENCY
FREQUENCY

THERE IS NO IN BETWEEN

YOU GOT TO BE EITHER HERE OR THERE

YOU BETTER BE → IN OR OUT

GET DOWN ↓

MY MUSIK SAYS

GET UP ↑

HOW MUCH FURTHER DOWN CAN YOU GO

* Mind levels up

Coming through
Coming through

GREEN IS REGROWING

RAISING LEVEL
GREEN
470×10⁴0
EXPENDING
RED
RED LIGHT ARE

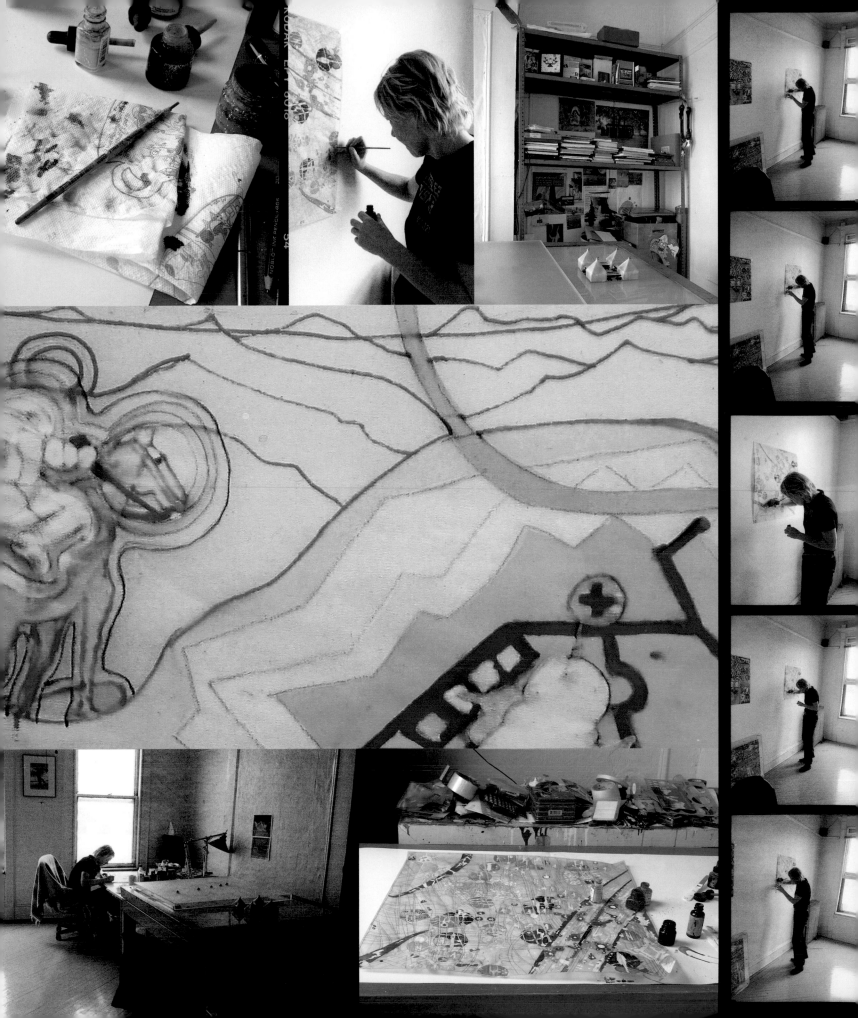

Above, from top: Ati Maier, *Blue Horses*, 2003; *Boy Meets Girl*, 2003; *Six Moon Red*, 2002; *West*, 2004
Ink and wood stain on paper,
7 1/2 x 7 1/2 in. (19 x 19 cm) each
Collection of the artist; courtesy
Pierogi, Brooklyn, New York

Right: Ati Maier, *Phast*, 2004
Ink and wood stain on paper,
23 5/8 x 23 5/8 in. (60 x 60 cm)
Collection of Jed and Jamie Kaplan

boundless•little bangs•light-years away•peepholes•parachutes•pulse

colored paper she first discovered as an art student living in Vienna. Though heavy on reds and blues, Maier's palette seems as boundless as the deep space her drawings project. Sometimes she executes quick sketches of landscapes or simple subjects like parachutes on these small sheets, using only a few colors, as in *Six Moon Red* (2002), which she occasionally stores between pages of a book in her studio. At other times she adjoins several pieces of paper to make larger, rectangular works that are composed of many layers of imagery and ink and take up to a few months to complete.

Into the dense space of these larger works, Maier often injects the written word—sometimes in the form of graffiti-style tags, as in *More*, or, in the case of *Drop Your Gun*, in a standard computer-based font encased within a scrambled grid of pixilated squares. The implication seems to be that technology might correct this jumbled mess of letters and cells and sort it out for our mind's eye, but again and again, Maier does all she can to complicate our assumptions and engage our curiosity. When the phrase "HOW FAR OUT ARE YOU?" crops up as a doodle in her sketchbook, Maier's words, much like her images, push the limits of our imagination.

Maier's imagery hails from an array of sources, and she's constantly replenishing her supply. She scans the internet, making frequent visits to the NASA and CNN science news sites, and browses science journals and books by Stephen Hawking, Brian Greene, and Albert Einstein. She conflates the related yet disjointed images she finds into new interpretations of otherworldly places. Airborne spaceships and satellites appear alongside stellar phenomena in her most recent work, attesting to the artist's consuming interest in space exploration and flight. But before she turned to outer space as a source for imagery, Maier's inspiration was the American West, whose mountains, prairies, and grazing cattle were dominant subjects for her during the mid-1990s. One figure that remains from the Western images is the horse (the artist is an avid rider), though now that equine presence transports astronauts through starry interplanetary realms rather than across sparse plains.

A journey through Maier's expansive vocabulary and dense composition can set the viewer on edge. Volcanoes erupt, tempests reel, supernovas explode, and satellites zoom, and we're left with only a glancing premonition of what will remain when the calamity subsides. Like the big bang, Maier's paintings are an act of creation, one with the potential to birth all the matter and energy that will compose and power the universe for years to come. Perhaps they might even be called little bangs—diminutive portals to our future, however volatile, unpredictable, and far-out it might be.

—*Tina Kukielski*

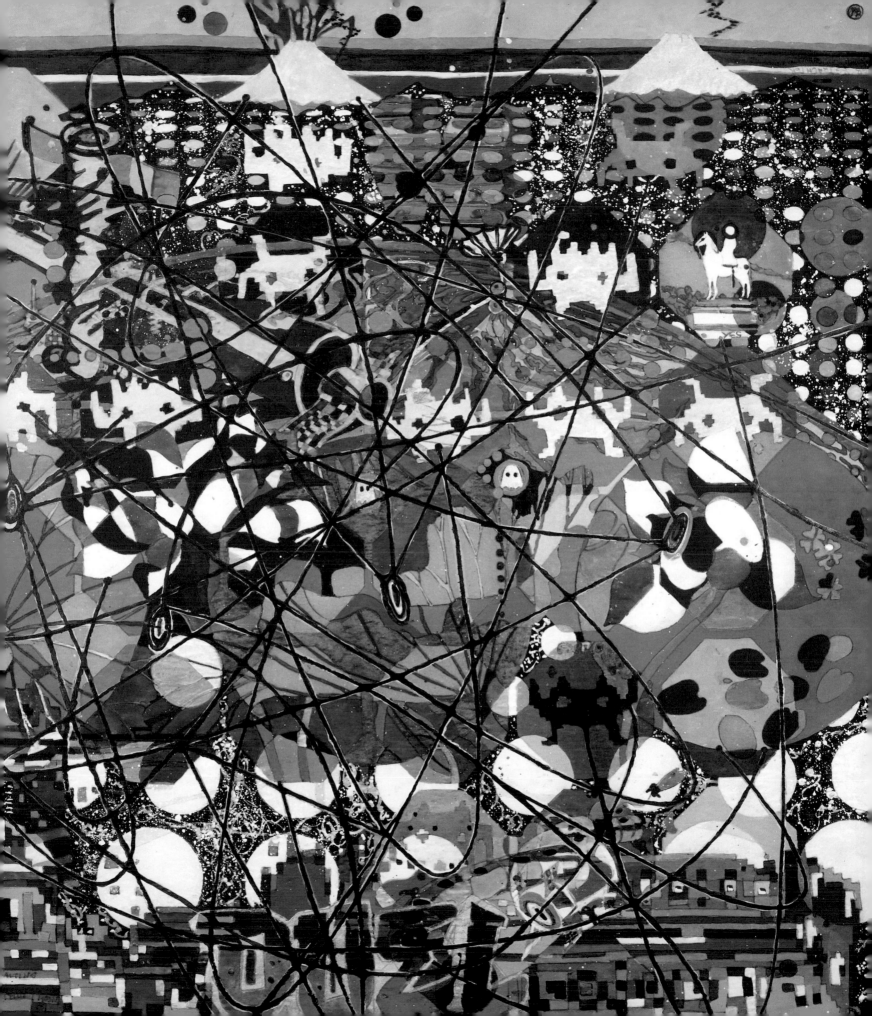

JULIE MEHRETU

ferocious speed•nebulous•explosions

Julie Mehretu's paintings and drawings simultaneously deflect, refract, implode, and explode—all with ferocious speed. Her work incorporates everything from aerial views of teeming African cities to detailed studies of architectural structures in Istanbul to fragments from plans of unidentifiable ancient cities, everything surrounded by richly colored shards, swooping vectors, and frenzied lines, dots, and swirls. Her style is at once reminiscent of maps, charts, architectural drawings, and calligraphy. But unlike these methodical tools, which give coherence to our lives, Mehretu's constructed world is in a constantly capricious state; the compositional elements cyclically detonate, crumble, and rebuild, and any chance at coherence does much the same. Combining disparate sites, sources, and eras, Mehretu juxtaposes here and there, past and present to mold a new vision of the future.

A vast amalgamation of visual sources—among them newspapers, weather maps, television, the internet, architectural plans, comic books, and graffiti—crop up in Mehretu's canvases. Within the layers of just one, the painting *Stadia III* (2004) for instance, we might find both the NBC peacock symbol and graphic icons like crosses, stars, and triangles from national flags or corporate logos, superimposed over delicate renderings of architectural plans. This merging of parts and pieces from multiple sources results in intentionally dissonant juxtapositions that never quite gel into recognizable wholes. The resulting incongruities evoke feelings of dislocation and interference, exposing our fragility and undermining our trust in iconic (and nationalistic) structures.

Born in Ethiopia, raised in Michigan, and now living in New York, Mehretu possesses an itinerant history that would seem to underlie these varied references. Engaged in what she calls a "self-ethnographic" project, she sorts through and recomposes the memories, stories, and genealogies of her own identity in her work.[1] The impetus for one painting might be Africa's urban architectural history, as in *Transcending: The New International* (2003), while

Previous pages: Julie Mehretu, *The Seven Acts of Mercy*, 2004 (detail)
Ink and synthetic polymer on canvas, 114 x 252 in. (289.6 x 640.1 cm)
Collection of Dennis and Debra Scholl, Miami Beach; courtesy The Project, New York and Los Angeles

Above: Julie Mehretu, *The Seven Acts of Mercy*, 2004

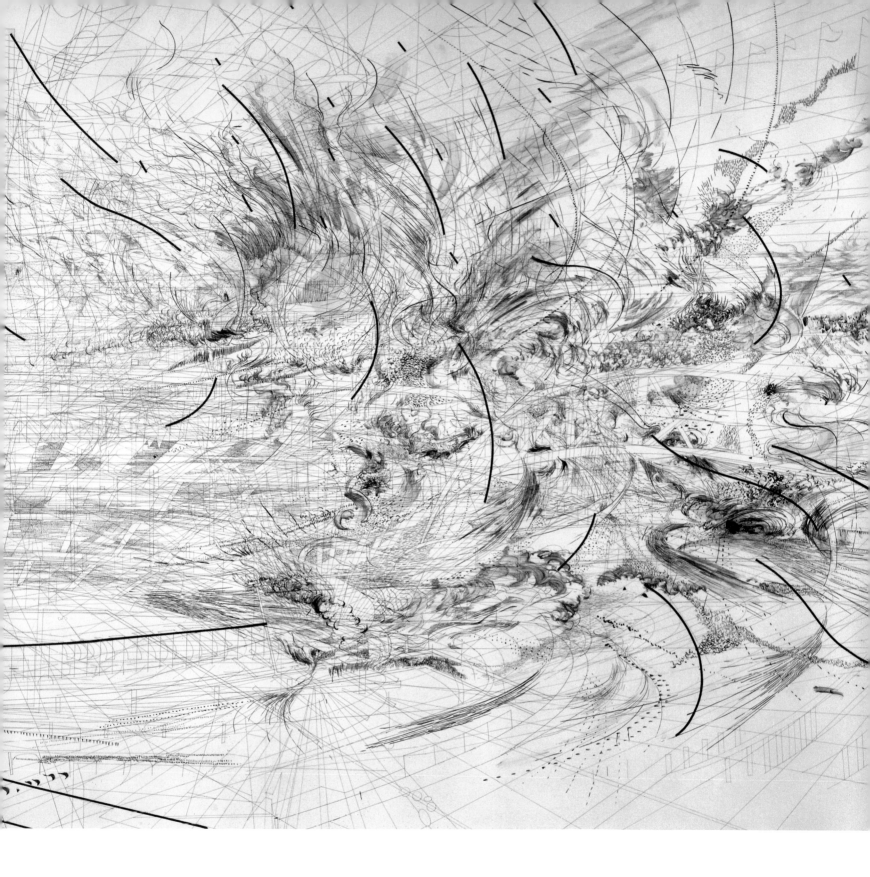

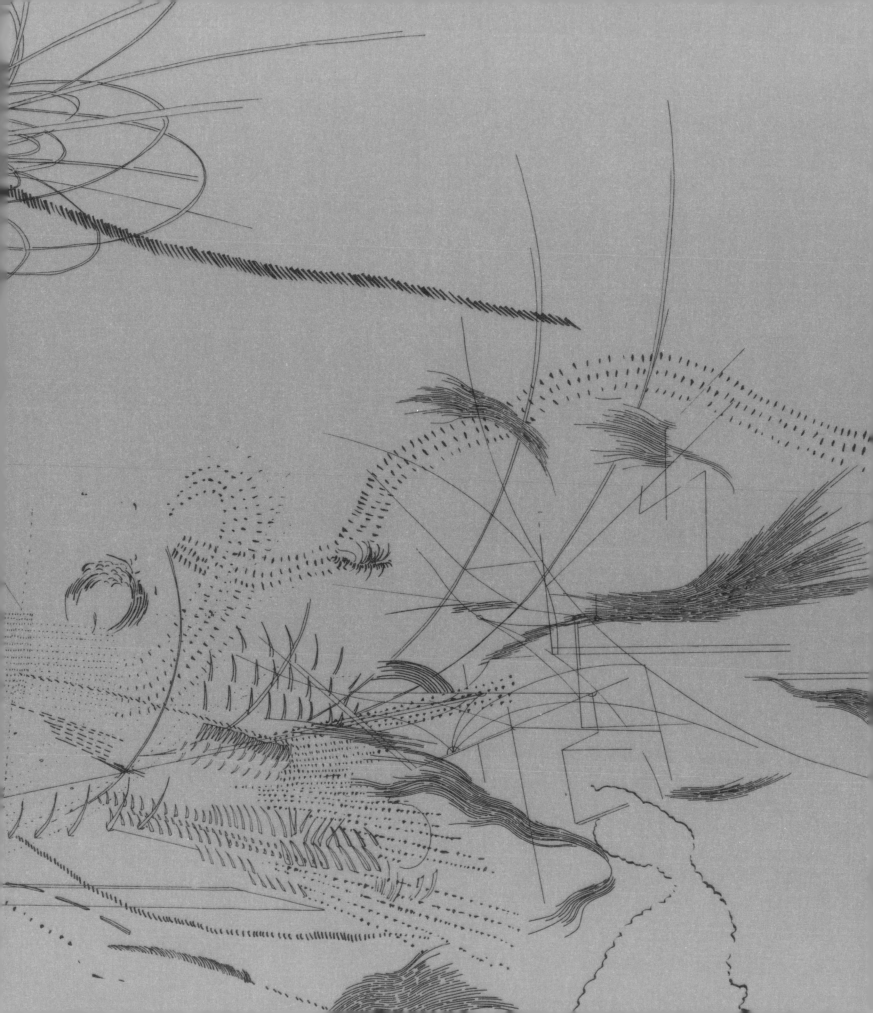

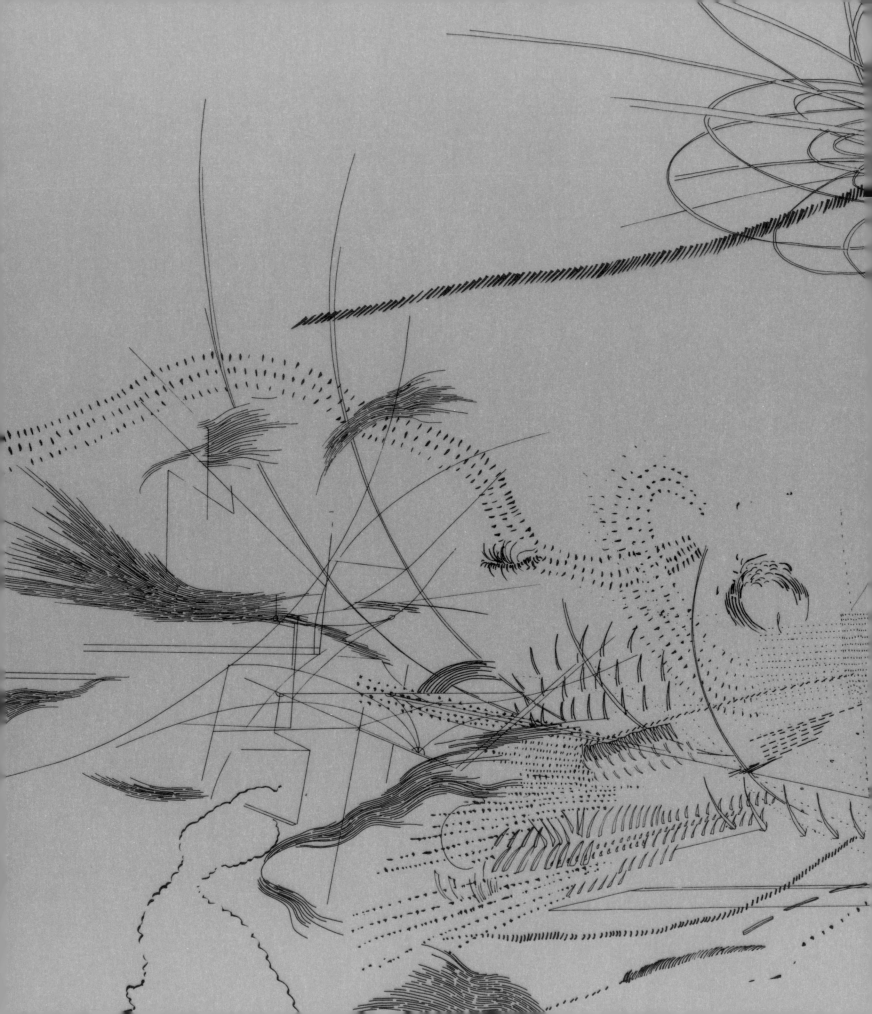

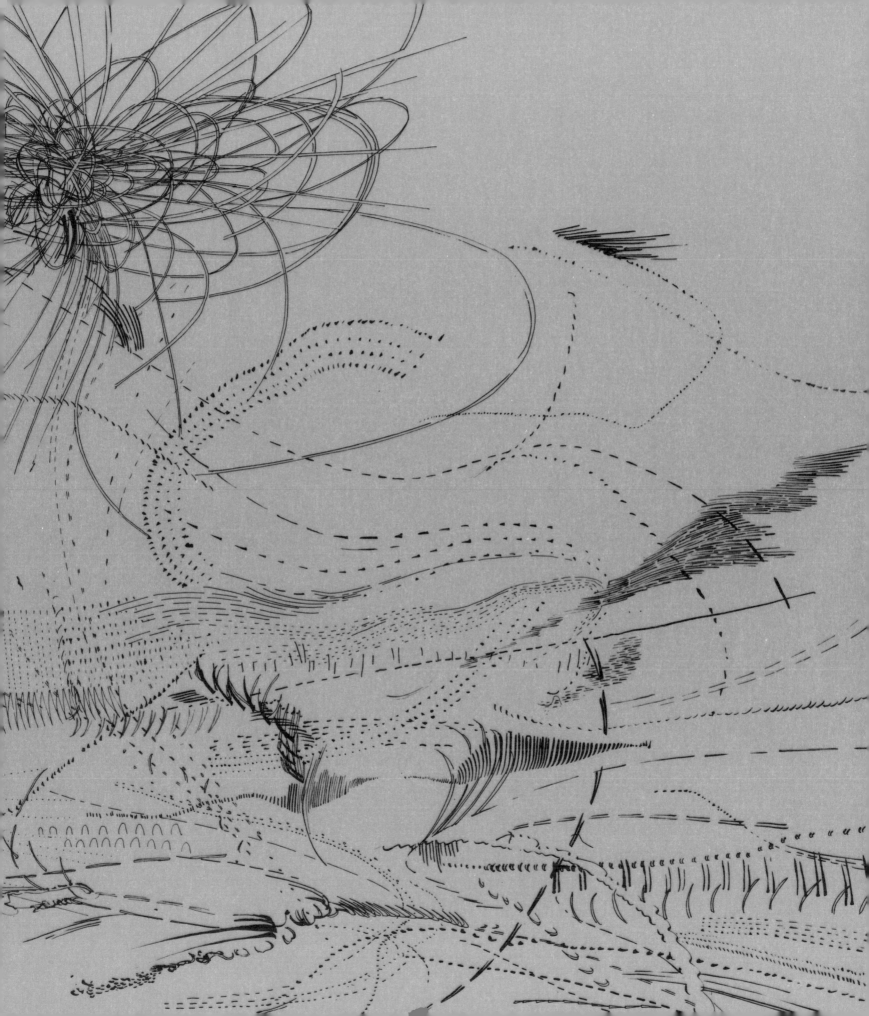

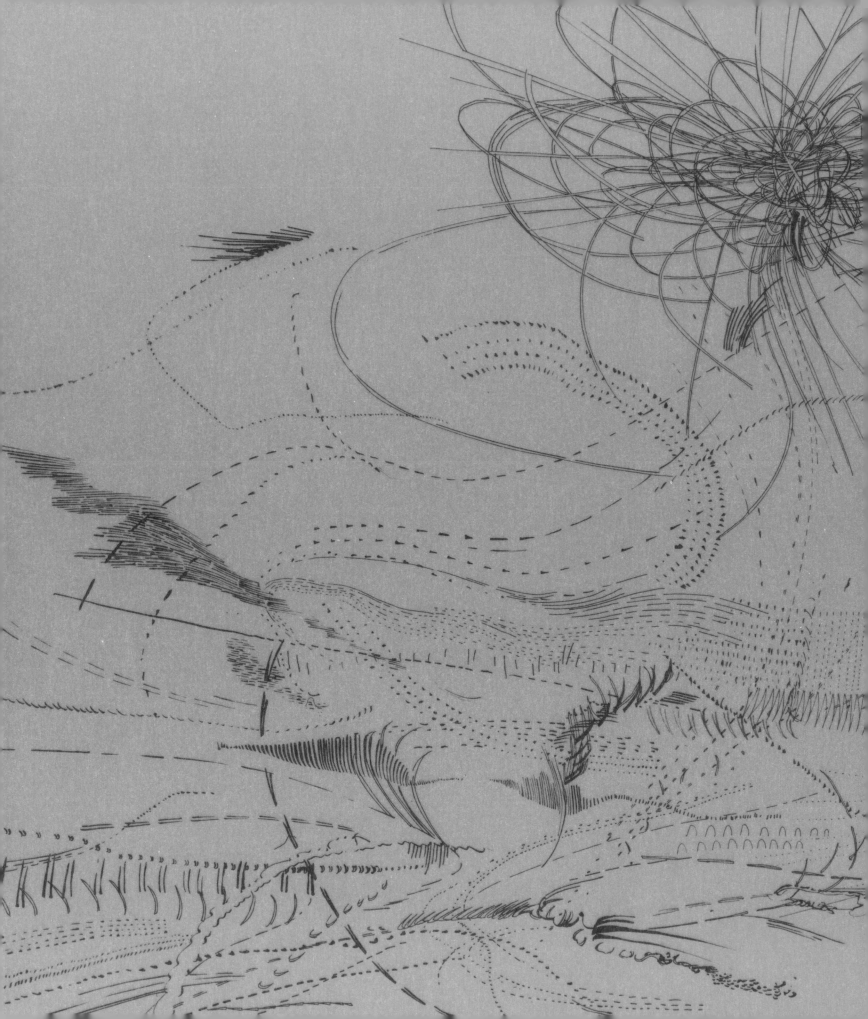

Julie Mehretu, *The Seven Acts of Mercy*, 2004 (detail)

the influence for another might be the lights and logos of Times Square. But perhaps this artist's urge and ability to "transcend" location is the same as any city-dweller's: a reaction to the constant and chaotic influx of stimuli infiltrating our daily lives at a local and global scale. Mehretu acknowledges both the dominance of place and the need to contest that place, calling her project "a response to the social space I inhabit and challenge."[2]

But can what we see in Mehretu's work be reduced to an explicit set of symbols stemming from sociological factors? Certainly not. Mehretu welcomes the unexpected, reaching beyond direct visual sources to incorporate the everyday "thought experiment."[3] For instance, in her small drawings on polyester film, vellum, or paper, Mehretu expressively contends with one idea, expounding on certain focal points, like the wind's crosscurrents or the atmosphere's nebulous explosions. Extractions from these smaller works get layered together in her paintings. Mehretu first sketches her imagery, then projects, enlarges, stencils, or otherwise copies her drawings onto the canvas. She then applies a synthetic polymer and silica mixture over the entire surface. This smooth transparent layer serves as a second canvas on which to add another complex layer. The result is a dense composition in which each stratum tells a different piece of the self-ethnographic story.

Inspired by Caravaggio's *The Seven Acts of Mercy* (1607), which depicts the seven charitable Christian narratives, last year Mehretu made a billboard-size ink-and-synthetic-polymer painting of the same title. Calligraphic, flamelike black swirls jump, smoke billows ominously, pointillist clusters of dots gather to make a line, and vectors float like confetti as a centrifugal whirlwind absorbs and circulates all of these marks around the center. Entrenched in the tempest, a vigorous bed of crosshatchings forms the infrastructure of a crowded virtual landscape awaiting its impending torrential fate. Mehretu situates the calm eye of the storm right in the middle of her *The Seven Acts of Mercy*. Here the swirling constellations of dots are absent and the fires are extinguished. In place of the deluge of nature, rhombuses register in an ordered row, echoing semblances of an architectural plan or a bar graph. As forms align and lines converge in a moment of clarity, a stadium emerges, one with ascending staircases, occupied seats, and an arena floor. A communal container for spectacle and sport, the stadium is as much a classical marker from ancient Greece as it is a symbol of the expansive growth of consumerism and nationalism in our time.

Despite its presumed stability, the stadium edifice appears feeble compared with the swirling network descending on it. Along with a sense of disaster, there remains an unmistakable force of regenerative communal power in Mehretu's work, most notable in the mass of markings. Like Caravaggio in his version of *The Acts*, in which he fused various moral narratives into one composite act of mercy, Mehretu reveals our potential for ambitious social agency in a way that is at once powerfully reformative and compassionate. At the same time, ambiguities of space, place, and time leave the door open for interpretation: Is this an evolution or devolution? For Mehretu, it's both. What will be left standing in the wake of the turbulence of her work is anyone's guess, but the future—some future—is inevitable, and Mehretu's will undoubtedly be a rejuvenating, cross-cultural one.

—*Tina Kukielski*

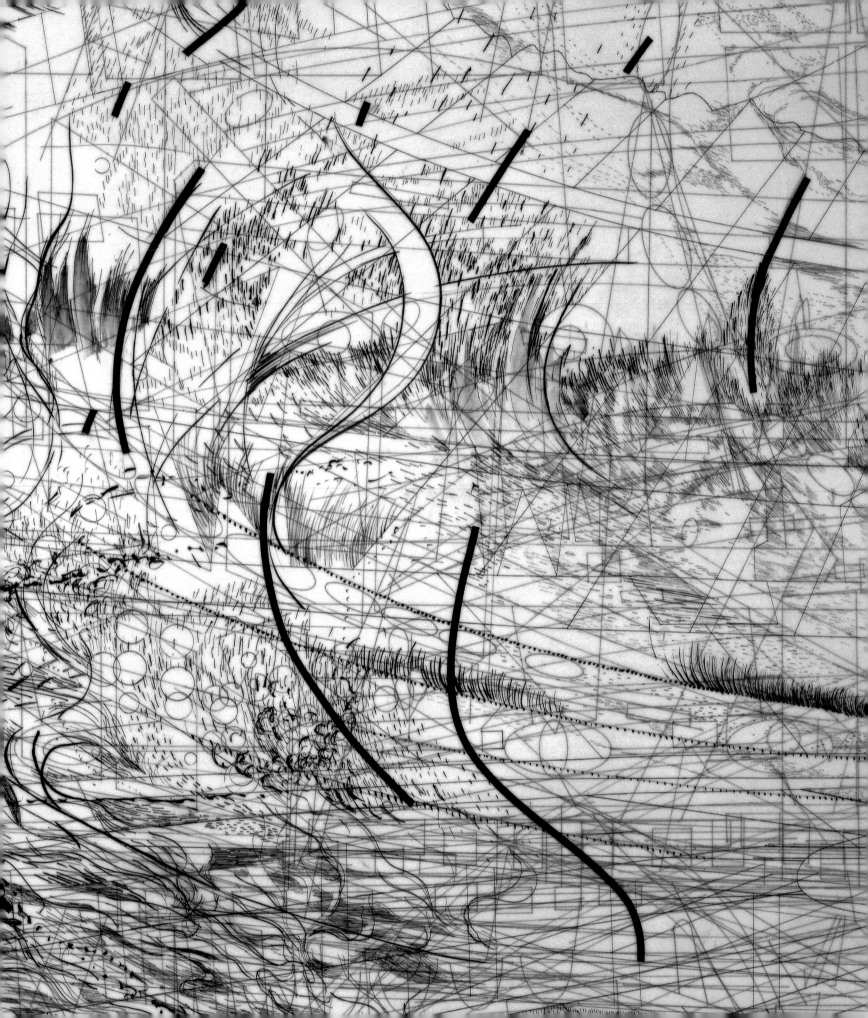

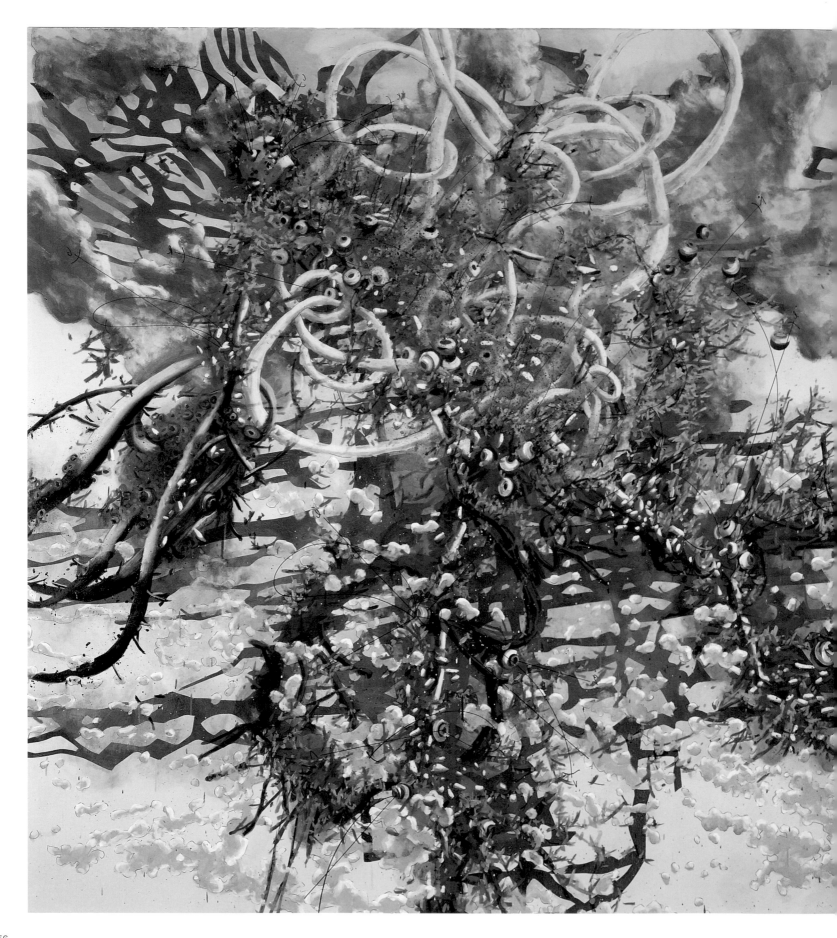

MATTHEW RITCHIE

A poem takes time to read, music is heard over a period of time, but a painting happens all at once. Instantaneous bombardment with visual information can shock both the eye and the brain, as Matthew Ritchie well knows. "The information friction is high—it's a rough little ride when it enters your head," he admits.[1] But Ritchie doesn't send us on the rough ride alone. He takes responsibility for it, helping us come to terms with the abundance of data in his painted world by slowing down our rate of absorption. Layering the imagery in his paintings, Ritchie allows us to grasp it in stages; presenting information in various media, he lets us view the same idea from different perspectives. Thus our comprehension slowly evolves, with iteration and repetition, as the very shapes of our brains, through the actions of experience and memory, begin to adjust, and onslaught gives way to understanding.

Pulsating with pure energy and clotted with gobbets of sticky matter, Ritchie's paintings, drawings, sculptures, and installations diagram the workings of the universe. His references include the first and second laws of thermodynamics (where energy is conserved, but everything changes) and quantum physics, as well as mythological and religious explanations for the way things are. The totalizing environments he creates, like those in *Proposition Player*, a major exhibition organized by the Contemporary Arts Museum Houston in 2003 and most recently on view at Mass MoCA, are made up of paintings that spill off the canvas and onto the walls and floors, materializing unexpectedly in both the third and fourth dimensions—as sculptural elements experienced over time while we move through architectural space.

Ritchie first illustrated his system of thought in the oft-referenced *Working Model Chart* (1995, illustrated on page 99), but this is only a rather useful "toolkit" (the artist's term) for his larger project. Ritchie's toolkit is made up of forty-nine characters or properties of the world,

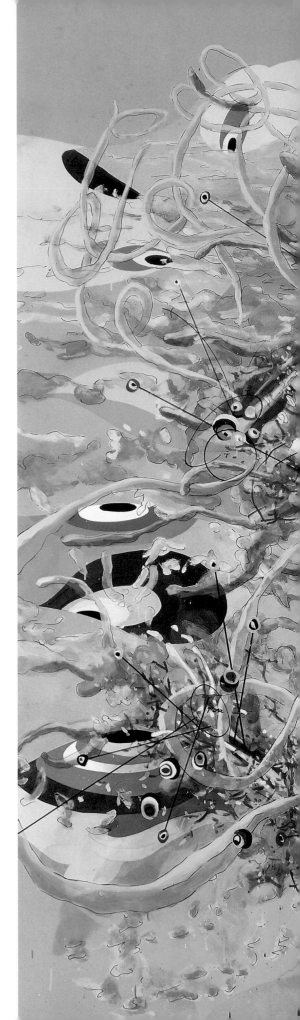

Previous pages: Matthew Ritchie, _The Living Will_, 2004
Oil and felt-tip pen on canvas, 88 x 99 in. (223.5 x 251.5 cm)
Courtesy Andrea Rosen Gallery, New York

Right: Matthew Ritchie, _The Eighth Sea_, 2002
Oil and felt-tip pen on canvas, 99 x 121 in. (251.5 x 307.3 cm)
Courtesy Andrea Rosen Gallery, New York

clotted•freedom•instantaneous

and his works are concerned with the interactions between them. Citing figures from various religions and cultural traditions, he associates them with human qualities and scientific principles. For example, the four figures Teiel, Souriel, Metatron, and Mihr, members of a family called the "Working Group," correspond to time, volume, temperature, and mass. Demonstrating the endless chain of connections between the family members by way of a story, as he often does in texts that accompany exhibitions, Ritchie writes: "They work in a box factory and are all in a lousy tribute band after hours. . . ." Wow. Suddenly his world extends past physical science and time-honored tradition to meet pop culture head on, embracing even the most lowbrow of musical endeavors—the cover band. Acknowledging that such broad synthesis can become a little perplexing, he says, "I know it's hard to accept that the world is as complicated as it appears to be. But in the end we only have two options: either embrace complexity and the freedom that comes with it, or hide behind the veil of appearance and prejudice." Diving into this deep, thick pool of consciousness is its own reward, but the challenge in Ritchie's work is not to understand every nuance of the artist's system, which is perhaps no more possible than to fully understand the workings of another's mind (though it sure is fun to try). Rather it's to use it as he does, to connect seemingly unrelated fields toward reopening the rich history of human thought to new paths of inquiry.[2]

All fields of human inquiry are inextricable from the material world we inhabit, and it is therefore impossible to see our condition from outside our own models of the universe. But this need not be confounding. The symbiotic relationship between thought and matter is part of Ritchie's point. Mineral and chemical pigments, sketchy diagrams, notational writing, and mysterious equations function in his work as a shorthand for investigating the history of human intellectual endeavor, as in _The Measures_ (2005), the series of four paintings exhibited in _Remote Viewing_. Though some of the philosophies he references here, like medieval scholasticism, may seem antiquated, they remain a part of our civilization, and thus retain their potency. Ritchie puts it this way: "You've got these things . . . that are still very powerful, like a virus that's lying around—deactivated now, but if you touch it, you'll probably still get sick."

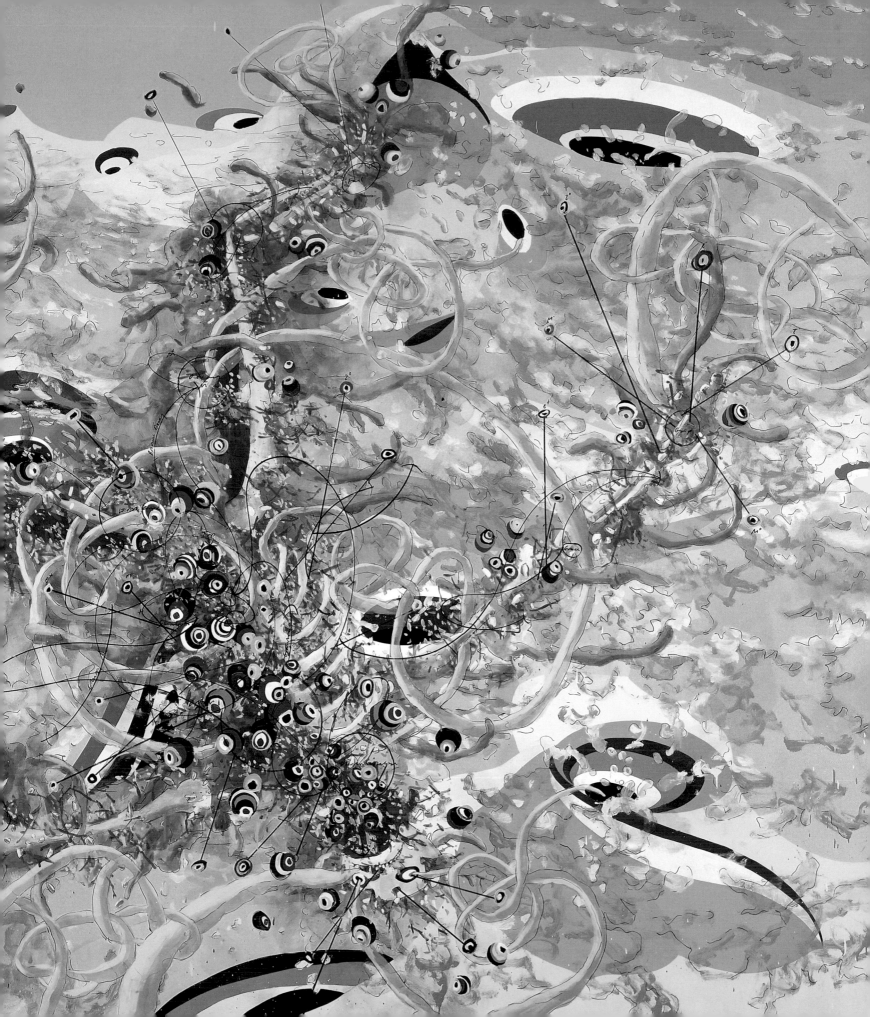

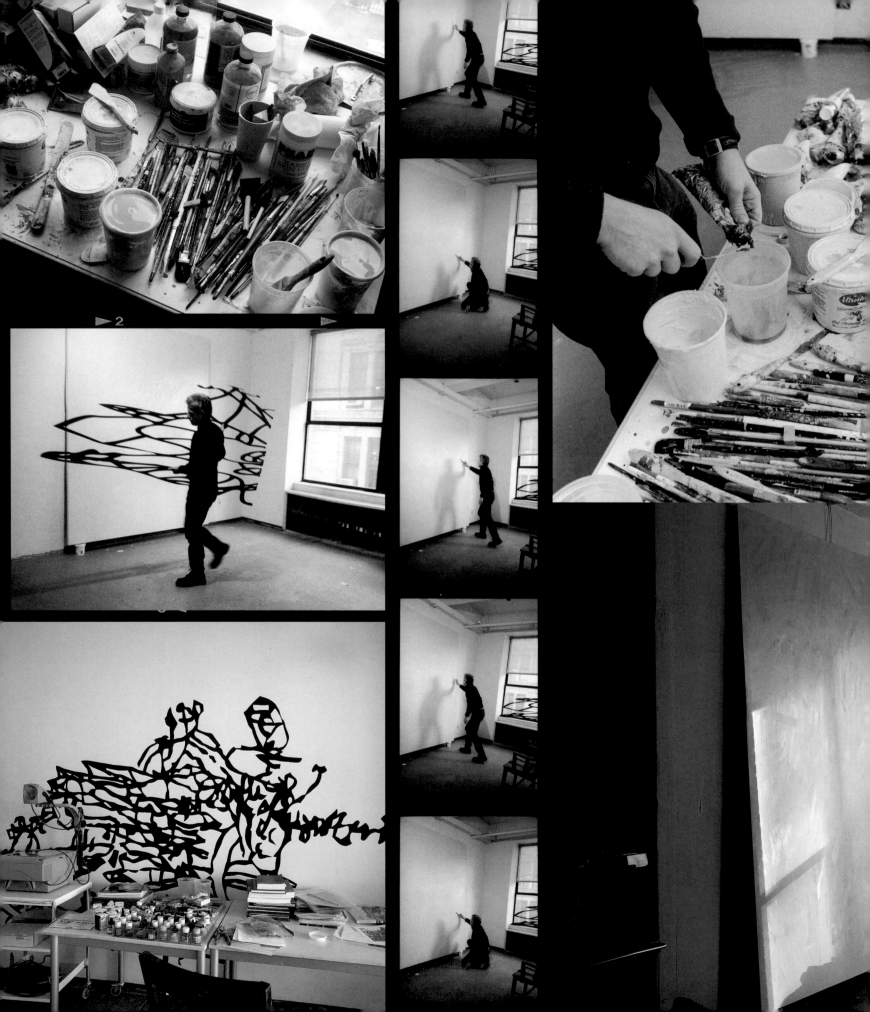

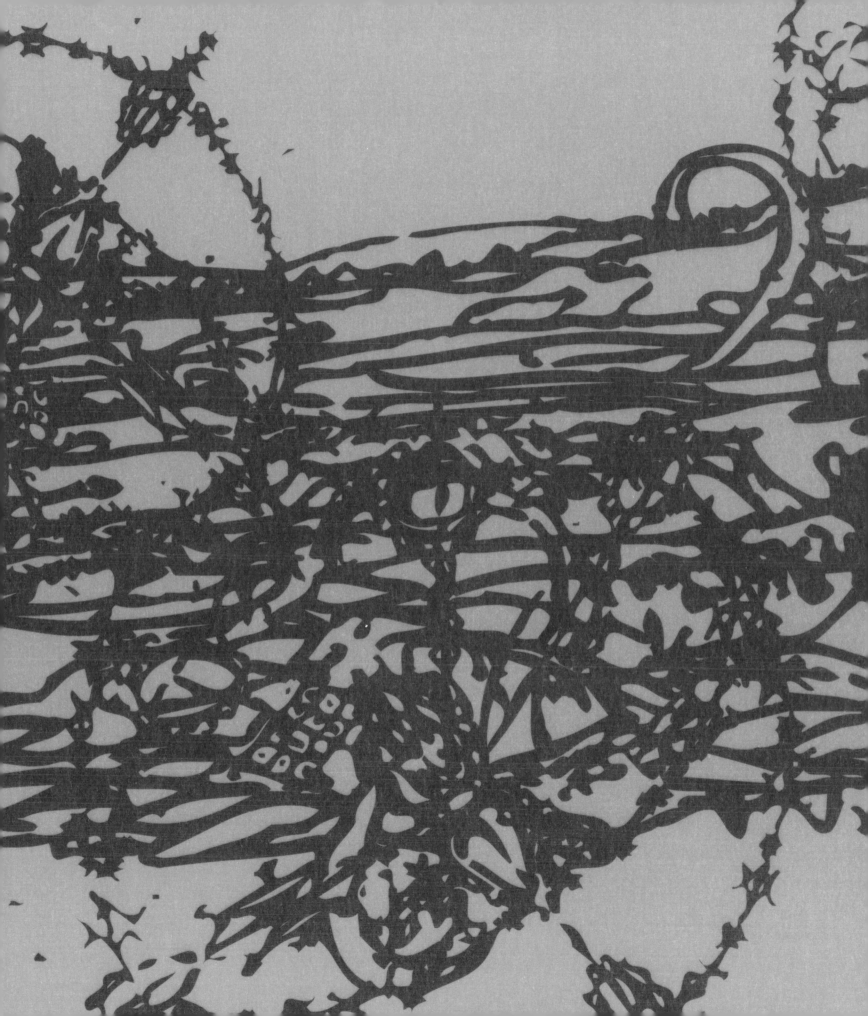

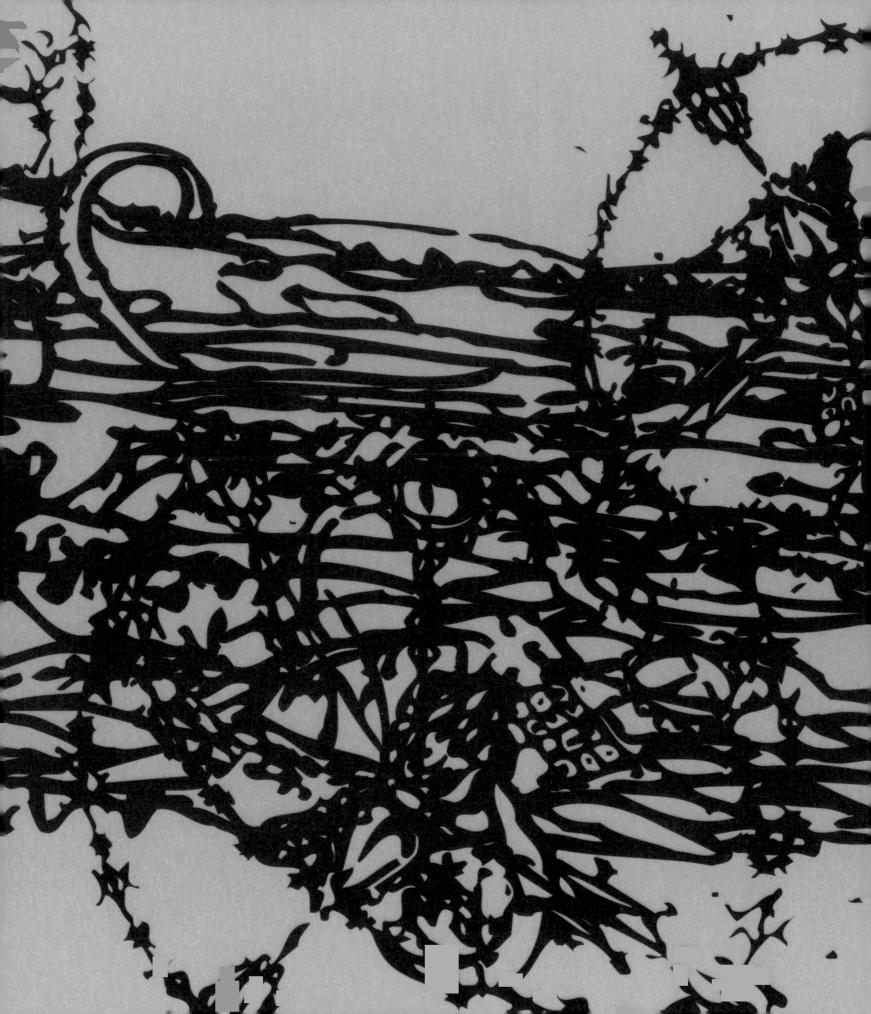

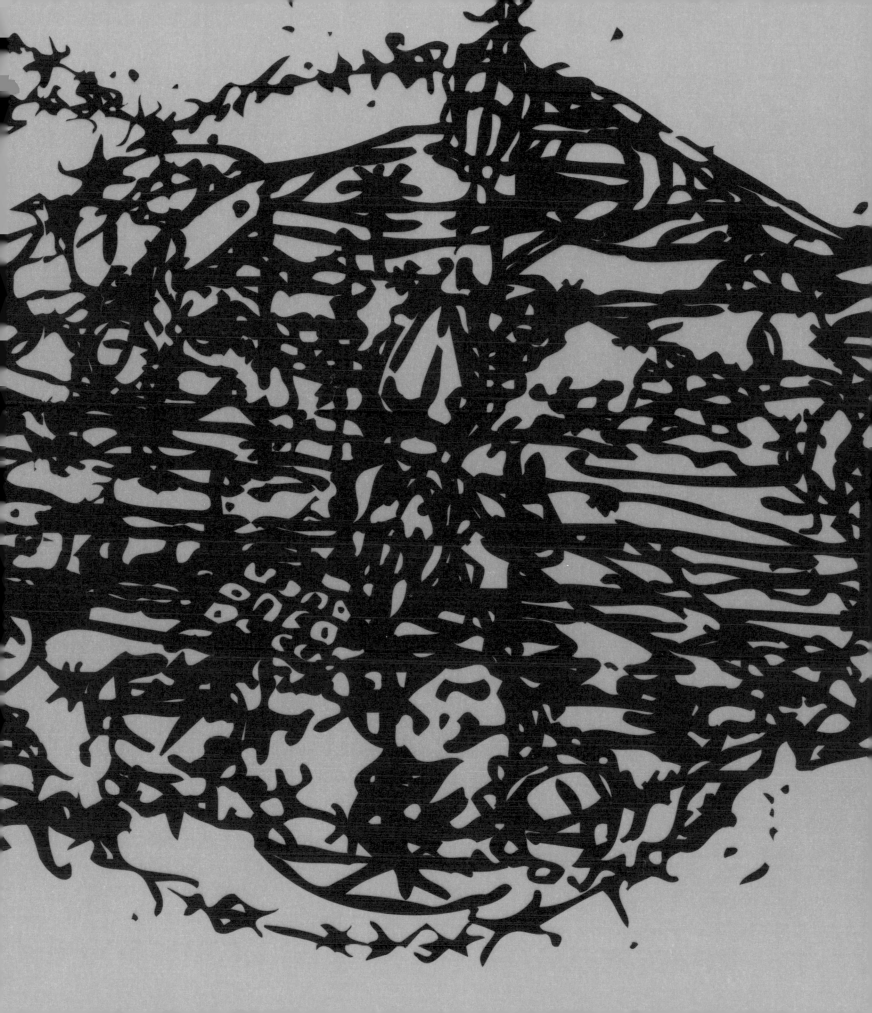

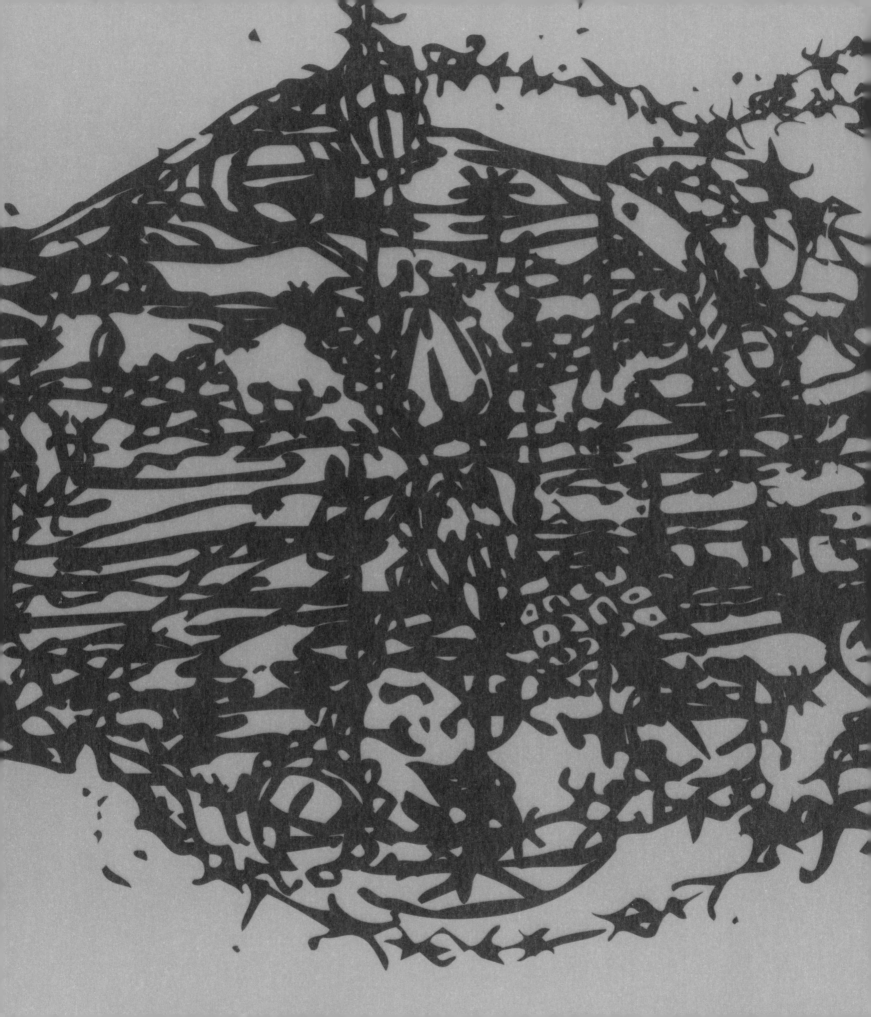

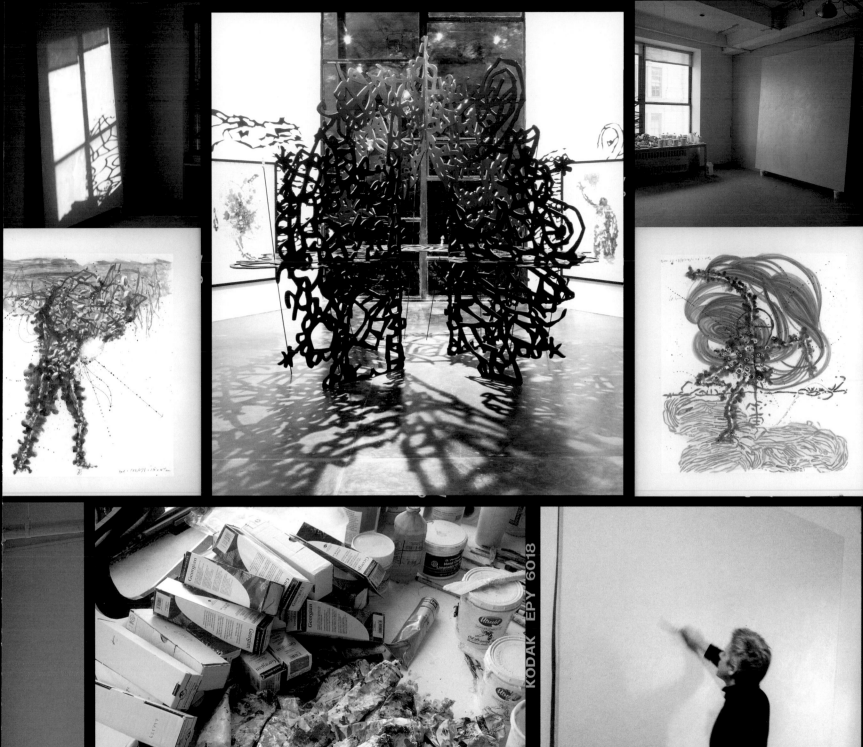
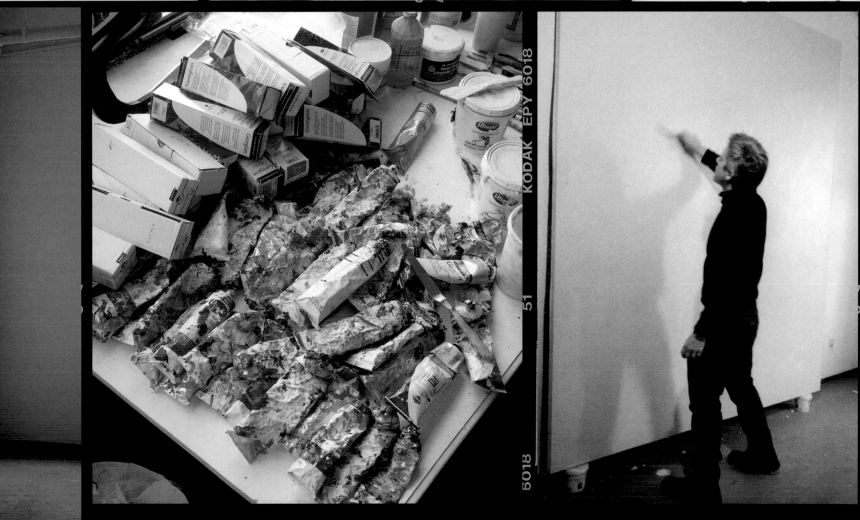

KODAK EPY 6018

51

6018

Matthew Ritchie, *No Sign of the World*, 2004
Oil and felt-tip pen on canvas, 99 x 154 in. (251.5 x 391.2 cm)
Courtesy Andrea Rosen Gallery, New York

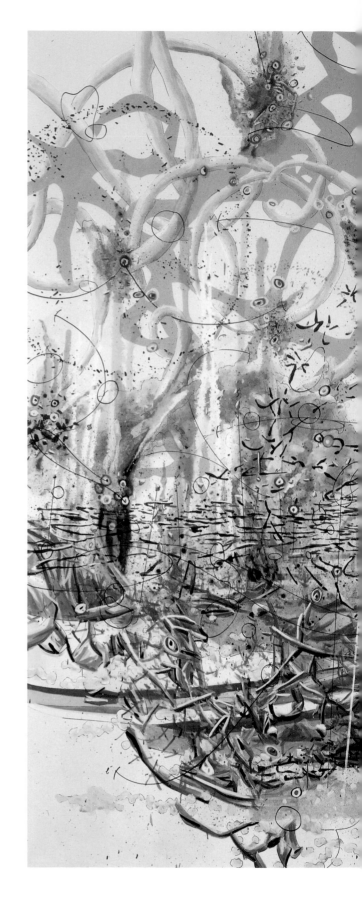

As Ritchie implies, the power of information is not only productive; it can be degenerative as well, like a disease, or like entropy. Just as entropy produces change in a closed system, so death can be a product of ideas—think of the horrors of fascism. In the paintings *The Living Will* (2004) and *The Eighth Sea* (2002), for instance, characters dissolve into their backgrounds; the permeable layers of color and lack of clear contour lines enhance the impression of dissolution, suggesting decay as they release entropic energy and rot. Ritchie once worked as an orderly in a hospital morgue, and it seems that this experience impressed deeply on him the fact that all that lives must die. But for him this is not something to lament—it's just reality. It's no more or less fascinating than the winking out of a star in the sky. Since death is a part of our life, it must play a role in all of our concepts of the workings of the universe, be they scientific or mystical. And like the death card in a tarot deck, any demise signifies that a new start is imminent.

Ritchie offers us the whole of reality—not just the pretty part. He makes no moral judgments about the merit of the ideas he presents, putting theology, science, and philosophy on an even playing field. He acts not as a master-creator of his own universe, but as a collaborator with thinkers past and present. His role is simply to return to us our forgotten intellectual property. When he presents the link between the material and the ideational, the growing and decaying, he gives us an opportunity to see the gap between what we know and what we could know, driving us to the brink of discovery. In other words, we're given the greatest possible freedom to engage whichever of Ritchie's ideas best suit us. This is where the work takes on both an ethical dimension and an energy of its own and functions as an engine for thought. "If I have an agenda, it's to allow people more freedom, genuine freedom," Ritchie says. But in offering us the freedom of discovery, he demands that we be answerable for the choices we make. In this way his exuberantly cerebral work requires that each of us more deeply examine our relationship to the universe and take personal responsibility for our role in it.

—*Elizabeth M. Grady*

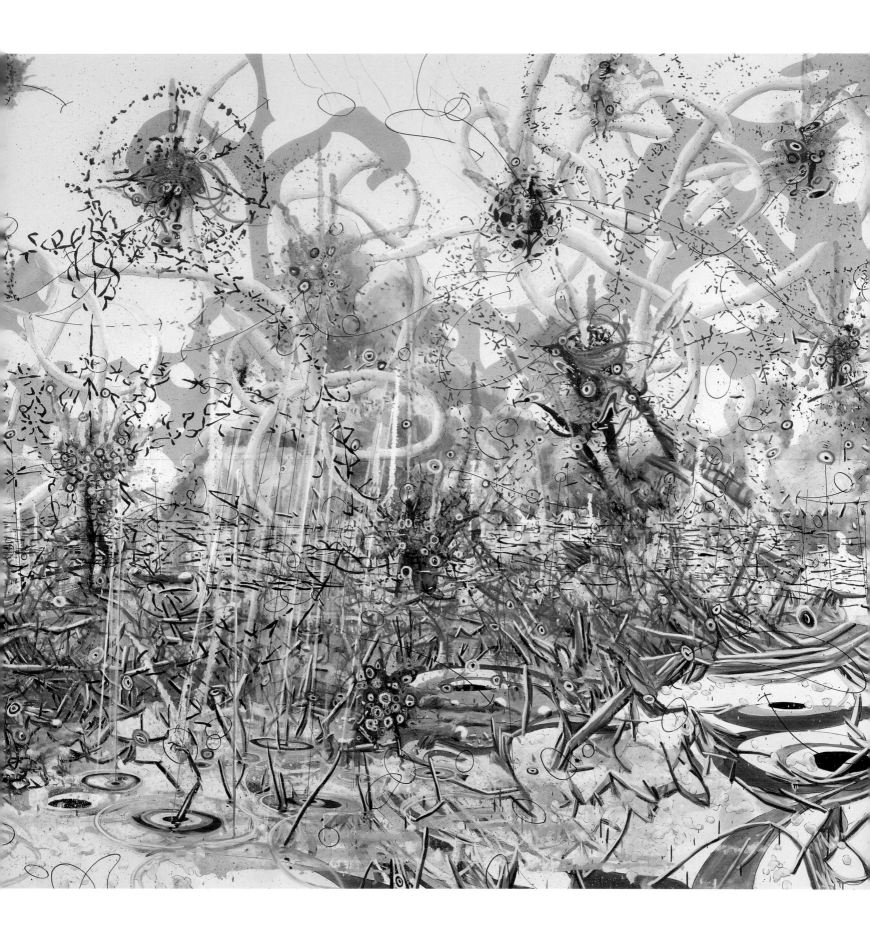

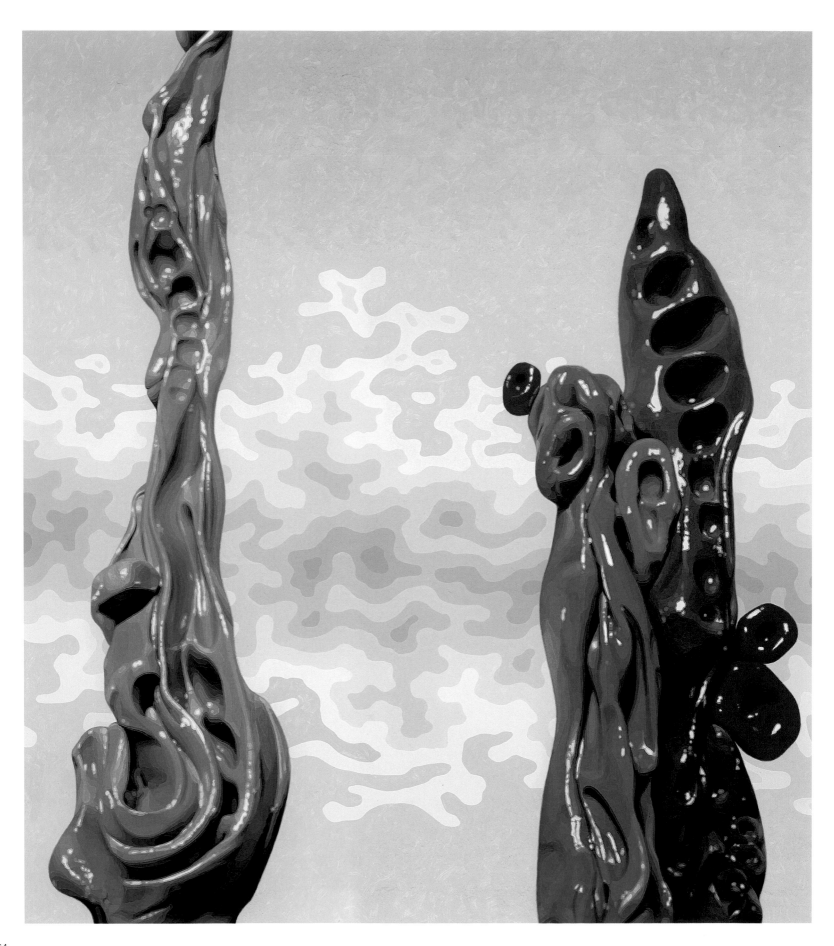

ALEXANDER ROSS

Alexander Ross is best known for his large-scale, luminous paintings of precisely rendered yet unidentifiable forms presented in a carefully gradated palette of cool greens and blues. His forms float against a space that is at once deep and indeterminate, their nooks and crannies, holes and protuberances inviting exploration. But just as the viewer begins to succumb to the seduction of their beautifully executed surfaces, in creeps a vague sense of repugnance. This counterbalance between attraction and repulsion is at the heart of Ross's mastery, as he bends to his will the basic vocabulary of painting to investigate a liminal realm between the artificial and organic, the mineral, vegetable, and animal, breaking down the categories that underpin our most fundamental assumptions about the world.

Ross, who lives and works in New York and Massachusetts, draws his imagery from a variety of sources ranging from scientific illustrations to direct examination—often with the aid of a microscope—of the natural environment. Cells, crystalline and plant forms, and the proboscises of insects are hybridized to the point of becoming abstractions. As Ross has described it, "Representing the surface of a pod, egg, or seed offers the exciting opportunity to arouse (via optical patterning) the hidden potential held within that seed, like an energy field perhaps, that bathes and nourishes the future entity. The way an object is rendered, in a world made of paint, belies the character or essence of that object."[1] In *Untitled* (2004, opposite) Ross places against a pale-blue background slimy green figures that have a kind of festering fecundity, like an exotic mold that evolves the ability to send out pseudopods to slither and probe in search of light and CO_2. Scale becomes confused: Did the image before us originate in a desert landscape or a petri dish? Is it depicting a monstrous deep-sea creature or a tiny protozoan? Are we seeing Ross's world through the right or the wrong end of the telescope?[2] This spatial confusion is a real strength; Ross's works can look as gorgeous at a six-inch distance as they can threatening from sixty feet away.

A disturbed sense of scale stems directly from the artist's working method, which he has employed since 1998, the year of his first major solo exhibition. Ross begins most works by making a small sculptural maquette out of oil clay. Lighting the model brightly allows the heat of the lamp to draw oil to its surface, which becomes slick and shiny. He then photographs the result and paints from the photograph. The transfer of imagery from a small, desktop model to a large canvas (one untitled work in the exhibition is more than five by twelve feet) replicates the extreme shifts in scale between the micro- and macrocosms of nature. His use of malleable, oil-based media for both model and finished work is another point of synchronicity. Providing a certain cool detachment from Ross's visceral forms,

Previous pages:
Alexander Ross,
Untitled, **2004**
Oil on canvas,
96 x 85 in.
(243.8 x 215.9 cm)
Collection of Dominique
Lévy and Dorothy Berwin

Right: Alexander Ross,
Untitled, **2002**
Oil on canvas,
65 1/4 x 96 1/4 in.
(165.7 x 244.5 cm)
Collection of Sr. Leopoldo
Villarreal Fernandez

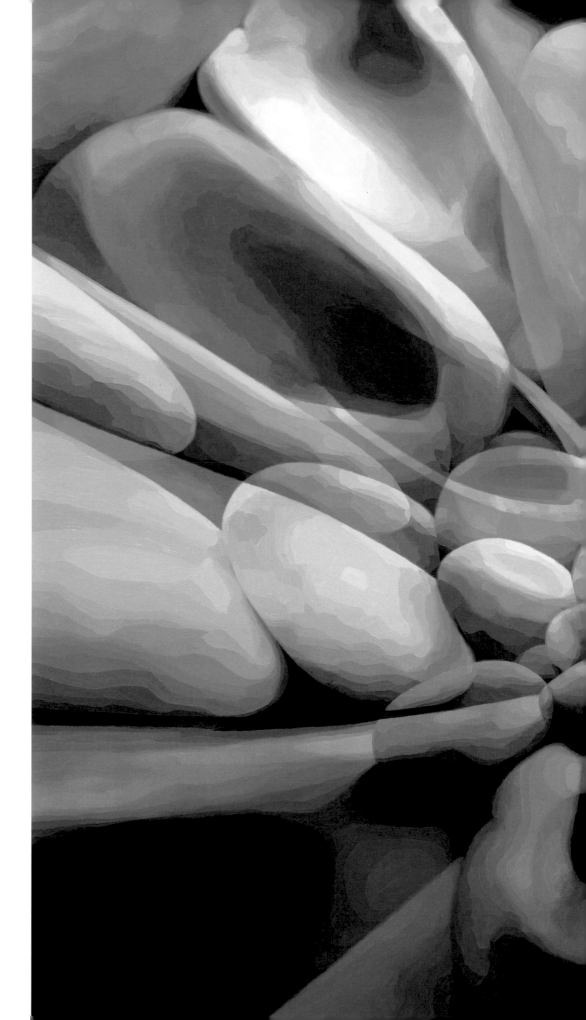

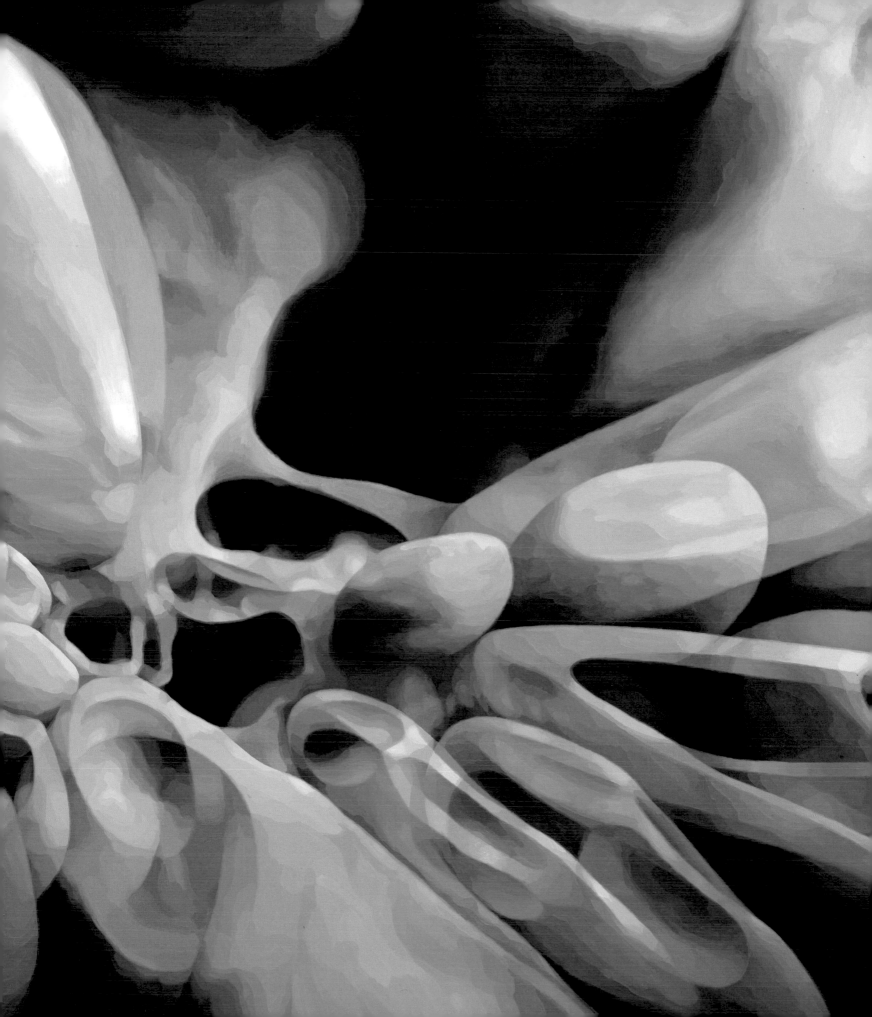

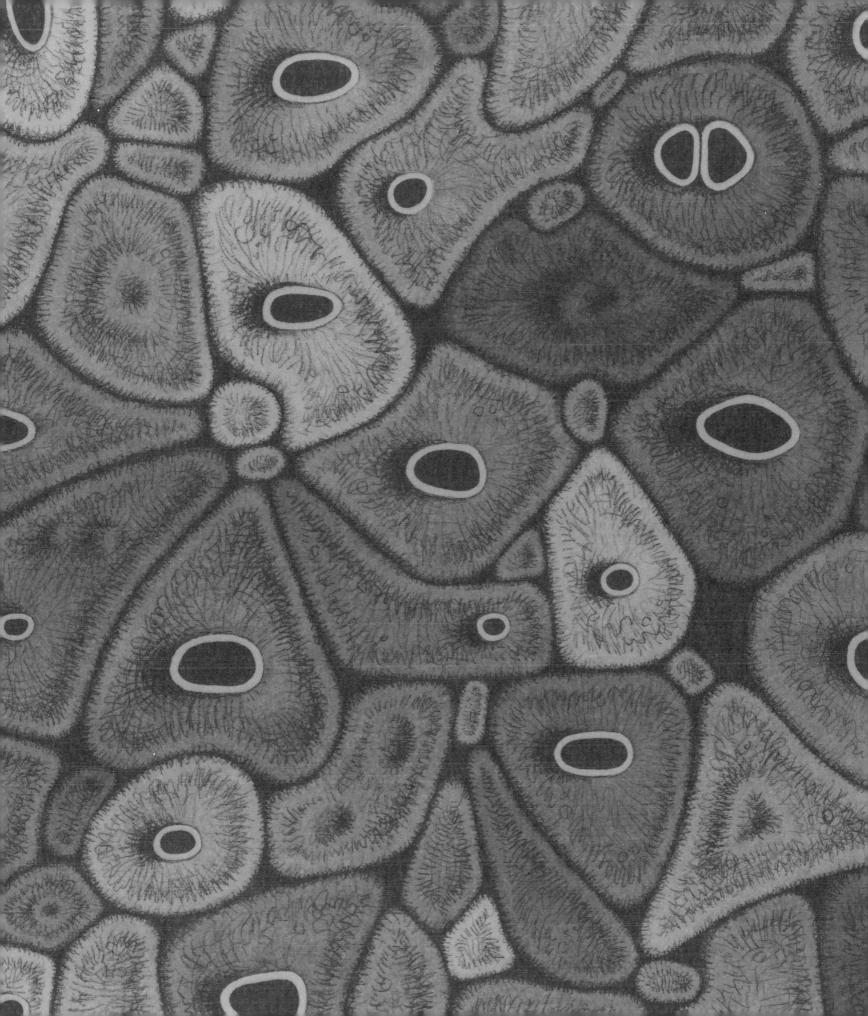

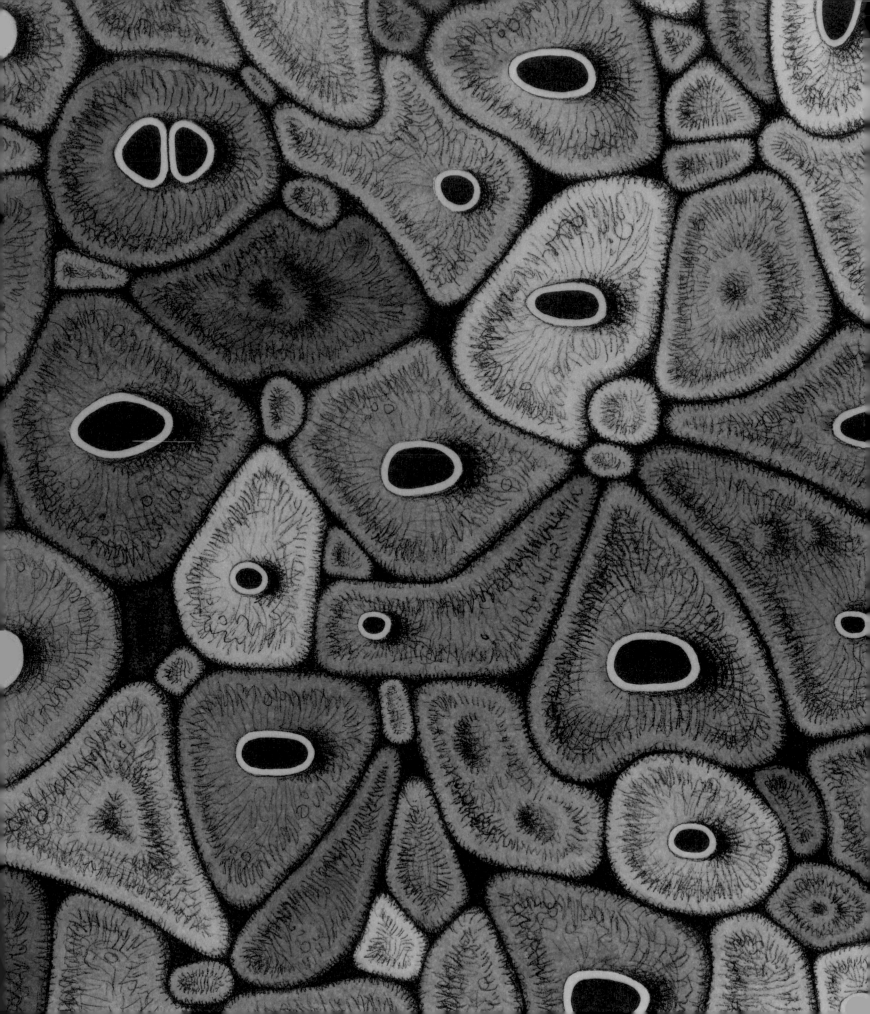

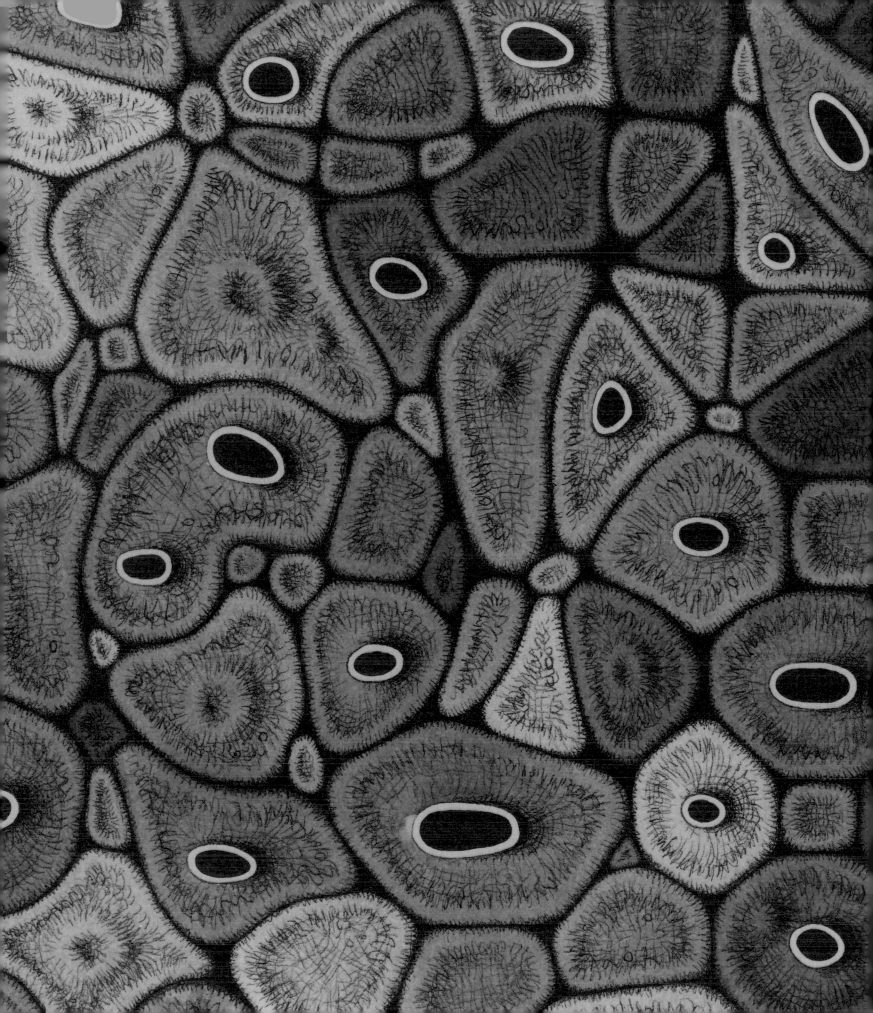

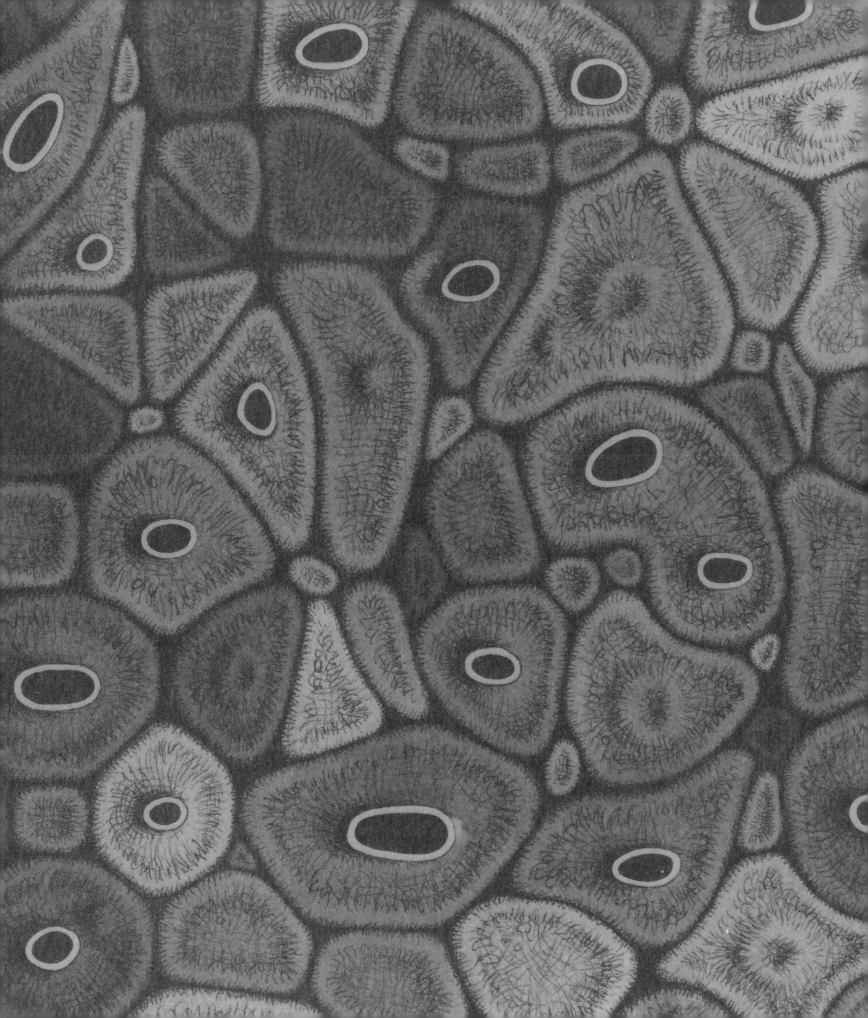

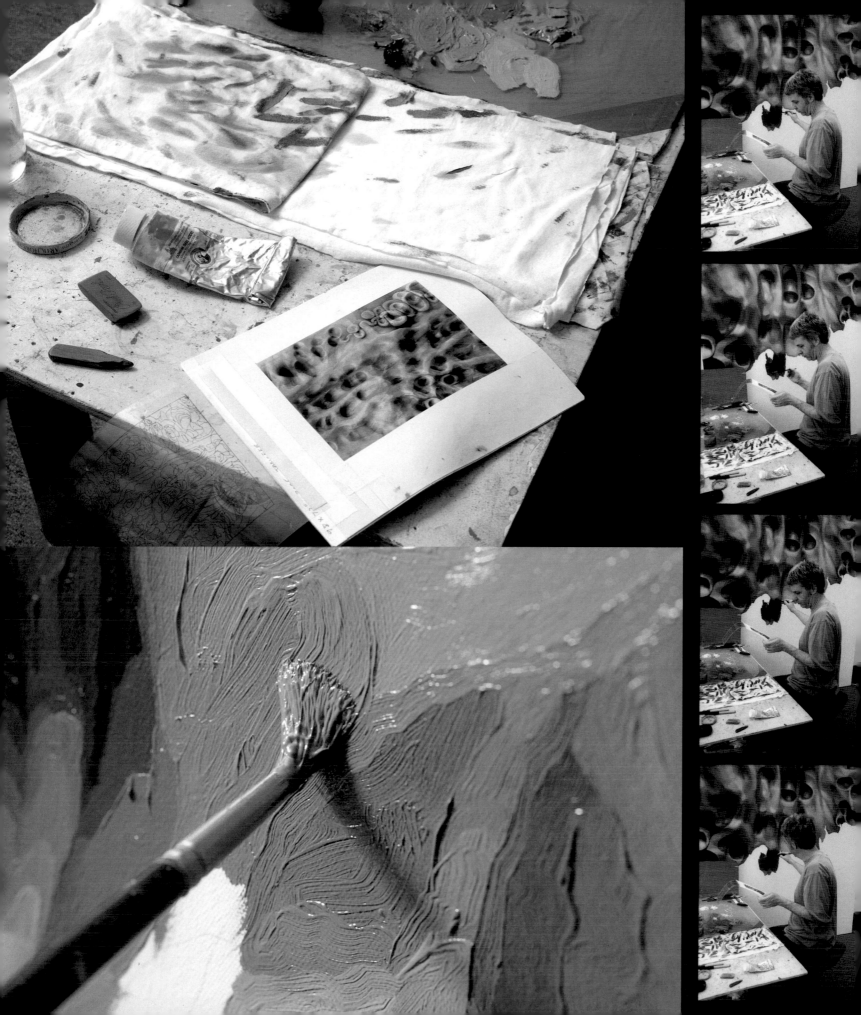

protozoan • nooks and crannies • monstrous • microcosms • festering

Above:
Alexander Ross,
Untitled, **2004**
Oil on canvas,
68 x 120 1/2 in.
(172.7 x 306.1 cm)
The Nelson-Atkins
Museum of Art,
Kansas City,
Missouri (Purchase:
acquired through the
generosity of the William T.
Kemper Foundation—
Commerce Bank,
Trustee) 2004.39

Right:
Alexander Ross,
Untitled, **2004**
Watercolor and
graphite over
synthetic polymer
on paper,
30 1/2 x 23 in.
(77.5 x 58.4 cm)
Private collection;
courtesy Kevin Bruk
Gallery, Miami

the intervention of the photograph hints at the kind of clinical mood more common to scientific illustration than to painting. This impression is occasionally heightened, as in *Untitled* (2004, illustrated on pages 66–67). Here a photographic distortion approaching double exposure is reproduced, making the viewer as aware of Ross's production process as of the disconcerting image that the work depicts.

For all their creepiness, the paintings make the tension between the clinical perspective of science and the chaos of the natural world it seeks to manage formally explicit. Two shiny green forms hovering between mineral and vegetable are superimposed on a background that suggests at once sky-blue pixilation and a diagram of a crystalline structure. "Sky is useful for me," Ross says, "It is natural and yet empty. Perhaps it's just the air, open and luminous and swirling with potential."[3] Ross's application of color and his delicate, curved brushstrokes suggest both fingerprints and topographic contour maps, even as they describe sparkling highlights; the apparent geometric logic of the background is belied by the obviously handmade marks left by the artist.

Ross delights in closely examining normally overlooked things, like the microscopic world of mites, or rotting tree stumps that contain teeming little universes. He offers an analogous experience to the viewer, inviting us to visit these curious places with him. The effect is not unlike that of Chinese scholar's stones, which represent elements of the natural world in miniature and function as objects of contemplation. Ross's paintings likewise offer the viewer an excuse to let the mind wander.[4] But engaging and playful as the paintings are, their oozing surfaces and commanding images give them a life of their own, declaring their seriousness and ambition.[5]

Refusing to categorize the world as a biologist or botanist might, Ross prefers instead the potential of ambiguity, for it is within the fuzzy edges that real discovery happens. Ross finds inspiration for this perspective in the world of scientific classification and inquiry itself, for instance in the illustrations of the Austrian zoologist Karl von Frisch, whose theories on gestural communication between animals as a simple language fascinate the artist. But while the precision of science is clearly present in Ross's work, there is a simultaneous elusiveness, a drive toward a new form of expression. As he puts it, the "word part of the brain is shut down while I'm working."[6] And it is this nonverbal thought process, this alternate way of conceptualizing a highly personal world, that provides us the key to his works' significance. By evading traditional ways of ordering nature and conventional means of communicating, Ross renews the power of intuitive thought, breaking the old empiricist mold to make room for a deeper understanding of our place in the world.

—*Elizabeth M. Grady*

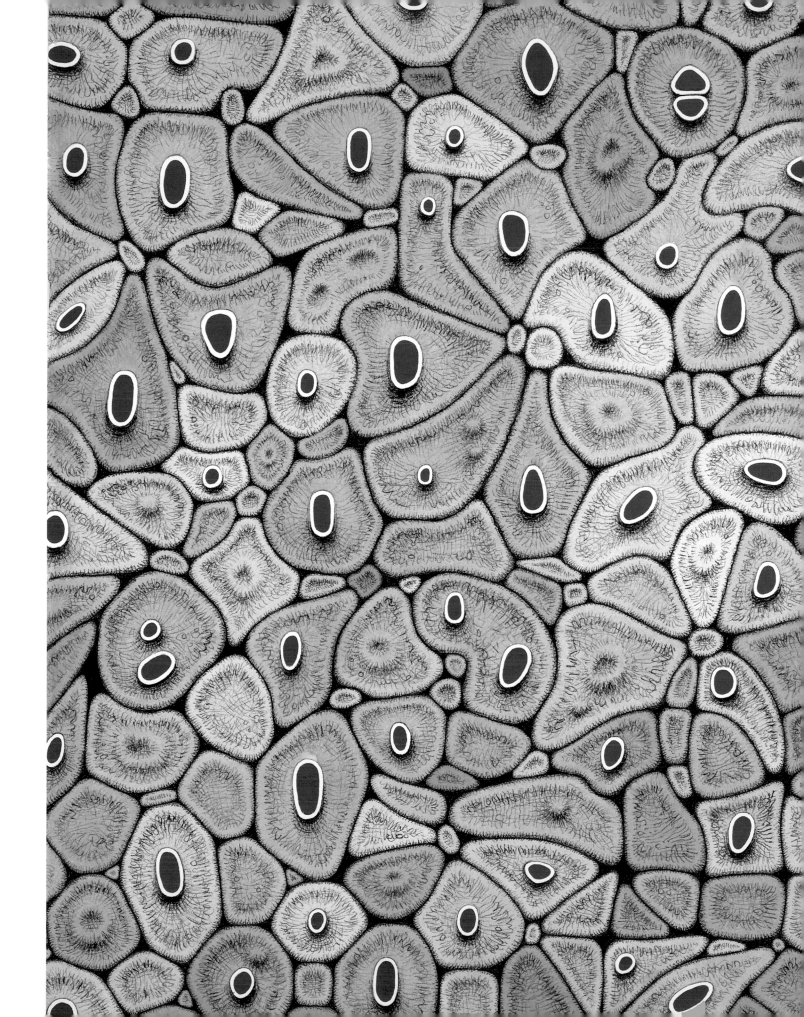

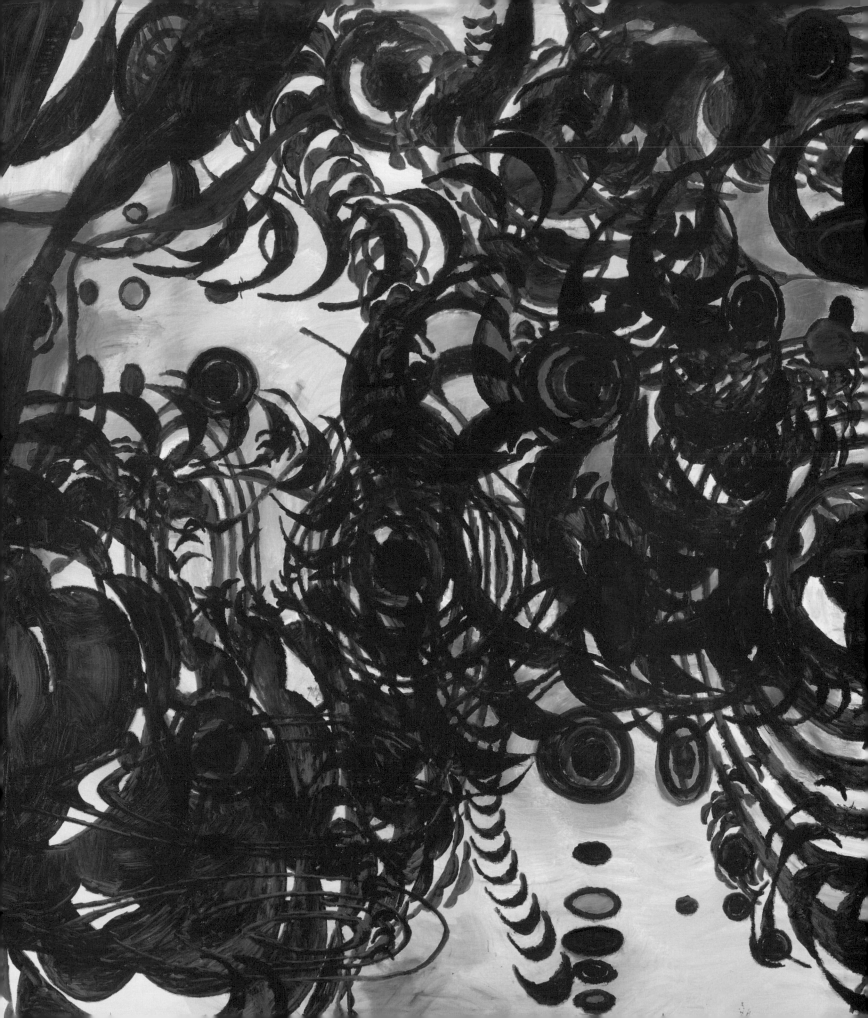

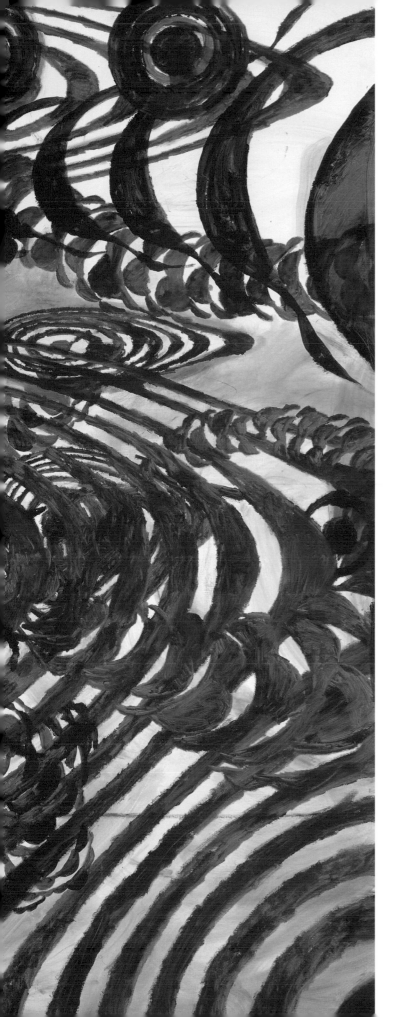

TERRY WINTERS

Materiality has always played a significant role in Terry Winters's work, from his first solo exhibition at Sonnabend Gallery in 1982 to his recent show at the Addison Gallery of American Art, *Terry Winters Paintings, Drawings, Prints 1994–2004*. Throughout, he has focused on the painting process, often mixing his own paints and applying them freely in works that draw on rich sources of images ranging from scientific diagrams to ancient textiles. Winters structures his paintings and drawings in layers formed by successive mark-making. This logic behind each work's creation becomes a method for visualizing animated forces and worlds. It opens myriad possibilities for creating pattern and significance, providing the impetus for the artist's project—to "make a new optic, a new description of nature."[1]

A variety of theoretical models have been used to shed light on this new optic. Most recently Richard Shiff, in his essay for the Addison catalogue, compared Winters's preference for creating many simultaneous connections between forms and ideas to the philosophical writings of Gilles Deleuze.[2] Deleuze's work posits a kind of multidirectional thought that intersects with itself repeatedly along many paths. This model helps us to consider the way in which Winters's widely diverse reference images are absorbed through the eye and reinterpreted by the hand, manifesting other potential worlds.

The act of drawing or painting is like a train of thought, a succession of events that happen over time. Envisioning action and reaction, Winters leaves open varying possibilities for form. This openness can be seen as analogous to methods of ordering consciousness or developing language. Although we must speak, read, or write over time and within a given grammatical framework, still after each word we have the option to change our mind or redirect our thought. Winters hints at this linguistic connection, describing forms in his latest work as "characters" and "signs." He also tends to "like patterns which complicate legibility, where figural readings

supralinguistic•potential

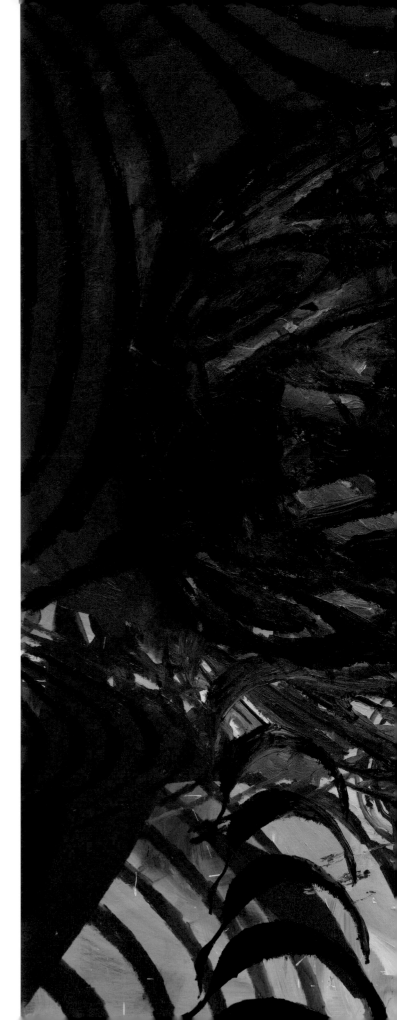

Previous pages: Terry Winters, *Display Linkage*, 2005
Oil on canvas, 102 x 132 in. (259.1 x 335.3 cm)
Collection of the artist; courtesy Matthew Marks Gallery, New York

Right: Terry Winters, *Vermilion*, 2005
Oil on canvas, 68 x 88 in. (172.7 x 223.5 cm)
Collection of the artist; courtesy Matthew Marks Gallery, New York

are implicated." The references to figurative imagery and language inti-
mate the potential for independent movement and contingent exchanges.
An animated character is able to make decisions about how and when to
move, and commonly understood symbols, like letters or numbers, change
in meaning depending on their context.[3] When letters or numbers occa-
sionally appear in the work, they thematize the provisional meaning of
Winters's forms, as in *The Influencing Machine* (2005). These two poles of
independence and contingency indicate that the forms and gestures occu-
pying the works have an energy of their own, an ability to generate thought.
The signs function instrumentally, acting directly on the viewer and forming
a cohesive image whose meaning is not fixed. "They're signs, but they tend
to be asignifying . . . their identities are fluid," Winters says.

In Japanese calligraphy the way that a character is written—in tight, dry
lines or with inky flourishes—inflects the meaning of a sentence as much
as what the character commonly represents. Similarly, the pencil strokes
in a Winters drawing, like *Untitled (12)* (2004), can have a double mean-
ing that is both descriptive and expressive—as a sign and as a relation-
ship between intersecting ideas and processes. The contours that outline
the forms serve to define their boundaries, yet the frenetic energy of the
hatching within acts autonomously, threatening to burst free. The mark be-
comes an active figure, moving in cooperation or conflict with its surround-
ing forms. When Henri Michaux reached the limits of poetic expression, he
turned to abstract drawing. Likewise, Winters uses the stroke of the brush
or pencil to create meaning, allowing a visual vocabulary to function as an
alternative language "where the meanings can be multiple."[4]

The shifting narratives of the works are structured by formal means, and
as the artist layers mark upon mark, gesture becomes object and figure.
"Each painting is like an event-scape, a constructed or directed series of
activities, the result of which is a picture," Winters says. But the control
implied by "direction" is tempered here by the intuitive responsiveness
of the artist to the sometimes surprising results of his own actions. In
works like *Display Linkage* (2005) these varied actions remain visible, and
through sensation they occupy a kind of supralinguistic world where the
story moves along different tracks simultaneously. "I think of my paintings
as an invented language, where meanings are acquired," Winters says,
"Each painting is a series of links, each in itself and from one to another.
The colors, like the shapes, are part of the syntax. They become indicators
in a field of activity."[5]

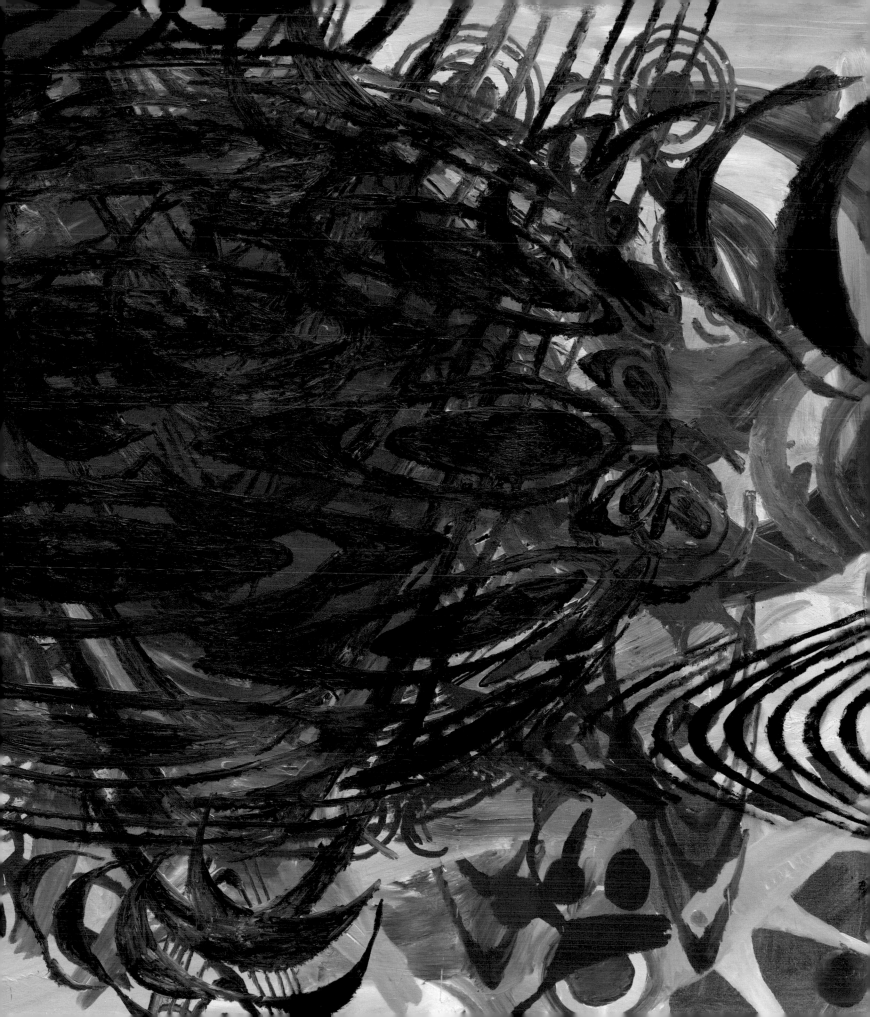

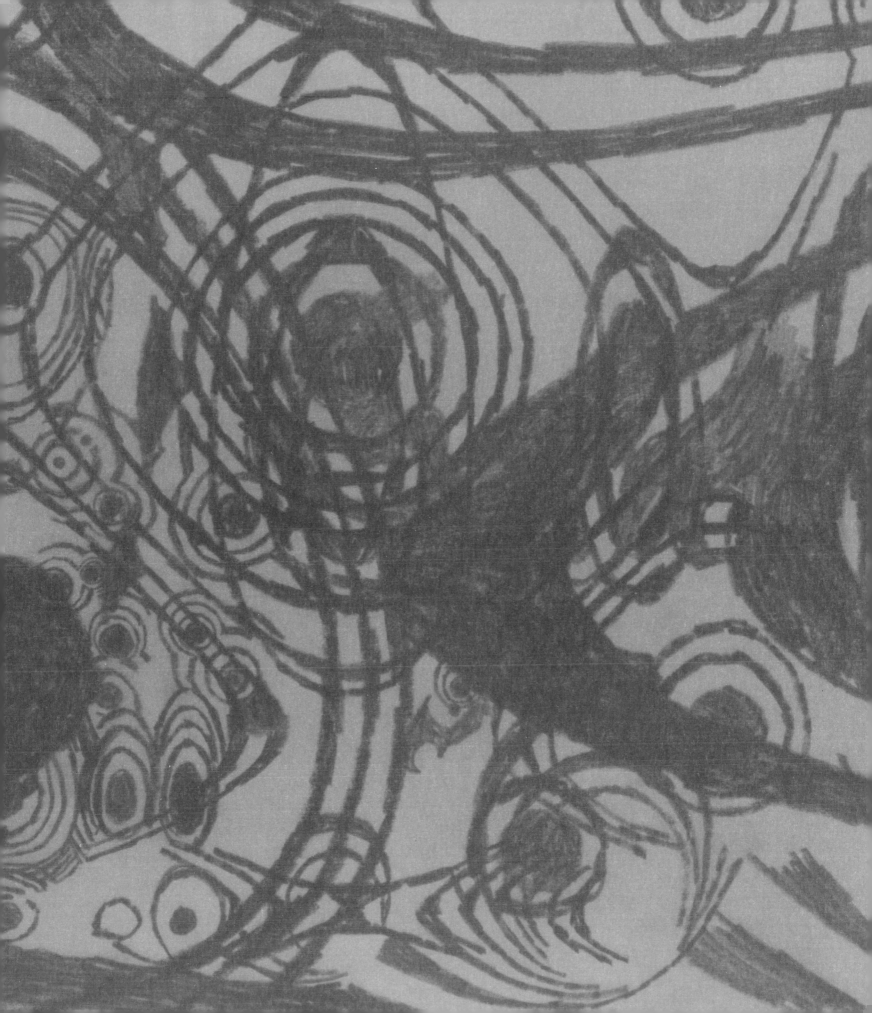

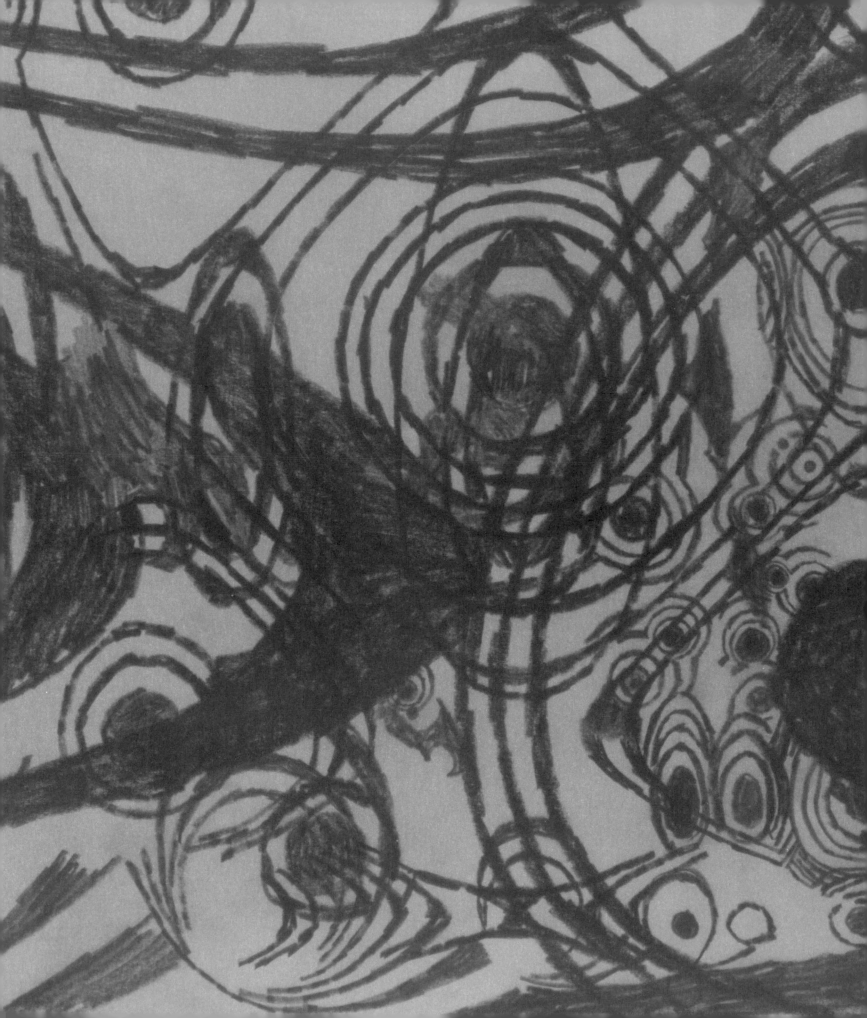

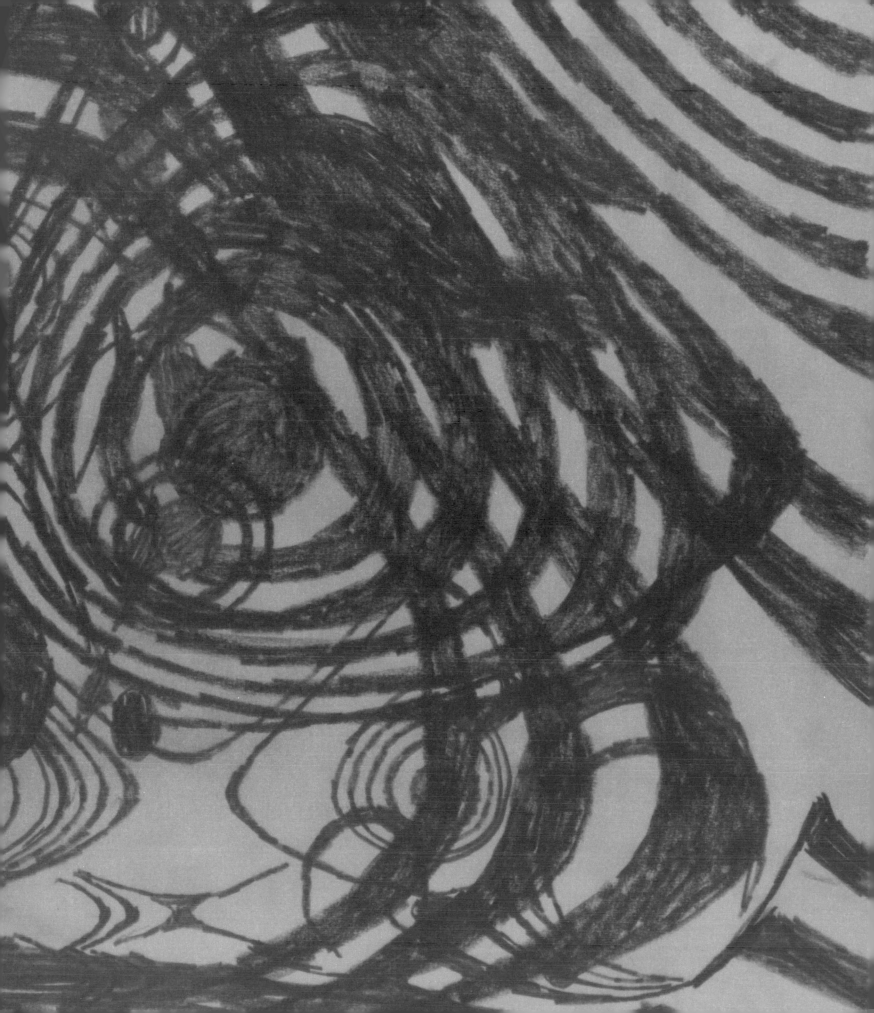

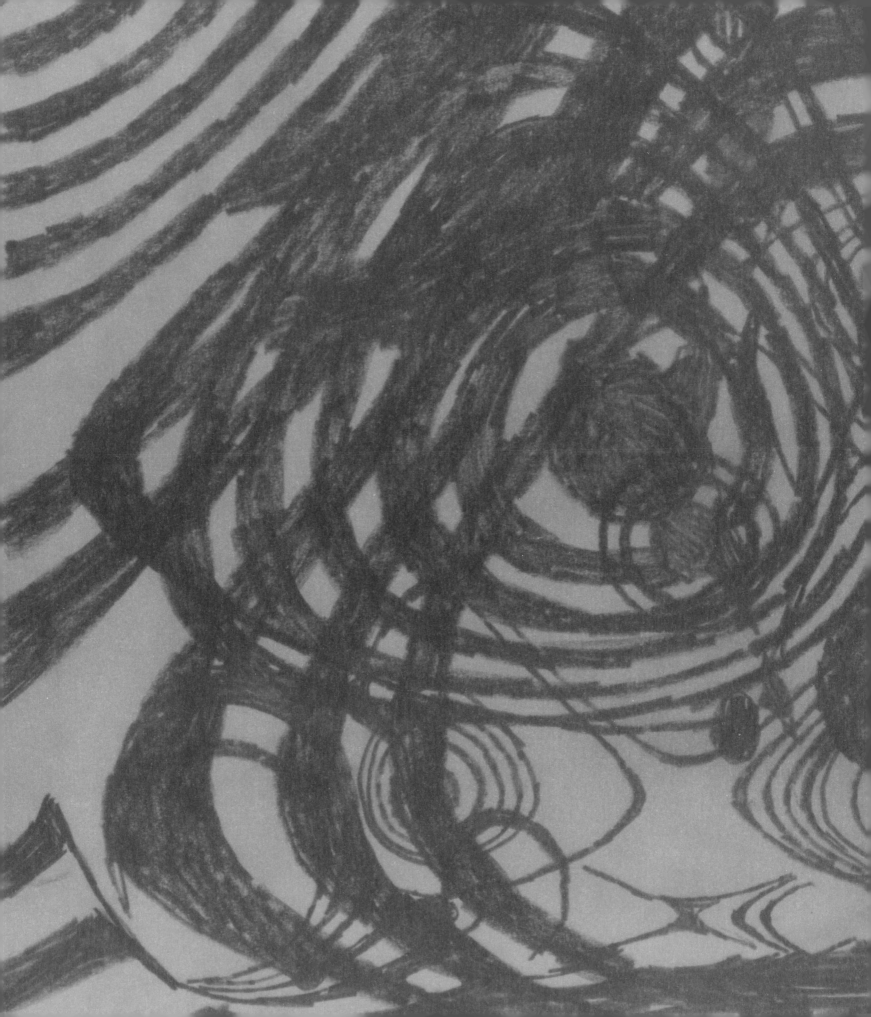

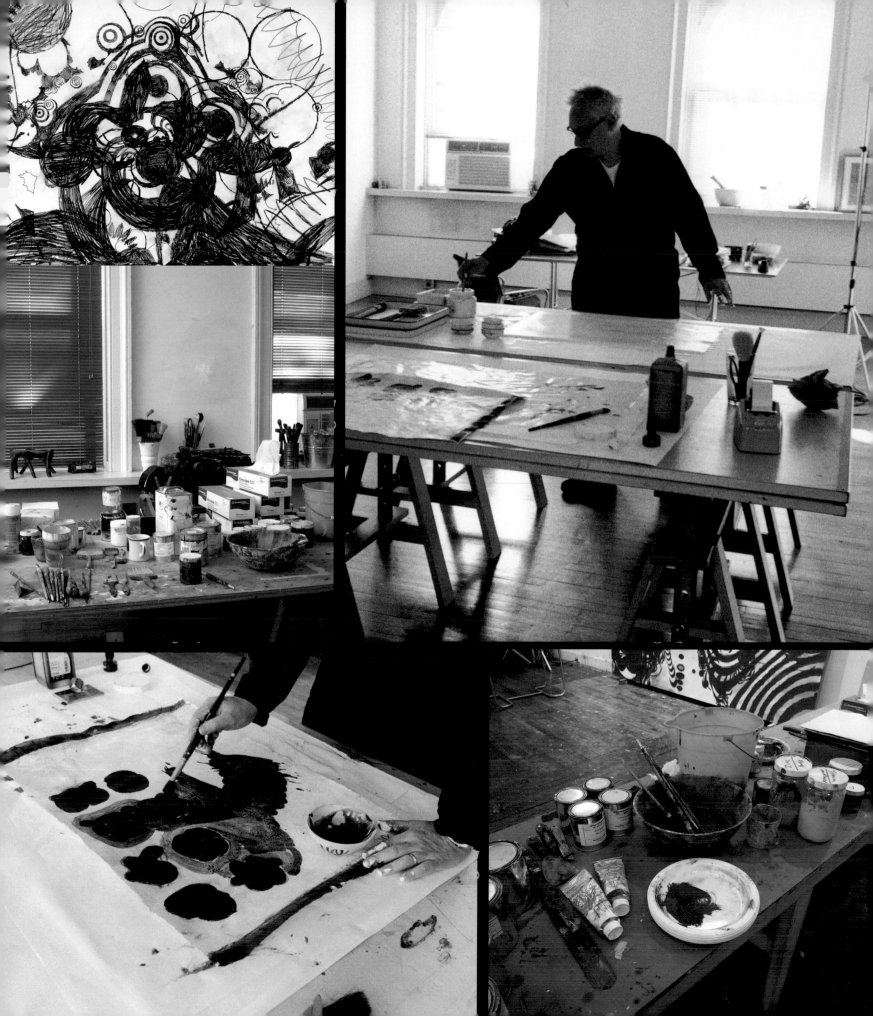

Terry Winters, *The Influencing Machine*, **2005**
Lithographic trial proof with graphite additions; text by Ben Marcus,
30 x 41 1/2 in. (76.2 x 105.4 cm)
Collection of the artist

Winters believes "there's intelligence in the material," in listening and reacting to its elemental makeup. The "overwhelming cadmium energy" that holds the pigments together is expressed in works like *Vermilion* (2005).[6] Here the physical properties of the paint—a metallic mix of sulfur and mercury—give the work its title, suggesting that before us lies a plane where powerful chemical tensions operate. Wave forms collide with heavenly bodies and neutrinos, mapping a topography of the workings of the universe that is both imagined and real—a contemporary poetic visualization, a scene. In a manner akin to the "lines of force" of the Futurists, or the natural dynamism found in the work of Bohemian Orphist František Kupka, Winters's work transforms the functions of energy into a mapping of virtual realms and psychic dimensions.

So where do we stand in relation to all of this? The artist insists on a direct relationship between the viewer and the artwork: "You're in the same space with it, it's yours." But what is it that is ours? In our physical encounter with the solid reality of the artwork, Winters offers us an imaginary space into which to project ourselves, to make connections with the data of the images, recognizing in their generative and interpenetrating forms references to firing synapses, invisible slipstreams, and similarly real but intangible phenomena. The works in this exhibition hint at questions of cognition, occupying the gap between physics and philosophy while indicating the crucial indivisibility of image, process, gesture, mark, and meaning. They similarly form a point of intersection between eidetic models of the world and its physical and psychic realities.

—*Elizabeth M. Grady*

A series of short narratives featuring people who use or invent contraptions to change themselves into text. Each to be about three or four pages, with paper made of chuff. Narrative-driven. Language simple and blackened. No wind or weather or cloth or mouth or edible particles. New objects without a half-life. Plain in tone. Keep fantastical elements minor, so they might rule quietly. Take normal situations and wrap them in balloon material. Sentences to be built of lead and wood, with holes at one end, through which the characters might fall out. Narratives that are literally combustible. Several featureless characters named Jeff who provide supporting bodywork to the leading characters, who must ascend into dangerous areas. When called by name, they walk from the village and quietly expire. A tray beneath the text to catch the detritus.

it produces, as well as removes, thoughts and feelings

This was written some years before the invention of hands

DW
2004

inky flourishes•psychic dimensions•supralinguistic•potenti

FIELDS OF INTUITION
(in Four Proportions and Five Mods)

Caroline A. Jones

Among the formative arts I would give the palm to painting: partly because it is the art of design and, as such, the groundwork of all the other formative arts; partly because it can penetrate much further into the region of ideas, and in conformity with them give a greater extension to the field of intuition than it is open to the others to do.

—Immanuel Kant, *Critique of Aesthetic Judgment*

Virtual :: World

How enviable the Enlightenment seems, with its unassailable confidence in well-nourished eyes and cultivated judgment. Painting almost always got the palm in those days. More public than drawing, less constrained than architecture (whether by physics or the whims of patrons), painting could claim conceptual supremacy even over sculpture—the brush had greater freedom than the chisel from matter's base demands. Thus painting came to dominate what Kant called the "field of intuition," which we might identify today as the limitless realm of the virtual. The way had been paved by the fifteenth-century success of perspectival illusionism and the perfection of the oil medium by the van Eyck brothers, and painting's dominance lasted quite a while. Ironically, it was when mid-century modernism attempted to secure painting's purity and supremacy for all time that the painted canvas was finally muscled out of the limelight. Installation art, video, Body art, social sculpture, new media—these genres have given painting short shrift. Yet painting persists. *Remote Viewing* is just one in a long line of seemingly necessary declarations: Painting is still here.[1]

The tenacity of painting is due in part to its technological simplicity, to its being relatively inexpensive to produce, to its permanence, and to its portability. But the primary contributor to painting's survival is its surprising capacity, even now, to summon for its viewers an evocative virtual world. Of course the virtual has tremendous currency in our digital age, updating and instrumentalizing artists' approaches to those unseen realms that have always been an object of human representation (in song, epic poetry, and dance no less than in purely visual forms). But how are we to understand artists turning to the virtual worlds of *paintings* in the new millennium—their stubborn desire for this flat and static medium that is somehow imbued with the icons and energies of electronic life? The artists in *Remote Viewing* are not only topographers of Kant's "field of intuition," they are also miners. They sift through a stream of images and pan for gold in the data rush. Images are caught and transformed; each datum is incorporated into highly personal maps of the unseen. Whether viewers choose to understand these realms as virtual, intuited, unreal,

invisible, or simply *new*, they will also recognize (in a sometimes uncanny way) what has always been available in painting—the capacity to materialize a visual reality that is patently alternative to the one we live in, yet brashly confident in our belief. Contemporary artists are drawn to this parsimonious medium *now* because they and their viewers are attracted to a virtual world that has material heft. There is something newly magical about a nonelectronic virtuality; it summons both a kinesthetic and an imaginative response.

One way to get at this present phenomenon is to look to the past. Keys to the seduction of the virtual and its modes of operation can be found throughout the history of Western painting, which is also a history of the perceiving subject. The rise of secular burgher culture in late-fifteenth- and sixteenth-century Europe, for instance, brought with it a triumph of domestic visuality that heralded an apogee of the virtual and initiated Western painting's long rule. Renaissance artists strove to make mimetic images that could be clearly distinguished from the archaic codes of the medieval illustrators and artisans who preceded them, while still nurturing a faith in unseen realms. Spiritual or simply occult, the unseen was never banished from representation, but lay coded within the blandishments of illusion.

For the best Renaissance painters, the virtual bloomed within the stuff of the world. Objects, textiles, and savories seemed insistently present, delivered into the light from a spiritualized shadow world that would soon become known pejoratively as the "dark ages." Yet such textured things were still laden with the symbolic and occult significance of earlier times. Lilies and snuffed candles, rotting fruit and ultramarine gowns—these miracles of illusion were also emblems of belief. Talented limners could paint spirits, ideas, and feelings as though such virtualities had palpably materialized on earth.

The very ontology of such illusionist pictures haunts contemporary painting, even if viewers no longer have access to the specific beliefs once conjured by the canny manipulation of light and mud. This haunting is what gives the contemporary paintings of Alexander Ross their "poignancy," according to Frances Richard: "as if the hush of Dutch still life were reimagined by HAL or Deep Blue."[2] Renaissance patrons, their beliefs subtended by religion, could look into the perfected illusion of an altar commissioned for the home and enter virtual sacred worlds far more easily than the proverbial passage of a camel through the eye of a needle.

This artful balancing of secular and spiritual virtuality is well demonstrated by Jan van Eyck's virtuoso double portrait of the Arnolfinis, in which the cracked and scumbled plaster of a particular wall exists in the same visual field as a flourishing imaginary signature. The painter's calligraphic sign is clearly virtual—made of *paint*, to be sure, but intentionally nonmimetic, its virtual perfection undeformed by contingencies of surface or light. Likewise, Giovanni Arnolfini's bride is simultaneously *there*, gravid with life and heavy with costly draperies, and *purely virtual*, emerging as a welcome, luminous vision from beyond the grave.[3]

Jan van Eyck, *The Arnolfini Wedding*, 1434
Oil on oak, 32 1/4 x 23 5/8 in. (82 x 60 cm)
National Gallery, London

The Arnolfini Wedding (detail)

So profound were such pictorial achievements, so exhilarating in their appeal to both mental and corporeal imagination, that they propelled painters out of the artisan class and up into better walks of life. Now on par with courtiers and humanist poets, the talented few could thank their ability to balance spiritual and material values for their unparalleled worldly success. Jan van Eyck's most powerful patron, Philip the Good, conceded that the work of this painter was a "paragon of science and art"—conjoined terms signifying the mastery of matter through its crafty manipulation into the virtual.[4] Ambitious, omnivorous painting was to be the new model for all the arts, but where Renaissance artists trumpeted the slogan *Ut pictura poesis* (as painting, so poetry), the artists in *Remote Viewing* have pushed Philip's *paragone* even further: *Ut pictura scientia* (as painting, so knowledge).

The dream of painting's supremacy was based on this capacity to summon entire worlds from a bit of pulverized dirt suspended in a translucent medium and fixed to a planar support. But where those worlds could once be imagined as united (if only divinely), artists today must accept a certain incommensurability about their virtual worlds. With the possible exception of Matthew Ritchie (who seduces us with hints of a grand unified theory), this exhibition's artists acknowledge their realms as specific and (true to their modernist past) individual. The surprise is not that they are pursuing alternate realities, but that they have chosen painting as the vehicle for that pursuit. *Remote Viewing* shows, in fact, that painting's dream has not only survived into this new millennium, but achieved surprising confidence. Clearly, this is no return to Renaissance illusionism. Neither is it a rehabilitation of late-twentieth-century figurative postmodernism. The paintings in *Remote Viewing* are mostly abstract; as Ross notes, "Painting . . . is visual information. . . . More of a screen or a window." [5] The artists here insist on the complexity of abstraction, its access to realms of visual data from a range of disciplines. Terry Winters's magnetic structures and cellular histograms, Ritchie's periodic tables, voodoo cosmogonies, computer avatars, dark-matter maps, and tarot card patterns, Steve DiBenedetto's and Ati Maier's psychedelic vortices, Ross's microphotographic forms, Franz Ackermann's spiral cartographies, Carroll Dunham's cartoon iconography, Julie Mehretu's explosive graphic marks—all are modes of abstracting and encoding data from the world. Seemingly personal, the works on view here are also mediated, saturated with icons and information mined from a matrix outside the self.

What are the circumstances propelling these artists' interest in making paintings and our interest in showing them? A baroque expansion fueled by the collapse of modernism into a white dwarf? It's not too late for that. Another spasm of the market, desirous of the portable commodity that Western painting has always offered to its patron class? Surely that's a factor. The exhaustion of the photographic? Quite possibly. The return of the repressed? No doubt. But while I want to deal with some of these historical conditions, it is the works' conceptual status in mapping virtual worlds that most interests me. This

Medieval artists held on to methods for depicting the flow of time, often mimicking the stately, unfurling pace of an ancient scroll even when they operated within the new format of the codex. Then, accepting the inevitability of the isolated image, they forced the rectangle of page or panel to register the spatiotemporal coordinates of the divine. They deployed a sacred geometry of planar space, using the size of figures and their placement (above, below, at the left or right hand of God) to reflect heavenly rank and narrative role. It was a flat space, yet coordinates X and Y could be scaled to encompass the known universe. Renaissance pictorial modes gained ground only slowly against this divine geomancy, but eventually triumphed because their optical and geometric rendering schemes were better at calibrating measurements across various frames of reference, better at transporting invariant information. But triumphant Renaissance systems of perspective had one major drawback: The image was mortgaged to an abstracted human eyeball—a monocular eyeball that imagined life in still perfection, miniaturized as if by a lens. The virtual world would now appear as a single, static moment, and viewers were positioned in unreal stasis before it.

"conceptual topography" functions to channel the compressed energies of the small screen (whether laptop computer, television play station, Game Boy/Girl, scanning electron microscope, or desktop dataport linked to the Very Large Array)—energies that have been summoned by artists who clearly have designs on the world.[6]

White Cube :: White Dwarf

The paintings in *Remote Viewing* seem to explode the small-screen portal into the larger scale of kinesthetic space—but what remains pictorial? Stasis and flatness. These conditions are conceptual rather than compositional; they derive from medium (on the one hand) and message (on the other). Indeed, if one attends to composition, the works in *Remote Viewing* are anything but static. Think of Mehretu—her compositions, like so many in this exhibition, are dynamic, centrifugal, baroque. The stasis I refer to is merely the limit condition of what is left to painting: Something hangs flat and motionless on a wall. Not cinema, not the ubiquitous video installation (black box in a black cube), these paintings' expanding forms and spiraling geometries are frozen (static), as if "Doc" Edgerton had aimed his stroboscopic apparatus at the big bang instead of the first light of the A-bomb. And while notions of the big bang animate Ritchie's pictorial thinking, it is Edgerton's A-bomb snapshot that has found its way into Terry Winters's sketchbooks—data arrested in the form of a photographic image, impossibly snatched from the flux of fission. For Winters in particular, a given canvas (which might be hung on the ceiling or massed in series of one hundred, as in his architectural installation *Set Diagram* [2001]) offers a way to sample and layer data in systematic ways. Generative forms and grammars lead to serial explorations and a sense of dynamic "organic" growth—even when violent, elemental turbulence provides the image source. In its constructive constriction, painting must provoke or incite movement in the viewer rather than project it (hence the potential for kinesthesia on the part of the viewer). As "painting" (please internalize those scare quotes, and apply them as needed to the mixed-media objects in the exhibition), this genre must choose a moment, or a sample, or an overlay to stand for the ceaseless flux of the lived visual world. The results constitute what information designer Edward Tufte calls "confections"—hybrids of different kinds of data, annealed and cooked into a single shallow plane.[7]

As for flatness, that teleological condition attributed to modernist painting by Clement Greenberg decades ago, it can still be located, but not where the great enforcer would have looked for it. Mehretu's flatness resembles the unquiet surface of a pond, roiling with life, where marks are trapped in separate layers of transparent medium like larval entities in different stages of transformation. Hers are deceptively shallow surfaces (as if depth charges were hidden under each graphic mark). Like the depth of field in a Pollock skein

The video installation, like the cinema before it, often holds the body of the viewer in stasis quite literally, imitating the Renaissance picture's captivation of the gaze. In the abstract picture, by contrast, there is no cinematic dream state—no flow of electrons or flicker of frames to suspend awareness of the body's stasis. Theorists of the abstract picture struggled to find an equivalent for cinema's suspension of embodied dailiness. Their rhetoric aimed to induce a transcendence of the body, if only momentarily, through the power of an ontological category: "presence." Echoes of that ontological project also emerged in photographic discourse around the index—the traces of light that were once "present" to entities in the world became deposits of emulsion, material facts that paradoxically neutralized the observer's own perceptual role in finding them meaningful. For modernists, presence (and the index) promised a yearned-for transcendence of particular viewers' bodies, converting perception into universal aesthetic experience. The embodied percipient was meant to disappear in contemplation of an ideal virtual world of form, space, line, and color.

painting ("flat" only when Greenberg could contain it within the navigational bounds of "eyesight alone"), Mehretu's "flatness" is semiotically laden, utopian, and explosive. Ross's works, on the other hand, display the flatness of the simulacrum, mediation upon mediation reducing "modeling" to code. Others in the show take "flatness" where they want to go: Dunham's line limns the flatness of a graphic world, but captures a whole world-picture; Ackermann's paintings display the flatness of maps, yet reference territories of impossible intractability, "highly subjective GPS technology rendered at the level of the hand."[8] And in the work of Ritchie, it is the miraculous flatness of space-time itself that the painter aspires to inhabit. In many of these artists' cosmologies, the precise geometry of the universe is analogized to the pictorial condition, resulting in a complex flatness nothing like the negative, ascetic restraints that Greenberg imposed.

Ritchie's works in particular exemplify many of the themes I want to draw out of (and into) *Remote Viewing*. Shuffling referential systems from physics, pagan religions, and cybermythologies like cards in a poker deck, Ritchie's conceptual topographies can barely be contained within the pictorial, though it is "painting" that he wants to prioritize. This expansive artist (who aspires to know the universe rather than produce a false universal) implies through his works' omnivorous referentiality that there is an infinite quantity of information that can be presented in a restricted dimensional frame (whether it be painting or galactic space-time). Rather than confronting Greenberg's modernist flatness with the radical geometries of Nikolai Lobachevsky or Georg Riemann, where space is curved negatively (so parallel lines expand infinitely away from each other) or positively (so parallel lines eventually cross), Ritchie welcomes the fact that current astronomical observation suggests instead an entirely eerie equipoise—or very close to it. Einstein himself mistrusted the cosmological constant he theorized eighty years ago, but it was the only thing that made sense of the equilibrium observed in our universe, the only thing that could allow us to exist.[9]

There is nothing "classical" about this equilibrated flatness, however, since its apparent functionality requires that what we perceive must be balanced by far vaster quantities of mass and energy that we cannot perceive or measure—although we can observe certain effects. This dark matter and dark energy (the latter constituting Einstein's cosmological constant) is what makes possible the apparent "stasis" of the universe (and, by my metaphorical extension, Ritchie's paintings). Contemporary astrophysicists now surmise that the universe is both flat and accelerating in its expansion (a theory awaiting confirmation from the WMAP, the Wilkinson Microwave Anisotropy Probe, which is mapping minute heat variations in the background radiation from the big bang to provide a "baby picture" of "the oldest light in the universe"), suggesting an inflationary universe.[10] This fuels the almost Futurist stylistics of speed that seems to govern Ritchie and others in *Remote Viewing* (notably Ackermann, Mehretu, DiBenedetto, and occasionally Maier).

Carroll Dunham, *Pink Box with
Two Extensions*, 1995–96
Mixed media on canvas,
69 x 81 1/2 in. (175.3 x 207 cm)
COLLECTION OF B.Z. AND MICHAEL SCHWARTZ

Steve DiBenedetto, *Vortex*, 2003
Oil on canvas, 48 x 60 in. (121.9 x 152.4 cm)
COLLECTION OF CLIFFORD S. DIVER

It also offers a direct (and conscious, at least for Ritchie) analogy to the aspirations of contemporary painting—mostly flat, yet accelerating. The conceptual topography Ritchie and his peers seem to want represents a scale of almost inconceivable dimensions, confounding classical physics in the same way that a cosmic "lens" formed by the gravitation of galaxies confounds the palm-size lenticular crystal of Newton's *Optics*.

The secular miracle that animates science (and Ritchie) resides in the remarkably limited range of elements and energies in the world—limits that allow us to become conscious and aware of them *as* limits. Like the odd colors to which Ritchie restricts himself (is it 1970s "avocado" or the military drab favored by the current U.S. administration? Renaissance ocher or coffeepot "harvest gold"?), these limits constrain the world but not what it can signify. Color for this younger generation could be compared to the astonishingly restricted protein chains that make up organic life—they *could* arrange themselves in trillions of ways, but in fact they exist in relatively few and harmonious combinations. In an analogous way, the flatness and systematized color of these paintings represents the structure of the known universe—an informationally dense and knowable flatness, a bounded yet infinite spectrum of color within visible light. There are limits, but within them we can roam, think, live, and perceive. The formal attribute of "flatness" is reinforced in these paintings by the mostly hard edges of color; flatness is also a property of their relatively uninflected hues, often laid out with a paint-by-number sensibility suggested by adjacency and repetition. Artists' personal topographies echo the mathematical map problem (how few colors can be used to distinguish areas in a given map of average complexity?). But rather than approximate the rationality of the modernist grid (think Utah or Ohio), their configurations are torqued by the baroque (think the Balkans, the archipelagic, or the fractal). Gone is the continuous, barely modulated flatness and emanating color associated with Greenberg's favorite Field paintings of the 1950s and 1960s—that bureaucratic cold-war optic is replaced by a punctuated, syncopated flatness attuned to an inflationary universe of Pop, Op, and psychedelia. Dunham's priapic cartoon worlds, Ritchie's proliferating eyeballs (an homage to Takashi Murakami?), Mehretu's exploded Kandinskys, and DiBenedetto's halations are "flat" only as code is—iterative, digital decisions that can be computationally amplified into robust virtual worlds. These artists have little interest in the shading and modeling that once secured pictorial illusion, nor in the tonal slippage that once gave abstraction its "human edge."[11] Postphotographic at last, their frequently mural-scale paintings are sites for depositing data, sorting and disporting it in personal and quirky ways.

Stasis and flatness have evolved, and theory must adapt to their new connotations. Historically, the qualities of "stasis" and "flatness" might have been the logical antipodes to the epithets of "duration" and "theatricality" that Michael Fried once leveled against Minimal and Process art in his crucial defense of modernism, the 1967 "Art and Object-

hood."[12] Fried's essay seems more and more important to the periodization of our current situation, since for this art historian and critic it was "presence" that synthesized stasis and flatness into something potentially transcendental. Presence signaled the atemporal moment of grace offered by the modernist painting, the payoff for the works' excruciatingly conscious manipulation of medium-specificity and pictorial conventions. The embarrassing body, the ethnic body, the political body, the gendered body were meant to disappear.

The condition of disembodiment that Fried so movingly described is no longer desirable. There's quite enough of it in the workaday world of webcams and cell phones, PowerPoint presentations and video games. The younger artists in *Remote Viewing* court a virtuality that no longer dissembles an awareness of the viewers' bodies; on the contrary, I'm arguing that they *count on* them. Taking the lessons of Fried's abjured Minimalist sculptors to heart, these artists are acutely aware of site, often adjusting their works to incorporate specific elements of the room's architecture (sockets and soffits, to say nothing of stairwells, ceiling tiles, and swimming pools). Ritchie, Mehretu, and Ackermann are central players in this newly casual practice of site specificity, cheerfully plotting their infinitely scalable installations to maximize impact on moving viewers or accommodate shifting, anamorphic spectatorial positions.[13] No longer monocular, the viewer is imagined to possess scanning eyes that are cradled in a skull, poised on a neck, mounted on a torso, and mobilized from below.[14] All that kinesthesia is acknowledged by Ritchie, for one, in the low-tech devices he deploys to make his paintings move in our eyes: lenticular walls, stretched images (as if Holbein's *Ambassadors* ended up on a light box), paintings that pour out into vinyl on the floor, and his recent powder-coated aluminum "drawings," which surround the viewer with veritable architectures of information. These are savvy ways to repurpose various gambits from the past (whether appropriating "3-D" advertisements, riffing on Lynda Benglis's poured paintings, or offering cyber-variations on David Smith's "drawing in space"). For this generation of artists, the body of the moving spectator is part of the game. The postmodern horror of the spectacle is transmuted into a wry brand of showmanship, and modernist ocularity and disembodiment is staged as a familiar joke. Put succinctly, this work knows we're looking, and it sees every reason to utilize that fact.

Viewers move in to read the small units of color, pull back to grasp the vertiginous baroque ensemble, slip across to feel the strangely virtual pictorial world colliding with peripheral vision, and return again to test the current of these often spiraling compositions. Here the smaller works of DiBenedetto are exemplary of the "close reading" regime, which demands proximity so we can parse the obsessive graphic markings constituting the image while simultaneously propelling us outward to grasp the "octocopter" hybrids or psychedelic heads they depict. Gaming and simple mouse moves have trained the average viewer in such modes of navigating the virtual, although here the whole meat machine gets into the act.

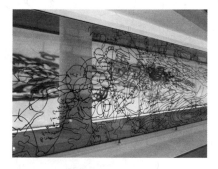

Matthew Ritchie, *Games of Chance and Skill*, 2002 (installation detail)
Mixed media
PERMANENT INSTALLATION, ALBERT AND BARRIE ZESIGER SPORTS AND FITNESS CENTER, MIT, CAMBRIDGE

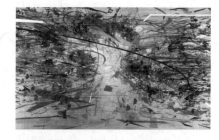

Julie Mehretu, *Renegade Delirium*, 2002
Synthetic polymer on canvas, 90 x 144 in.
(228.6 x 365.8 cm)
PRIVATE COLLECTION

Painting in the new millennium has fewer conventions than ever. Computers, by contrast, have lulled us into accommodating their limitations: "millions of colors" that still present no adequate green; software that deals with explosive encounters but cannot simulate the proprioceptive behavior of flocks in synchronous flight; black boxes, flat screens. Painting is starting to feel like drawing: notational, wide open. Because painting was, for decades, at some kind of nadir, it can now be anything or nothing. The stakes are low, but "you may already be a winner . . ." Duchamp's observation that the tube of paint was already a readymade has lost its cynical edge and broadened to encompass a world of available display technologies. "Paintings" can be projected photographic prints of paintings, oil-painted canvases layered with felt-tip pens, ink washes over graphite on polypropylene vellum, decals sandwiched between glass or crawling around corners, vinyl flooring razored into shapes and glued onto the floor, marks trapped in urethane, wood stain on cellulose. The more irrelevant painting is, the freer it can become.

Gaming is a powerful point of reference for these artists, yet we are more than simple digital flaneurs navigating *Remote Viewing*. Ritchie's works in particular refer to the avatars and spatial logistics of computer games (indeed, in *Proposition Player* the artist offers a game, but in real body space-time with digital dice). There is a difference between the body movements summoned by most of these paintings and the microgestures triggering the simulated movements of a computer game. Gaming (and, for that matter, video-art installation) offers ubiquitous and seductive ways of producing the mental perception of movement in a virtual world, and these postphotographic paintings are clearly marked by cinematic modes of virtuality. But in their abstraction, such paintings also provide a more open architecture for what these artists want to do. (Ritchie has commented that he can still draw and paint what he thinks faster than if he were to use electronic or digital means; Ross's representational strategies privilege painting, "especially when it is flat and depictive, [because it is] more abstract than sculpture.")[15]

How does all this kinesthesia affect the discreet charms of the bourgeois white cube? Battered by photography and politics and cinema and war, painting's capacity for transcendental reason was both represented and made possible by the clean white walls of the modernist gallery—the white cube.[16] The white cube explicitly invoked Enlightenment values against the critique of humanist subjectivity that Surrealism, existentialism, and Marxist theory had demanded. Without ever acknowledging it as such, Greenberg implicitly relied on the cube's muted architectonic presence to reject these destabilizing critiques and to establish the necessary conditions for an "Apollonian" (versus a quite palpably Dionysian) modern art. He defended the civilized culture of modernist painting, cited Kant ("the first modernist," in his view), and called for disinterested contemplation of the aesthetic object. Crucial to this project was the genre-police work emblematized by *Laocoön*. From Johann Winckelmann to Gotthold Lessing to Irving Babbitt to Greenberg (and thence to Fried), the aesthetic debate that had long been organized around this ancient writhing sculpture (to which, incidentally, Ritchie's paintings have been compared) gave critics the tools to channel feelings and regulate kinesthesia, enforcing their own authority at the same time.[17] *Laocoön*'s capacity to stand for suppressed feeling is emblematized by the way the Hellenistic sculpture is photographed now—isolated, detached, bathed in light against a photographer's "infinity" backdrop. As such, its isolation is utterly consistent with the modes of containment figured by the white cube. To imagine its more complex original function as an ornamental trophy for Roman conquerers, possibly installed with other violently struggling figures around an imperial pleasure grotto, is to make the white cube implode with the energies of *Laocoön*'s erotic and political meanings.[18] That implosion approximates the present status of the white cube, which has now become a white dwarf, its contemporary weight-in-theory little more than a pinpoint of its once luminous, naturalized, gaseous, and expansive state.

As a figure for entropy, the white dwarf (the final state of collapse in the life of a star; or the endgame for the modernist gallery) can also offer the paradoxical benefit of the second law of thermodynamics—while energy necessarily drains from any complex system, the quality of remaining information can be intensified and improved as a result. Moreover, that remaining information can be seen to *represent* its own relation to the universe as a whole. Ritchie's pictures reverse the terms of their own containment in just this way, much as *Laocoön*'s supposed message of stoic suffering gives way in Ritchie's death-drive epics to a delirious embrace of dismemberment. Ritchie's paintings are imagined to "take the viewer into a scintillating yet cerebral never-never land . . . among swirling clouds interspersed with snaky, death-of-Laocoön coils," or to offer "some kind of radioactive Rococo spiraling out of control in a passionate surge."[19] Similarly, Mehretu's images work to intensify and layer information; her visual data can be read at various levels—from the close-up of comic books to an imagined aerial view of the big bang. Crucial to what we might call the "expansion mod" (users' modifications of computer games) of these paintings' virtual programs is their scalable quality, their capacity to refer to microbes or parsecs, depending on the frame of reference or mood of the viewer.[20]

The expanding, filamentary nature of the psychogeographies in *Remote Viewing* suggests the freeing of Laocoön—even if it is only into death. The hulking Trojan priest and his sons, we imagine, can now express their anguish and indulge an erotic expenditure of life force/death wish that has been pent up for thousands of years. Similarly, the implosion of the white cube entropically compressed modernist energy (into that white dwarf), but it has also released streams of matter that register as "Installation art," "social sculpture," "narrative structures," and other complex exhibitionary forms. *Remote Viewing* reverberates with this implosion; pictorial energies in this exhibition are restless, violent, yet highly compressed. The shrinking of the white cube and the corresponding expansion of other art venues has its logic, stemming from the intense pressure put on the modest architecture of two-by-fours and drywall since the 1960s. Modernism's bureaucratization once seemed worth the cost—painting was for eyesight alone, hi-fi for the ears, chemical isomers for specific fragrant memories. Each sense was adapted to its appropriate aesthetic administration, but the cultural curve of binding energy proved short-lived.[21]

The contemporary artists at work in the present exhibition are not interested in a synesthetic overturn of that former bureaucratic modernist regime (that's already been accomplished). But neither is "looking" all the visitor is meant to do. Reading, playing, or following an avatar may be necessary. Learning a personal mythological system is highly recommended. Thinking is required. Painting here is more than a return of the repressed pictorial gesture—unless we imagine that gesture as it was theorized by B.H. Friedman in his 1972 book on Jackson Pollock, *Energy Made Visible*. As Friedman

The Laocoön Group, first century CE; Roman copy, perhaps after Agesander, Athenodorus, and Polydoros of Rhodes Marble, 82 11/16 in. (210 cm)
Museo Pio Clementino, Vatican Museums, Vatican State

intuited, the most promising trajectory from Pollock's hurled paint was not the Cubist classicism enforced by Greenberg; it was the infinite scale and ambition we label "baroque."

Smithson :: Baroque

At this point, memories of Baroque decay become seductive and full of grace. . . . Flickering cataclysmic hope tries to meet the need of dry abstraction. . . . From the dooms of "modernism," something cries out for the Missing Dust, then fades into the printed word and photograph. The Dust is leaving us with "pop" art and Clement Greenberg's visual Puritanism. Soon there will be nothing to stand on except the webs of manufactured time warped among throbbing galaxies of space, space, and more space.

—Robert Smithson, "The Iconography of Desolation," c. 1962

Robert Smithson, *Spirals*, c. 1970
Graphite on paper, 9 x 12 in. (22.9 x 30.5 cm)
COLLECTION OF TONY AND GAIL GANZ
ART © ESTATE OF ROBERT SMITHSON/LICENSED BY VAGA, NY

Writers on this generation of pictors—particularly those focused on Ritchie, Mehretu, Ackermann, Maier, and Winters—are quick to spy the baroque in operation. Formal cues are frequent enough, for the paintings here are full of "spirals . . . spirals . . . circles curling out of the sun"—as Robert Smithson intoned at the end of his film *The Spiral Jetty*. Indeed, Smithson could be construed as a kind of patron saint for the millennial age, especially given our growing attraction to the weird, funky, religious Smithson, who turns out to have been there all along. Clearly Ritchie's "goblins and ghoulies" and "radioactive Rococo" are ways of channeling Smithson (who linked Pollock's work, as Greenberg had, to "Gothic dread," but pushed the analogy to its logical conclusion by ranting about ritual jack-o-lanterns on "a million crabgrass-ridden lawns").[22] Smithson's flat voice intoning "spirals" floated a final cosmological metaphor over his materialized "mud, salt crystals, rocks, water" production in *The Spiral Jetty*, as the filmmaker/narrator read from a science-fiction novel at the film's end: "Gazing intently at the gigantic sun, we at last deciphered the riddle of its unfamiliar aspect. It was not a single flaming star, but millions upon millions of them . . . a vast spiral nebula of innumerable suns." The helical formation of cubic salt crystals to the infinite flatness of space—spirals all the way down.

Like the art-historical period Smithson was calling into being (in those remarks about "Baroque decay"), the millennial baroque of our own moment is interested in everything the Enlightenment relegated to the unseen and the unsaid—the feelings put into the sublime or the transcendental, the dark matter of spirituality, the embodied gaze. Smithson's early death only added to his postmodern authority on these subjects. But it is odd that his ghost should haunt painters in the current exhibition, since the science-nerd-turned-artist did everything but paint. His anti-painting campaign governs the way painters paint today; it can't be pure coincidence that Smithson's retrospective occupies the Whitney at the same moment *Remote Viewing* comes on stage. And truly, if there were painters Smithson could have tolerated, they might be these. "Dry" (which he liked) as opposed to "wet,"

their works sift visual data as much as they manipulate paint—transposing tattoos, sports diagrams, mental maps, magnetographs, and gravitational lensing theory into iterable icons rather than transcendental color fields.[23]

The Baroque is more than an artistic look of writhing bodies and virtually exploding ceiling frescoes. It is a moment of restlessness in the Enlightenment that still motivates contemporary philosophy, especially since Gilles Deleuze theorized Gottfried Leibniz and the Baroque in his slender but compelling rumination on *Le Pli* (1988, translated as *The Fold*). Deleuze's Baroque is just the one we want, rescuing Leibniz and his *Monadology* for a poststructuralist view of the subject. Twisting, folding, playing with extensive surfaces that we intuitively understand are the source of any possible interiority—this is the experience of the subject in the ostensibly "post-humanist" present. No coincidence either that this concept of folding from the world is also affecting the look and feel of architecture, design, and the complex virtuality summoned by the artists in *Remote Viewing*. Ackermann's mental maps, Maier's flickering grids, and Ritchie's swirling fragmented bodies invite us to adopt the incoherence of a subject who is ever at the mercy of her environment, "folding" herself in dynamic interaction with the flux of the world. As Mehretu puts it: "Places like Lagos or Times Square on a Saturday night are completely intriguing to me in their supreme, dazzling capacity. I want my paintings to convey . . . this type of speed, dynamism, struggle, and potential."[24]

Baroque sensibilities do not repeat; they rely on generative grammars (like Leibniz's own calculus) to produce endless variations from miraculously simple building blocks. The "folding" of the subject, per Deleuze, can take numerous and various forms without denying its origin in the socius. Similarly, in Ritchie's more recent wall works, the clean crisp lines of information from earlier drawings are subjected to a creaky bit of software from a "calculating machine." Ritchie's computer, archiving an outmoded graphics program, extrapolates a "better" path from points in the drawing, thickening lines in its own logical algorithm and producing paradoxically random-looking effects. As with Sigmar Polke's *Xerox* works, we intuit in newer Ritchie wall paintings (such as *The Fine Constant* [2003]) the operation of information degradation—entropy made visible, as it were, as mediatic abstraction.[25] Ross is similarly interested in mediation, if less entropically; his versions of Yves Tanguy parade their photographed and digitized stagings. DiBenedetto's fondness for Polke and his neo-expressionist ilk seem to have a different outcome—in his "cerebral folk art" the mediation is mentation, a chaotic feedback loop between world and mind that may never be successfully colonized by system or machine.[26]

Deleuze recognized the mismatch that characterizes most thinking about the Baroque. He critiqued the dominant view of Leibniz that celebrated the Enlightenment's supposedly simple, rationalist teleology but ignored the disorienting play with space, time, and the subject that surges through the art and architecture of the period.

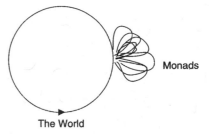

Illustration of the monad (subject), from Gilles Deleuze's *The Fold: Leibniz and the Baroque*; drawing by Bernard Cache

Matthew Ritchie, *The Fine Constant*, 2003 (detail) Powder-coated aluminum, stainless steel, gypsum, wax, and enamel, 95 x 1,152 x 192 in. (241.3 x 2,926.1 x 487.7 cm)

Against the Cartesian privileging of the mind, Deleuze argued for Leibniz's originality in *demanding a body*:

> The mind is obscure, the depths of the mind are dark, and this dark nature is what explains and requires a body. . . . It is because there is an infinity of individual monads that each one requires an individuated body, this body resembling the shadow of other monads cast upon it. . . . *In the place of Cartesian physical induction Leibniz substitutes a moral deduction of the body.*[27]

Artists in the current exhibition, I am arguing, deduce the body in a related way (indeed, Winters is an active reader of Deleuze). The viewing subjects produced in this abstract, contemporary baroque are mobile, folded from the thick surfaces of the universe, and willing to think through levels of mediation that construct them as they navigate painting's virtual worlds. Smithson set the terms for this Deleuzean relationship, declaring, "I'm just interested in exploring the apparatus I'm being threaded through."[28] So are we.

The mature Smithson, that patron saint of the contemporary baroque, tucked the body austerely between Site and Nonsite. (Ackermann and Mehretu similarly position their works as mappings of a not-here on a not-there.) Like Ritchie's complex system maps or some of Mehretu's titles (*Minneapolis and St. Paul Are East African Cities*, for instance), Smithson's dialectical chart of the Site/Nonsite makes for good reading: "open limits / closed limits, . . . scattered information / contained information, . . . some place / no place, many / one." As the foundation of Smithson's conceptual topography, the Site/Nonsite dialectic implied the body's negotiation with information and its necessary navigation of the physical world:

> The range of convergence between Site and Nonsite consists of a course of hazards, a double path made up of signs, photographs, and maps that belong to both sides of the dialectic at once. . . . The land or ground from the Site is placed in the art (Nonsite) rather than the art placed on the ground. The Nonsite is a container within another container—the room. The plot or yard outside is yet another container. . . . Large scale becomes small. Small scale becomes large. A point on a map expands to the size of the land mass. A land mass contracts into a point. . . . *The rules of this network of signs are discovered as you go along uncertain trails both mental and physical.*[29]

Smithson's baroque was no stranger to psychopharmaceuticals, yet in the end he didn't need drugs to map the inherently mind-bending scale of cosmological time ("millions upon millions . . . of innumerable suns"). Before computers ever graduated from the classrooms at Big Blue, artists like Smithson (and philosophers such as Deleuze) could intuit a future in which matter would become code, and code material for aesthetics, making the body an instrument for physical cognition ("as you go along uncertain trails . . . ").

The current work/play environment is hypermediated, giving a new valence to things, bodies, quiddities, ipseities. The mind is the most active site for capital to "develop" in the post-industrial information age, yet its necessary tethers—the body, the social network, a fragile ecosystem of food chains and mutual dependencies—demand our attention. Much global art production positions itself assertively within fields of matter or offers altered environments, as if walking through talc or experiencing alpine atmospheric pressure will offset the overwhelming daily requirement to exist in an instrumental virtual world. The forgotten playground of painting clearly occupies a different terrain—one where Marxist cultural historian Raymond Williams might have looked for "residual" ideologies. By capturing the "look" of virtuality but demanding the body's navigation and perception of a surrounding space, some painters may be both residual and resistant. Only time will tell how it all pans out.

Ackermann, Ritchie, Winters, Ross, Mehretu, and company call on the conventions of the mural picture (while also wrapping their imagery around stairwells or puncturing it with doors). They want us to get our minds around the material but keep our bodies in vertiginous negotiation with their spiraling virtual worlds.

The spiral is the ultimate critique of the modernist grid. It is still systematic, still plottable (or ploddable, to invoke Smithson laying out the stakes for *The Spiral Jetty*). But it is inherently disorienting, producing a different kind of viewing subject. Proprioceptively, we never know quite where we are on its curve. If Rosalind Krauss wrote the definitive analysis of grid systems in modernist art, we now need to understand the subject/viewer produced in an encounter with the baroque spiral.[30] In the current moment, it is rarely a mathematically precise spiral (although the natural order of fractals and Fibonacci numbers is suggested by some of Ross's work). More often, spirals in contemporary art are interrupted, crisscrossed, and difficult to parse. Gone is the tidy grid, which kept things predictable for so long—whether you were a Roman general confident in the invariant layout of the next garrison town or Greenberg finding "hallucinated uniformity" in Abstract Expressionism.[31] To follow a spiral, even with one's eyes, is to court vertigo, implosion or explosion, information overload. Movement along a spiral sets off eddies of fluid in the inner ear and rattles whatever speck of magnetite we might harbor (like birds) in the orienting centers of our brains.

Cursor :: Viewer

If the artists in *Remote Viewing* purvey a millennial baroque in which the gaze is solicited and understood to be embodied, that does not mean there is any promise of containment or comprehensibility. The whole point of these virtual worlds is to puncture the quotidian, paint some escape hatches into the world (like Harold with his purple crayon—doubtless a precursor to the world-making cartoons of Dunham). The subject position produced for the viewer is complex. The user at the other end of the cursor finds her choices limited; she follows the program's logical paths. But because these are *painted* virtual worlds, our folding into their visibility is unpredictable. We will always need to dip into the unseen to make our own sense of these careening, intensely colored conceptual topographies. Our movement will likely be tentative, as if we were still stumbling over Smithson's "uncertain trails both mental and physical." The politics of our position is aligned with this disorientation, which implicitly critiques "navigation as usual." At the same time, there is an ethics of principled escape. Principled, because the path through these artists' conceptual topographies, their mental maps, and their specific virtuality is largely ours to make. The avatars are open-ended (even God allows play, as Ritchie suggests in his Sophie Taeuber/Hans Arp–like *The God Game* [1995], with its beautiful combinatorial rearrangeability). There are no aspirations for

Alexander Ross, *Untitled*, 2000
Ink, graphite, and colored pencil on paper,
18 x 15 in. (45.7 x 38.1 cm)
COLLECTION OF A.G. ROSEN

Paradoxically, because Baroque paintings were arranged—one might say orchestrated—for the gaze, they gave viewers a sense of control within the system of awe produced by the artworks' tumultuous pictorial and sculptural spaces. "Ctrl space" now is often an illusion, like a back door left open in the gaming environment purposefully to elicit the hacker mods that will cement an "alternative" user community and produce happier customers for location-based entertainment. Seamlessly, cursor moves have evolved into viewing modes, and immersive virtuality feels like movies we can play a part in, dreams we can script. Painting can only compete with this by appropriating detachable components of gaming culture—siding with the hackers in developing narratives that never tidily conclude, avatars that can be customized to suit, and screen names (subject positions) folded from the mediated world.

paralytic mimesis, no aliens to kill under "universal lighting" (the grail of graphically dense computer games). Abstraction has always been about underdetermination; the cartoon characters that provoke the viewer's easiest identification are those whose facial maps are least defined. Such underdetermination is here an ethical principle—in *Remote Viewing* the cursor gets unplugged and the viewer is free to roam.

This pictorial underdetermination has its analogy in the dark energy now speculated to sustain the universe and in the dark matter that huddles beyond our instruments' grasp. It's paradoxical that such brilliantly psychedelic canvases should summon metaphors of darkness—but it is precisely the way fluorescence functions, to summon energy from imperceptible wavelengths and recalibrate it to radiate in the visible spectrum. Similarly, the unknowable "look" of the universe in the first three minutes becomes the backdrop for Ritchie's passion plays, and a mute echo in Mehretu's frozen explosions. Winters and Ross evoke the look (and iconic forms) of scientific imagery for related purposes, to signal flows of matter and meaning that only fractionally and momentarily materialize on the picture plane. As with Smithson, we have to hold in our minds simultaneously the scale of microns, the scale of the gallery, and the scale of cosmological time, the inframince of cell walls, the stretch of our fingers, and the barely conceivable span of galactic gravitational lensing.

The place of the body in this pictorial experience has been my leitmotif, and Ritchie's work is, for me, what calls this argument into being. Staring at Ritchie's abstractions induces reverie (the gaze); but moving around and among them generates a higher informational uptake (scanning, the glance, the unconscious operation of pattern recognition). Suddenly the conscious and unconscious movements of our bodies—at the level of breath, glance, and stride—are pricked by what the subliminal scanning operation has put together. A "punctum": awareness of the depicted bodies and abject fragments smuggled into the Pollockian sprawl of lines and Picabia-like facets of color. The subconscious fires a missile into the neocortex, shouting, Whoa, isn't that a skull / a ribcage / a bunch of viscera / some nasty shit goin' down? Ritchie's *The Eighth Sea* parses in this way, unraveling pictorially in our interpretation even as its depicted body unravels before our eyes. The blue coils (recurring motifs that have summoned *Laocoön* in reviewers' minds) at once cradle and devour this body, nicely complementing the sanguine tones of dissolving flesh. In Ritchie's cosmology, they stand for Lucifer, light-bringer. And/or the cerebellum. And/or Protista (the kingdom of few-celled eukaryotic organisms). And/or infinity. The eyeballs-become-whirlpools are further confirmation of the scalability of this universe— we could be viral phages looking for a host, or godly creatures watching cycles of entropy on a cosmic scale.

Rescuing us from drowning in this virtual world and from disappearing down the hoary path of sublimity is the expansion Ritchie intends viewers to experience behind

Matthew Ritchie, *The God Game*, from *Working Model*, 1995
Forty-nine wooden elements on steel bases and Cactus print, dimensions variable

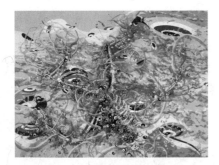

Matthew Ritchie, *The Eighth Sea*, 2002
Oil and felt-tip pen on canvas, 99 x 121 in.
(251.5 x 307.3 cm)

and beyond the confines of his own canvases. For many of the artists in *Remote Viewing*, the flows of information and intelligence that go into the pictorial system must have their way out. For some, critical and art-historical discourse must supply the data on the phase diagrams, travel journals, or political thinking (in Winters, Ackermann, and Mehretu, respectively) that fuel the painting. For Ritchie, the expansion is more physical. The graphically degraded diagrams that subtend the canvas, the aluminum archipelagoes that stretch out from just below its bottom edge, and the spreads of vinyl all work to expel us from the violence of paradise. We're meant to stay intact outside the canvas, folding in the palimpsestuous images and information but keeping our mind clicking in its portable cranial box. In this physicalization of cognition, Ritchie manifests the driving theme that pulls the highly individual psychogeographies and mental maps of *Remote Viewing* together. The mind is the ultimate dark energy for these conceptual topographers; the new eschatology will be discovering a cosmological constant we can access in our monadic, networked selves. Again, per Deleuze, "the depths of the mind are dark, and this dark nature is what explains and requires a body." The percipient bodymind offers the best field of intuition, the ultimate virtual world.

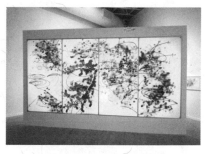

Matthew Ritchie, *The Two-Way Joint*, 2003
(installation view, Contemporary Arts
Museum Houston)
Photographic print on color transparency
mounted on lenticular acrylic panels, with
aluminum frame and fluorescent light,
96 x 192 x 2 in. (244 x 488 x 6 cm)

INSIDE OUT

Katy Siegel

Since the nineteenth century, artists—and everyone else for that matter—have struggled with the vast processes of mechanical production that dominate modern life. Not only industrialism, but living conditions wrought by urbanization, globalization, and government centralization deny human scale while demanding that we adapt. Different artists respond differently to this situation, of course: Some absorb and mimic the means of mass production; some aspire to the impersonal materialism or the global scale of late capitalism; others exalt the individual self, celebrating their own creativity, resistance to social forces, or uniqueness—either as an assertion of will, or simply out of a desire to escape the world.

In 1947, Clement Greenberg saw the conflict between the individual and the world as a primary problem of modernism. Stating that historically much American and European art has been "Gothic, transcendental, romantic, subjective," he traced the condition to the position of artists "confronted . . . by the paraphernalia of industrialism, [who] see the situation as too overwhelming to come to terms with, and look for an escape in transcendent exceptions and aberrated states."[1] While Greenberg was thinking specifically of his then-favorite Jackson Pollock, he also placed artists such as Vincent van Gogh and Albert Pinkham Ryder in this lineage. The position he describes can be found as well in the work of many contemporary artists, where the romantic or subjective impulse persists. Today, however, it coexists with the wish to face the scope and systems of modern life head on. These artists work from the inside but also engage what's outside.

Among the contemporary artists who might be said to share this attitude are those in *Remote Viewing*—Franz Ackermann, Steve DiBenedetto, Carroll Dunham, Ati Maier, Julie Mehretu, Matthew Ritchie, Alexander Ross, and Terry Winters—as well as countless others, including Fabian Marcaccio, Lydia Dona, Dona Nelson, Benjamin Edwards, Michael Majerus, Alfred Jensen, Fred Tomaselli, James Siena, Nina Bovasso, Diana Cooper, Thomas Scheibitz, Adam Ross, Erik Parker, Bill Jensen, Lari Pittman, Danielle Tegeder, and Thomas Nozkowski. No single quality binds these artists together, but each shares some theme or practice with several of the others, so that we might locate them in interconnected constellations—the kind of diagram that Ritchie or Parker might draw. These commonalities include intense drawing, obsessive studio practices, expressionist passages, personal cosmologies and iconographies, the desire to model a world within a painting, irrational space, outer space and other fantastic imagery, multiple perspectives, a wondrous attitude toward science, and extreme experiences of the city as magical or threatening. In addition, the painters all directly and obliquely address possible relationships between the exterior, material world and the interior, sensing self.

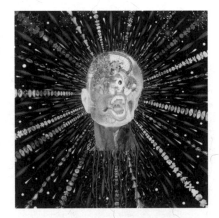

Fred Tomaselli, *Cyclopticon 2*, 2003
Mixed media, synthetic polymer, and resin on wood,
24 x 24 x 1 1/2 in. (61 x 61 x 3.8 cm)
PRIVATE COLLECTION

The deepest, most interior part of the self is what we conventionally call the unconscious. Winters, who has been around long enough to have a lived relationship to the New York School, with its interest in Jung and other philosophies of self-exploration, says that he sees his paintings as an "expanded picture of the unconscious."[2] His depictions of natural forms reveal forces we cannot normally see, as in the *Turbulence Skins* drawings and paintings, whose swirling surfaces describe the agitated patterns of gusting air; earlier work explores microscopic processes of nature such as cellular genesis, growth, and decay. Winters's repeating trope of the invisible but powerful and intensely active world just beyond our perception parallels that of the unconscious. Dunham, his peer, is more explicit; his work often reads as an expression of pure id, featuring violent, slapstick interactions between angry urban-dwellers brandishing weapons and inflamed, cartoonish genitalia.

Ati Maier, *The Great Unknown*, 1998
Mixed media on paper, 26 x 26 in. (66 x 66 cm)
COLLECTION OF THE ARTIST

Maybe "subconscious" would be an appropriate term to consider as well. While the younger artists in this exhibition are less quick to engage the traditional concept of a self that is centered on the unconscious, much of their work alludes to places, beings, and events that exist beneath the surface of things. The roiling, secret worlds these artists unearth are common allegories for hidden thoughts and desires. Ackermann's *Some miles under the ground* (2003), for instance, peeks just beneath a small and dreary city to expose a fantastic natural world of caverns, energy lines, and pulsing molten lava. Others figure the subconscious as the deep sea below the ocean's surface. DiBenedetto's drawings, like *The Wizard* (2004), frequently represent watery depths, often patrolled by menacing octopi. In Maier's most recent paintings, such as *Shooting Target* (2004), seashells and giant squid or jellyfish are bound together by plantlike tendrils. The resonant space in her art is not only "underneath," but also "out there"—in the kind of strange, haunted setting that represents not a literal view of nature, but an experience of the sublime and the sensations it causes. Her landscapes, like *The Great Unknown* (1998), for example, verge on clichéd Western frontier scenes, full of canyons and mountains—but with four suns instead of one. Maier's work descends from the lonely, eerie images of Ryder, a favorite of Pollock, Forrest Bess, and many other artists invested in the visionary self.

Forrest Bess, *Eye of God*, 1966
Oil on canvas, 14 1/2 x 16 in. (36.8 x 40.6 cm)
THE JPMORGAN CHASE COLLECTION

Critics have often seen such fantastic imagery, particularly DiBenedetto's, as representing not just the unconscious, but the mind under the influence of psychotropic drugs. As artist Dike Blair has said, "When I first saw DiBenedetto's paintings in the late 80s, my immediate (and obvious) response was 'They look like bad trips.'"[3] His work vibrates with the psychedelic aesthetic of late-1960s graphics but with an added paranoid twist. There is also occasionally a direct reference to drugs, as in *Dose* (1999), which looks inside a

Steve DiBenedetto, *Dose*, 1999
Oil on canvas, 11 x 14 in. (27.9 x 35.6 cm)
COLLECTION OF DANIEL AND BROOKE NEIDICH

human head filled with wild imagery and bright colors. The psychotropic question arises in the critical writing on almost all of the artists in *Remote Viewing*, although only Dunham speaks frankly and at length about his own drug use and its importance to his (early) work. He connects drugs to an ongoing interest in "altered states," to forms of consciousness also attainable through meditation and other techniques.[4] Other artists in this exhibition, when asked about drugs, laughingly dodge the question, championing not drug use per se, but what they see as related experiences: for Ritchie, the sensation of an expanding mind, for Winters, a heightened sensitivity to "the connection between things."[5]

Many of these artists distance themselves from the art world, perhaps in explicit reaction to its current hyperprofessional incarnation. Ritchie tells (and writers retell) the story of how he worked as a building superintendent in the 1990s, reading science textbooks discarded by his NYU tenants; Ross, too, takes on a slightly mad-scientist, autodidact persona. Dunham admits his feelings of complete isolation as a figurative painter of his generation. DiBenedetto says he wants to make "cerebral folk art."[6] Globalization allows for alienation from not just one but many cultures and identities: Ackermann maintains the position of perpetual outsider through constant travel, while Mehretu similarly assembles her identity from many different sites, rather than finding home in just one place. This is not to say that any of these successful and worldly painters are outsider artists in the usual sense of the term, but that their self-images are based on difference from rather than harmony with social groups, "schools," or scenes.

An emphasis on the self translates directly into these works, which place the artist's subjectivity at their center. While many painters of the past fifty years have felt compelled to grapple with the legacy of all-over composition, much recent painting, like that in this exhibition, recovers central composition. Central composition implies a human presence, a maker, someone who generates not neutral, all-over fields but worlds with perspectives, hierarchies, and values. In many of Winters's paintings and drawings, to take one example, the central element is in fact an eye. In some works, he depicts it as seen from the outside and schematically rendered (a common trope in the work of visionary artists), in others as an eye seen through, as a generalized ocular screen. In drawings from the series *Tenon's Capsule* (1994), which takes its title from the membrane that fixes the eye in its socket, an ovoid form recalls the shape of an eye, and a "window" of sight opens onto the world. In *Field of View*, from the previous year, a red web overlays the other marks on the canvas; it becomes an organic structure, a lens filtering the bright colors of the world beyond.

Even without the literal device of the centralizing eye (or, in Dunham's work, the central figure), many of these artists return again and again to vortices, convergences, explosions, implosions, and kaleidoscopes—forms that turn around a center. The helicopters that populate both DiBenedetto's and Ackermann's work generate energy, stirring the air, setting the paintings into motion. Both of these artists and Ritchie and Mehretu create

Terry Winters, *Field of View*, 1993
Oil and alkyd on canvas, 75 15/16 x 96 7/16 in.
(192.9 x 245 cm)

circular, whirling energy lines that whip through and marshal the hard-edge shapes scattered in their paintings, binding everything together. Maier, DiBenedetto, Ackermann, and, most insistently, Winters twist grids into circular holes that become volumetric, opening the surface of the painting into space of potentially limitless depth. Represented depth alludes to metaphoric, psychological depth; it also refuses the modernist-materialist emphasis on surface and plane.

It's interesting that these painters choose to challenge (in a totally nondidactic manner) the primacy of both all-over composition and flatness of the picture plane—the two essential components of modernist painting that Greenberg championed, both of which remain important to contemporary abstract painters. In fact, these artists are not constrained by or even concerned with the rules of painting per se, or its history. Their emphatically synchronic focus ignores the grand narratives of painting as a medium and even the critiques of those narratives; while this stance can seem ahistorical, it also keeps the painting from lapsing into academic exercises in theoretical illustration of irony or exhaustion. (Even Ritchie, who apparently draws on scientific paradigms rather than artistic ones, verges on a parody of totalizing structures.)

Matthew Ritchie, *The God Game*,
from *Working Model*, 1995
Forty-nine wooden elements on steel bases
and Cactus print, dimensions variable

The rules that these artists follow are not those of painting proper, but rather ones they make up. As Dunham says, "In these paintings that I've been making for a while now, the characters inhabit some other continuum, where different kinds of laws or conventions apply; they live within the conventions of the paintings. It's a different place than this place."[7] Some critics have complained that these rules are too esoteric or too insular (as in DiBenedetto's restricted iconography, or Ross's very deliberate method, in which he models an object in oil clay, photographs it, and then paints from the photo).[8] As the basis for art, the creative self offers thrilling possibilities, but also inevitable limits; despite Romantic belief, the imagination is not infinite. And the individual mind, however original, always betrays the social experience within which it was formed.

Generations of artists have of course had to reckon with signature styles, habits of the hand, and inevitably individual imaginations. Artists now in their thirties and early forties are particularly attentive to this tension. Many resolve it by making their individual marks, but cataloguing them as they go, repeating themselves deliberately, rendering a key to the shape of their artistic world. Ritchie traces the genesis of his art (his own creation myth, as it were) to a chart he made detailing his forty-nine personal interests (for example, sexuality and color). This developed into his early installation *Working Model* (1995), in which he assigned characters and shapes to his interests. Around the same time, Ackermann published his *Dictionary of Activities* (1994), an index listing (in no particular order) all the things one can do in a city, among them "rust" and "lie." Mehretu has been archiving her various marks since 1997 (both on paper and in her head); like Ritchie, she also inventories herself—her family stories, photographs, and genealogy—as

Matthew Ritchie, *Working Model Chart*,
from *The God Game*, 1995
Laminated Cactus print, edition of ten,
20 x 18 in. (50.8 x 45.7 cm) each

a way to generate and locate her present practice. Other artists of this generation who catalogue their personal vocabulary include Marcaccio, who has recorded more than six hundred drawn characters over the past decade. In contrast, slightly older artists—including Winters and Dunham—don't seem to share the desire to objectify their subjective impulses. Winters says plainly that he "can't step outside [the painting] process and construct an objective account."[9]

Making a world by creating conventions and limits implicitly challenges the conventions and limits of the "real" world. When Ritchie talks about making his own world, he says he creates its rules "in defiance of the underlying [rules]." He probably means natural laws, such as gravity and entropy, which he reinterprets and subverts in his paintings, but the statement is ambiguous, suggesting that perhaps those rules are social as well. Ross clearly articulates the fusion of the cultural and the natural, refusing a distinction between them in the era of artificial life. As he puts it, "I believe nature's will is her expression, which includes us and our activities. It follows then, that what we will is what nature wills."[10] In other words, he does not defy nature, because whatever he does *is* nature. Not only natural order, but manmade order (and the relationship between the two) weigh heavily on these artists. Mehretu describes this pressure powerfully:

> I am especially concerned with building and architecture in which militaristic rigidity has been used in construction to impose a fascist, purist social agenda. At the same time, there are many characters and plans in the work that struggle against this idea—some that are biomorphic, monstrous, organically overgrown. . . .
> They inherently resist order due to their gesture.[11]

Here the natural resists the social in the guise of the human, a theme that Mehretu, Ackermann, and Dunham all investigate in their representations of urban architecture and social life.

Unlike artists such as Andreas Gursky or Mark Lombardi, whose art seeks to pull back and reveal from a distance the totality of huge cultural and political phenomena, these artists tend to insist that exterior reality can only be grasped in a decidedly personal way. The objective view is an impossible goal; as Ritchie asks, "How can we perceive the structure that contains the model of our perception?"[12] This is not to say that these artists don't try to see the big picture. Almost all of them use some form of mapping in their work, for example, but only in order to play on the assumed objective nature of the map, which while detailing geographic or cultural features of the land, also distorts, filters, and reduces. Making this paradox explicit, both Mehretu and Ackermann engage the Situationist International practice of psychogeography.[13] In this method of mapping, the image of a space becomes explicitly personal, individual, and experiential rather than social or conventional. Distances are relative and flexible; scale corresponds not to actual size but to the importance of the place to the subject, so the post office might loom larger than city

Fabian Marcaccio, *#91,* from *661 Conjectures for a New Paint Management,* 1989–2004
Drawing on paper, 14 1/4 x 11 1/4 in. (36.2 x 28.6 cm)
KUNSTMUSEUM LIECHTENSTEIN, LIECHTENSTEIN

hall, or we might find Nigeria instead of Connecticut next to New York. Ackermann's drawings of cities made during his travels around the world portray environments as seen through his eyes and processed by his mind; his renderings of traffic patterns or commercial signs don't produce recognizable versions of Paris or Buenos Aires; you couldn't use them to navigate a city. *Untitled (mental map: night in the universe)* (2000) is a self-portrait whose outlines include the national borders and geographic features of various places Ackermann has visited. It functions as both a particularly personal view of geography and a porous image of a self that, rather than being made up of the reinforced preferences of home, neighborhood, and routine, lies open to the world.[14] Ackermann's paintings signify sensibility loudly, with cartoonlike forms, vertiginous shifts in scale, and bright colors. While Mehretu's style is cleaner, at once harder-edged and more finely wrought, her work is no less self-portraiture—or, as she puts it, "self-ethnography."[15]

Using the form of a map to express a personal reality seems to deny the existence—or the availability—of objective reality. This subjectification of the objective world is the other side of the tendency, described earlier, to objectify subjectivity. A confusion or reciprocal exchange between the self and the world, the painting and the city, inside and outside, permeates the work of all of the artists in this exhibition. Macrocosm and microcosm is a very old idea.[16] Ritchie sees balancing between the two as a constant process: "So every day we're making a map of our life in our brain. We're doing what we're talking about in a very abstract way, processing everything into a physical object, inside our heads, every day." Even ephemeral external events, like conversations, become concrete aspects of an interior reality. Abstraction maps information, imaging life in new synaptic structures. Thus we could think of Ritchie's large oil paintings, such as *The Living Will* (2004), not only as literal descriptions of theoretical scientific events, but as images of the artist's brain, growing and changing under the pressures of new information. Similarly, if less grandly, DiBenedetto's images swing perceptually between neurons and highways; Blair wryly characterizes this mingling as "a kind of brain doily."[17]

Maier also celebrates the interpenetration of inside and outside, small and large, near and far: "The amazing thing is that we on this tiny planet can explore phenomena such as supernovae and black holes, which are millions of light years away, inaccessible for our physical bodies, but well integrated into our conscious minds."[18] Her images of fetuslike astronauts, reminiscent of *2001: A Space Odyssey*, suggest not just interior and exterior space, micro and macro, but another old idea, that ontology recapitulates phylogeny. In a similarly sweeping temporal figuration, Ritchie sees his saga of the birth of the universe (unfolding as episodes in individual paintings) as a narrative allegory for the process of making art.

For most artists working now, it is impossible to imagine an existence or an ambition that dwells exclusively either within the self or out in the world. Modern art has of course always been one place where the individual meets society and negotiates some form of

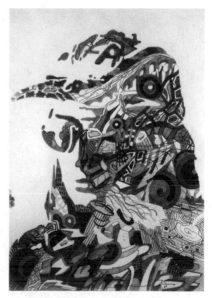

Franz Ackermann, *Untitled (mental map: night in the universe)*, 2000
Watercolor and graphite on paper,
7 1/2 x 5 1/8 in. (19 x 13 cm)
PRIVATE COLLECTION

relationship with it: escape, domination, resistance, complicity, and countless others. The painters in *Remote Viewing* try out a wide range of these possibilities for engagement, from the most interior to the most exterior. And they combine these strategies in surprising ways, reminding us that even insular imaginings are a product of contact with a shared physical and cultural reality. As DiBenedetto insists, "I'm somehow responding to the current social landscape (which does partly exist in one's head), where the distinction between the inside and outside is much more porous than ever before."[19] Romanticism once battled what seemed to be an imperiously pragmatic social reality. One hundred and fifty years later, industrial modernity has turned out to be not orderly, but chaotic and self-destructive; far from being too materialistic, governments and corporations in fact ignore the material realities of ecology, economy, and politics. Perhaps the artists in *Remote Viewing* gravitate toward "aberrated states" not in order to escape a frighteningly impersonal and rational modernity, as Greenberg assumed, but rather to reflect a social order that is itself aberrant.

I would like to thank Paul Mattick, David Reed, Richard Shiff, Elisabeth Sussman, and the artists in the exhibition for discussing these issues with me. I also thank Jennifer Liese for her perceptive editing.

SUCCESSFULLY PRETENDING NOT TO FEEL PAIN

Ben Marcus

Our almanac asserts that at this time of year, sunset is no accident. It lands at 6:30 pm, an event so forceful that the entire town trembles. This is why sunset is often referred to as a percussive event, inside of which one might conceal *numerous silent acts* not representable in image form, existing merely as sound waves the precise length of a person. These waves, stretched to their full length and combed free of all detail—neutered of their past—can be used to generate the unprecedented scenarios that arise when people refuse to be buried alive.

We have the luxury of not quite existing. What we don't have is the language to describe the new behavior, which frankly comes as some relief, since silence might ease the stress on our faces. We will make shapes with sticks instead, if sticks are taken to mean carvings of air injected with sound and percussion, and sound is the magnification of the wounds people receive when they collide with each other.

Upon scrutiny, our almanac further reveals that this is the precise time of year to take control of what has always existed, to sign our names to real people. We shall wear their bodies in the manner of hand puppets and generate real experiences—an invasion that leaves them gutted and exhausted, however relieved they might feel for ceding control of their actions. There remain the pressing issues of acoustics and behavior, how our conquest will be scored in text and sound, and what cloaking maneuvers will be employed to insure that, according to appearances, very nearly nothing has happened at all.

 Starting from scratch is another way to say that we won't stop clawing at each other until we see light on the other side.

Outline of Peterson's last sentence.

At the beginning of our project, when the conversation occurred that would create the person, it spoiled in the air, the way speech turns brown when children use it. The resulting person was therefore easily destroyable, which meant that people would have urges toward him that they could not master. This would be a person who would walk upright and quietly open his mouth to the speech of others, so that it might grow inside him and be available for later conflicts, should he learn to deploy it. He would forever be peeled away and shucked by his encounters. His leavings would constitute large-scale pictures of the world and other places, a wake of scenarios that small-bodied people could escape into. These images would be full-size, lifelike territories, suitable for accommodating a

certain evening music that accompanies failure, tinkling in the background. Such is why the term *illustration* is said to be a portrait of debris, a still image of the expendable parts of a person. To illustrate is to render the half-life of objects that are waiting to expire from sight. To draw a picture of this is to squeeze at the person's body until an outline is rendered from it, the body reduced to powder.

Before this man could calmly trod to his demise, he would need a location to contain and clarify his special decay—however much it resembled robust life—so that others would feel his death was deserved. Settings are not important because you can see them, but because bodies would fall through space without them. They are safety nets against sheer flight.

Each time a language occurred in the making of the new location, it was worked at with knives, which sounded like a man swallowing air, successfully pretending not to feel pain. When the knives grew dull, a person's hands were brought to the task, readying the language so that a mouth might contain it, which meant that the audible parts of the language would be abraded until no one bled from hearing them. Syntax is not only a softening agent, it also detoxifies the language to keep the speaker from being poisoned. Sentences can be built from wood, but they will rot.

Squinting at an object produces a 5% deceit, necessary if one chooses to look upon children without collapsing. A mechanical squinting device, called a hood, is frequently too effective, and causes a swarming darkness in most cases. Unfortunately, shining light through this hood is a form of storytelling that is no longer effective.

The sentence that killed the children (Speech Forensics Lab, 41989-0)

Before the place could convincingly exist, there would need to be a chronology of its past, even a garbled one, not yet decayed from conversational exposure. An investigation would additionally be necessary into the viability of people here, if people even existed. The death rate would have to be acceptable. Peterson's Scheme would be the criteria. The chronology, once launched from the math gun, would need to include a reference to the invented gentleman who—it had been decided—consumed small stones and other excesses in the world, in order to create new air, ingesting solidity so that others might move more freely without risking collisions. His official title, the concealer, would have to be used when the history was recited, but it would need to be translated through mouth scaffolds, so that it sounded like a proper American name, one that made children sob—but not bleed—when they heard it. There would be terrible arguments about his family history, his intentions, the issue of whether or not he swallowed the stones or kept them stored in his mouth, and whether or not an object created new space once it was stashed in his body. For instance, had he not surrendered his own allotted space when he stored something in his body? Was he not enacting a chesslike game between his interior

and exterior, a contest of territory with his body as the border? Are secrets of this kind possible if so much blood—the primary listening fluid—surrounds them?

The whole issue seems quaint and old-fashioned now. It is easy to laugh at the people who gather with seriousness at the speech huts to reenact the conflict, gesticulating inside their oversized group mitten, an act that resembles an animal roving angrily under a carpet. Conversations are used to tear apart the mouth—an almost embarrassingly simple concept to grasp. One wonders how often it will have to be asserted before it can go without saying. We will argue about it ourselves after all the children have died, the sermons have been exhausted, and the last of the breathable air has left the room.

To complete this world enough so that it would torment and confuse anyone who lived in it, we would additionally need to mention those foragers from outer Delaware who relocated sticks from one trail to another, who marked the leaves of trees with transparent gels. This drew the eye of hikers to them, so that more remarks would be made about the beauty of things, the exquisite shapes arising from the soil. Scenery demands a specific language and nature conspires to collect sentences that reference it—this is why landscapes are compared to the structure of the ear, why *distance* is the English word for *idea*. These men stored pockets of soil from one mountain area and relocated it to other regions, blowing the soil precisely into place with a bellows. They lifted people themselves and replaced them with some dull coins, which could be melted down and reshaped into figurines. When inflated, they huffed and wheezed briefly before expiring, withering down to their skins. This was the first economic transaction, and it was a failure; thus the phrase *keeping score* was first used to indicate the deepening of a knife wound.

Because this never happened, it was susceptible to an incessant kind of wishful thinking. It became clearly visible to anyone who thought about it. There was something unfair about how easily we could identify the people who dreamed of it, kept it in mind, cited it to others by blurting out singsong words for each other. Its lack of existence was possibly its only pleasing attribute. It weakened nearly everyone who encountered it.

A discussion of berries, clustered on branches or dispersed, would seem beside the point during the preliminary remarks about a place that has yet to exist, even if entire quadrants of the real world are filled with these items, and even if these items sometimes exactly resemble the maps that Peterson made of insincere speech as it leaves the mouth. Yet why would nature be placed in our path if we were not meant to inhale it? Why would scenery be flammable? Why would men bow so low, if they were not trying to hide themselves underground?

The unanswerable question is the crucial element in any territory—something uncertain the people might fight over, testing each other's authority with angry, one-syllable words. Settlers require a mystery that is just baffling enough to keep them from surviving.

A false history would be needed to appease the people, something that accounted for their confusing past without revealing the dull details, a misleading story they could sing to themselves when they chose to rub each other's bottoms and make their person-sounds. Insight loses its attraction if it is too accurate; it becomes pelted in a brittle hair. We would need to take care to modulate our error just so, to fail at the precisely correct volume, in the appropriate colors, and be sure that we were seen doing so.

Enter Peterson, who had a philosophy for everything that went without saying. It was he who knew that our people would feel more plausible if we could convince them they had narrowly escaped peril. It was he who devised the invisible harms, allowing people to regularly disappoint themselves and blame it on the air that lurked behind their houses.

Sunset is no accident.

So, the story we told them, which they could later misunderstand and then tell themselves: There were people in that place until the fire came (a fire that reasoned quietly with their flesh until they joined the landscape as deep, black scars—the first genuine landscape). But oh the fire was slow and clear and often cold, and it frequently took the form of children, who were built from the brown exhaust of other people. Afterward, what one often saw were piles of beige-colored dust, some bright coins, and stacks of documents. These three categories can be combined to create almost anything, which provides a nearly perfect argument against doing so, and could lead to a new kind of empty world. One so desires a fourth category, to undo what has so far been made so well already. A magical fourth category, named after someone dear to us. Something poisonous to the other three.

Without it, what we have to work with, if we choose to invest in something real that has a reasonable chance of refusing our command, is a gentleman walking the road in a mountain town, although even this description could be contested, and us reduced to silence. We have this man's telephone sign, a string of digits too unbearable to recite. We know the outcome of his family, the quiet parents dangling from a single rope, the businessman brother, the apelike sister who shouts. Such statistics. The sheer amount of numbers attached to this man threatens to break our mouths open. We can be certain of his schedule enough to know that he will not return to his house until sunset. We can attribute this certainty to *the law of return*.

When he does return to his house, he sings a particular song, a song built of wood and water, with space injected into it. We know who wrote this song, what the song is about,

and what happens when this song is broadcast at a barely audible volume to a stadium filled with children. We know far more than we are comfortable with here, a knowledge that makes us sluggish and too easily killable. We wish to know so little that trees would confuse us. We would ask ourselves horribly obvious questions such as: Why has this man frozen in place and turned so terribly brown? Why has this one child swallowed so many other children that his skin has hardened and cracked into bark? We would prefer not to know the answers, which is why, when you look at us, our hands are buried deep in our mouths.

Time, still under our command, since the people have yet to realize they can control it, has allowed us to lift and examine our man's body, toss him aloft, empty his pockets. We can remove him from the road where he walks and replace him with either a smaller or larger man, who has either more or less of a purpose. Our power is such that we could drain this man of his blood, store this blood in other bodies, and send those bodies after him in the form of a family he thinks he has created—the easiest way to disguise a threat. Is this where the old saying comes from: He struggled with himself? Is it true that unless you can actually move blood between people, you have absolutely no power to speak of?

Since he is a man, he either can or cannot accommodate our attention toward him. He either can or cannot breathe when we hold his face down in the mud. He either will or will not die today. If he did not exist, we would all breathe much easier. We would peer out from the side of our faces and lay down our weapons. We would introduce perforations in the sky so that our own children could make their escape from this place, leaving behind traces of gray powder that could be crudely shaped in their likenesses, figures to be blown at until nothing was left.

Peterson discusses other circumstances in which language is not available. If Peterson is to be believed, all the children are perished from this document. When we ourselves recite the document, we find little of interest, nothing that could actually be construed as harmful: dull descriptions of hair, the coordinates for an old-fashioned cheese shop, short confessional remarks from a retired town mayor. We would prefer the document to be more disturbing. Nothing of the sentences would seem legitimately viral, yet something lethal must obtain—a toxicity to the grammar itself, for example, something poisonous in the artificial environment that was erected between the sentences to keep them from collapsing in on each other. We cannot comprehend what about the document so engrossed the children, but we are able to examine footage of them reading it to each other, compulsively listening (using the Robertson Pose, and other methods of hearing), shouting for passages to be read again. In the footage, the children read from the document in different accents, holding their mouths in strenuous configurations, building small structures of

Weaponized Grammar Device, for Dental Insertion (Magnified 100x).

mud supported by matchsticks, which they would appear to swallow, but later expelled through their lips in beige bursts of foam.

A forensics should be produced for every act of speech. We would care to undertake an autopsy of the sentences that killed the children, to study the weaponized grammar. The report, when completed, would be a diagram presented annually at festivals and holidays, read aloud between courses. It would contain a sound-based antidote that is pleasing to hear, a medicinal language delivered by a stranger through the side of his mouth. There would be speaking parts for all of the new people, even if they were only allowed to say their own names and then expire. Every person would undergo a profound change of belief, which is another way of saying that they would each catch fire and burn until precisely nothing was left of them, as though we had wiped them from the air with our hands.

How we wish that all disappearance was accomplished with gestures alone, so that pointing at birds would erase us. Simply by walking toward each other, we would make it possible for ourselves no longer to exist. How many of us would rise from our chairs if such a thing were possible, strap on our shoes, and head for the door, looking for those other person-like targets of oblivion to disappear against?

NOTES

Introduction

1. "Carroll Dunham Interviewed by Matthew Ritchie, February–June 2002," in *Carroll Dunham: Paintings* (New York: New Museum of Contemporary Art, with Hatje Cantz Verlag, Ostfildern-Ruit, Germany, 2002), 92.

Franz Ackermann

1. Franz Ackermann, "Metropolenstress o.ä.," interview by Eva Karcher, *Die Zeit* (Hamburg), May 8, 2002, 72.

2. *Tempted to Pretend: Versuchung, Verheißung, Täuschung* (Kaufbeuren, Germany: Das Kunsthaus, 2001).

Steve DiBenedetto

1. All quotes from author's conversation with the artist, December 10, 2004.

Carroll Dunham

1. "Carroll Dunham Interviewed by Matthew Ritchie, February–June 2002," in *Carroll Dunham: Paintings* (New York: New Museum of Contemporary Art, with Hatje Cantz Verlag, Ostfildern-Ruit, Germany, 2002), 19.

2. Author's conversation with the artist, January 10, 2005.

3. Carroll Dunham, *Land* (New York: Nolan/Eckman Gallery, 1998), n.p.

Ati Maier

1. Author's email communication with the artist, December 20, 2004.

Julie Mehretu

1. "Looking Back: Email Interview between Julie Mehretu and Olukemi Ilesanmi, April 2003," in Douglas Fogle and Olukemi Ilesanmi, *Julie Mehretu: Drawing into Painting* (Minneapolis: Walker Art Center, 2003), 11.

2. Ibid.

3. Ibid.

Matthew Ritchie

1. All quotes from author's conversation with the artist, January 17, 2005.

2. For an in-depth consideration of Ritchie's characters, their interaction, and their significance, see Lynn M. Herbert, *Matthew Ritchie: Proposition Player* (Houston: Contemporary Arts Museum Houston, 2003).

Alexander Ross

1. Alexander Ross, "Q&A 10.28.00," in *Alexander Ross* (New York: Feature Inc., c. 2000), 7.

2. One of Ross's sources of inspiration for the magnification of tiny forms is D'Arcy Thompson, *On Growth and Form* (1917), but Ross expands the idea to a general disturbance of scale.

3. Ross, "Q&A 10.28.00," 7.

4. Author's conversations with Hudson of Feature, Inc., and Alexander Ross, December 2004, suggested the rock analogy.

5. Parts of this sentence paraphrased from comments to the author by the artist.

6. Author's conversation with the artist.

Terry Winters

1. Terry Winters, interview by Adam Fuss, in *Terry Winters: Computation of Chains* (New York: Matthew Marks Gallery, 1997), 9.

2. Richard Shiff, "Manual Imagination," in Adam D. Weinberg, ed., *Terry Winters: Paintings, Drawings, Prints 1994–2004* (New Haven: Yale University Press, in association with Addison Gallery of American Art, Andover, Massachusetts, 2004), 18–33.

3. The analogies to figures and animation are the artist's. The contingency of numbers as communication is suggested by their literal appearance in some of Winters' recent prints.

4. See M. Catherine de Zegher, ed., *Untitled Passages by Henri Michaux* (New York: The Drawing Center, 2000). The quote is from author's conversation with the artist, January 12, 2005. The reference to poetry is the artist's own.

5. Ibid.

6. Winters, *Terry Winters*, 15.

Fields of Intuition

1. See, for example, Yve-Alain Bois et al., *Endgame* (Boston: The Institute of Contemporary Art, 1986); Kasper König and Peter Weibel, *Das Bild nach dem letzten Bild / The Picture after the Last Picture* (Vienna: Galerie Metropol, 1991); Suzanne Pagé et al., *Urgent Painting* (Paris: Musée d'Art Moderne de la Ville de Paris, 2002).

2. Frances Richard, reviewing an Alexander Ross exhibition in *Artforum*, March 2001, 144.

3. This startling and persuasive argument solves the mysteries long adduced to the Arnolfini portrait. See Margaret L. Koster, "The Arnolfini Double Portrait: A Simple Solution," *Apollo*, September 2003.

4. Attributed to Philip the Good, the powerful Duke of Burgundy whose court Jan van Eyck joined at Lille. See Robert Hughes, introduction to Hughes and Giorgio T. Faggin, *The Complete Paintings of the Van Eycks* (New York: Abrams, 1968), 5.

5. Alexander Ross, "Q&A 10.28.00," in *Alexander Ross* (New York: Feature Inc., c. 2000), 7, www.featureinc.com/artists_bios/rossqa.html.

6. It was Matthew Ritchie who suggested to me that a shared focus on personal topographies linked many of the artists shown here. I'm also indebted to the work of Winnie Wong for educating me on the aesthetics of gaming culture.

7. Tufte's books have been highly influential for Matthew Ritchie. See his *Visual Explanations, Envisioning Information* (1997), *The Visual Display of Quantitative Information* (1983), and his latest book, *Beautiful Evidence*.

8. Douglas Fogle, "The Occidental Tourist," *Parkett* 68 (2003): 23.

9. Einstein introduced (and then abandoned) the cosmological constant in order to explain why the universe is not expanding. His mathematical tool made it possible to introduce quantities that would show expansion, and in fact recent observations have shown an accelerating form of expansion that seems to confirm Einstein's original theory. See "New Evidence for Dark Energy in the Universe," Jodrell Bank Observatory Press Release, University of Manchester, United Kingdom, November 7, 2002: 11, www.jb.man.ac.uk/news/darkenergy.

10. I thank Peter Galison for his helpful conversations on the subject of flatness in space-time. See map.gsfc.nasa.gov/m_mm.html for an explanation of the WMAP project.

11. I take the phrase from Helen Frankenthaler's 1967 painting *The Human Edge*.

12. Now anthologized in Michael Fried, *Art and Objecthood* (Chicago: University of Chicago Press, 1998).

13. See in particular Ritchie's 2002 *Games of Chance and Skill*, an anamorphic image incorporating elements from seven different representational systems, stretching in three media across the sides and ceiling of a long corridor at MIT's Zesiger Center.

14. Here the work of James Gibson is important. See J.J. Gibson, *The Ecological Approach to Visual Perception* (Erlbaum, New Jersey: Hillsdale, 1979).

15. Ross, "Q&A 10.28.00." Duration and depth, these artists seem to suggest, can best be invoked by soliciting the viewer's movement, mobilizing the frozen tableau that "pictures" still intend.

16. The summa on this subject, Brian O'Doherty's 1976 *Inside the White Cube: The Ideology of the Gallery Space*, was recently reissued by the University of California Press (2000).

17. For a fuller discussion, see my *Eyesight Alone: Clement Greenberg's Modernism and the Bureaucratization of the Senses* (Chicago: University of Chicago Press, 2005).

18. See Richard Brilliant, *My Laocoön: Alternative Claims in the Interpretation of Artworks* (Berkeley: University of California Press, 2000), 10–11.

19. Roberta Smith, "Cracking the Same Mold with Different Results," *New York Times*, November 15, 2002, E2:38; Patricia Ellis, "Matthew Ritchie: That Sweet Voodoo That You Do," *Flash Art*, November–December 2000, 91; both cited in Lynn M. Herbert, "Knight of Infinity, Champion of Enlightenment," in *Matthew Ritchie: Proposition Player* (Houston: Contemporary Arts Museum Houston, 2003), 24.

20. The parsec is an astronomical unit, 3.09 x 1,016 meters. Megaparsecs would be an even larger scale, but these require utilizing the redshift, a dimensionless measurement of spectral lines distorted by speed, which can only be determined as a function of the ratio of velocity to the speed of light.

21. See Jones, *Eyesight Alone*.

22. Smithson, "Iconography of Desolation," in *The Collected Writings*, 323.

23. By "wet" Smithson meant the thinly painted (soaked) canvases of Color Field painting, which he found irredeemably romantic. See the section on "The Climate of Sight" in Smithson, "A Sedimentation of the Mind: Earth Projects," *Artforum*, September 1968, anthologized in Robert Smithson, *The Writings of Robert Smithson* (New York: New York University Press, 1979), 88, 89, et passim.

24. "Looking Back: Email Interview between Julie Mehretu and Olukemi Ilesanmi, April 2003," in Douglas Fogle and Olukemi Ilesanmi, *Julie Mehretu: Drawing into Painting* (Minneapolis: Walker Art Center, 2003), 14.

25. The instability of information is hinted at by Ritchie's title, which alludes to the quantum electrodynamical theory of the "fine structure constant." Typical of Ritchie's interests, the constant is "dimensionless" and specifies only the relation between quanta of energy represented by the spectral lines of elements such as hydrogen and helium. Because only discrete energy levels are available for observation at any one time, one must calculate where energy is at different moments: the principal quantum number, the azimuthal quantum number, the angular momentum quantum number, and so forth. Quantum theory is the way physicists capture and quantify the built-in uncertainty of our perceptions of the universe.

26. DiBenedetto, quoted by Dike Blair, "Artists on Artists: Steve DiBenedetto," *Bomb*, Spring 2003, 13.

27. Deleuze, *Le Pli: Leibniz et le baroque*, 1988, translated by Tom Conley, *The Fold: Leibniz and the Baroque* (Minneapolis: University of Minnesota Press, 1993), 85, emphasis added.

28. Robert Smithson, interviewed by Bruce Kurtz, "Conversation with Robert Smithson on April 22nd, 1972," *The Fox* II (1975): 72.

29. Smithson, "The Spiral Jetty," 1972, in *The Collected Writings*, 153, emphasis added. Transcriptions from the film's soundtrack are my own.

30. Rosalind Krauss, "Grids," *October* 9 (Summer 1979): 50–64. See also her *The Originality of the Avant-Garde and Other Modernist Myths* (Cambridge, Massachusetts: The MIT Press, 1985), 8–22.

31. Greenberg's observation of "hallucinated uniformity" was made in conjunction with the all-over paintings of Jackson Pollock and Janet Sobel: "This very uniformity, this dissolution of the picture into sheer texture, sheer sensation, into the accumulation of similar units of sensation, seems to answer something deep-seated in contemporary sensibility. [It is] a monist naturalism that takes all the world for granted and for which there are no longer either first or last things . . ." from "The Crisis of the Easel Picture," *Partisan Review*, April 1948, anthologized in Greenberg, *The Collected Essays and Criticism*, ed. John O'Brian (Chicago: University of Chicago Press, 1986) 2: 224.

Inside Out

1. Clement Greenberg, "The Present Prospects of American Painting and Sculpture," in *The Collected Essays and Criticism*, ed. John O'Brian (Chicago: University of Chicago Press, 1986) 2: 164.

2. Richard Shiff, "Evolution," in *Terry Winters: Paintings, Drawings, Prints 1994–2004* (New Haven: Yale University Press, 2004), 19.

3. Dike Blair, "Artists on Artists: Steve DiBenedetto," *Bomb*, Spring 2003, 13.

4. "Carroll Dunham Interviewed by Matthew Ritchie, February–June 2002," in *Carroll Dunham: Paintings* (New York: New Museum of Contemporary Art, with Hatje Cantz Verlag, Ostfildern-Ruit, Germany, 2002), 99.

5. "Reflections on an Omnivorous Visualization System: An Interview with Matthew Ritchie," interview by Thyrza Nichols Goodeve, in Lynn M. Herbert, *Matthew Ritchie: Proposition Player* (Houston: Contemporary Arts Museum Houston, 2003), 43; Terry Winters in Bob Holman, "Terry Winters," *Bomb*, Spring 1992, 44.

6. As cited in Blair, "Artists on Artists," 13.

7. "Carroll Dunham Interviewed," 99.

8. In this, contemporary writers echo Greenberg, who lamented that expressive American painting of the 1940s (of the kind he related to a romantic attitude) relied too much on "sensibility confined, intensified, and repeated." Greenberg, "Present Prospects," 166.

9. Shiff, "Evolution," 28.

10. Ross, "Q&A 10.28.00," in *Alexander Ross* (New York: Feature Inc., c. 2000), 7.

11. "Looking Back: Email Interview between Julie Mehretu and Olukemi Ilesanmi, April 2003," in Douglas Fogle and Olukemi Ilesanmi, *Julie Mehretu: Drawing into Painting* (Minneapolis: Walker Art Center, 2003), 13.

12. Ritchie, "Reflections," 43.

13. For an early reference to this concept, see Guy Debord, "Exercise in Psychogeography," *Potlatch* no. 2 (June 1954).

14. Christina Végh, "Majorca: Everything the Heart Desires: Travels with Franz Ackermann," in *Franz Ackermann: Kunsthalle Basel* (Basel: Kunsthalle Basel, 2002).

15. "Looking Back," 11.

16. Ritchie, "Reflections," 43.

17. Blair, "Artists on Artists," 13.

18 Maier, artist's statement.

19. Author's email communication with the artist, December 13, 2004.

WORKS IN THE EXHIBITION

As of April 1, 2005
Dimensions are in inches, followed by centimeters;
height precedes width precedes depth.

FRANZ ACKERMANN (b. 1963)

Paintings:

Untitled (evasion I), 1996
Oil on canvas
110 1/4 x 114 1/8 (280 x 290)
Collection of Dominique Lévy and Dorothy Berwin

Untitled (evasion II), 1996
Oil on canvas
74 3/4 x 42 1/4 (190 x 210)
Speyer Family Collection

Faceland/White Crossing 1, 2001
Mixed media on paper with wall painting
33 x 25 (84.5 x 64.5)
Collection of Martin and Rebecca Eisenberg

[Not yet titled], 2005
Oil on canvas
110 1/4 x 137 3/4 (280 x 350)
Courtesy Gavin Brown's Enterprise,
New York

Drawings:

Untitled (mental map: the last 30%), 1994
Watercolor and bandage on paper
5 1/8 x 7 1/2 (13 x 19)
Collection of Patricia and Morris Orden

What happens in house #7, 1994
Watercolor and bandage on paper
5 1/8 x 7 1/2 (13 x 19)
Collection of Patricia and Morris Orden

Untitled (mental map: center I), 1995
Mixed media on paper
5 1/8 x 7 1/2 (13 x 19)
Speyer Family Collection

Untitled (mental map: farm), 1995
Mixed media on paper
5 1/8 x 7 1/2 (13 x 19)
Speyer Family Collection

Untitled (mental map: guess where i was), 1995
Mixed media on paper
5 1/8 x 7 1/2 (13 x 19)
Speyer Family Collection

*Untitled (mental map: just another place
for riots III)*, 1995
Mixed media on paper
5 1/8 x 7 1/2 (13 x 19)
Speyer Family Collection

Untitled (mental map: studio), 1995
Mixed media on paper
5 1/8 x 7 1/2 (13 x 19)
Speyer Family Collection

*Untitled (mental map: 15 times around
the main spot)*, 1997
Mixed media on paper
5 x 7 (12.7 x 17.8)
Private collection

Untitled (mental map: in and out), 1997
Mixed media on paper
5 x 7 (12.7 x 17.8)
Collection of Lydia Winston Robinson

Untitled (mental map: saturday), 1997
Mixed media on paper
17 1/4 x 13 (43.8 x 33)
Collection of Nancy and Joel Portnoy

Untitled (mental map: sea view), 1997
Mixed media on paper
5 x 7 (12.7 x 17.8)
Collection of Terry Winters

*Passengers tried to get off—
had enough, had enough*, 1998
Gouache, watercolor, and graphite on paper
27 5/8 x 19 1/2 (70.2 x 49.5)
Collection of the artist

Passengers try to get on, 1998
Gouache, watercolor, and graphite on paper
27 5/8 x 19 1/2 (70.2 x 49.5)
Collection of the artist

Untitled (Former Tourist Information Center), 2000
Mixed media on paper
5 1/8 x 7 1/2 (13 x 19)
Collection of Martin and Rebecca Eisenberg

*Untitled (mental map: headquarters, restored,
(Cu Chi))*, 2000
Watercolor on paper
5 1/8 x 7 1/2 (13 x 19)
Hort Family Collection

Untitled (mental map: night in the universe), 2000
Watercolor and graphite on paper
7 1/2 x 5 1/8 (19 x 13)
Private collection

Untitled (mental map: plans for more trading), 2000
Watercolor and graphite on paper
5 1/8 x 7 1/2 (13 x 19)
Collection of Patricia and Morris Orden

All the countries of the world, 2001
Mixed media on paper
27 1/8 x 40 3/8 (69 x 100)
Collection of Dominique Lévy and Dorothy Berwin

The Cyclops in Hotel Botanico, 2001
Mixed media on paper
8 x 11 1/8 (20.5 x 28.2)
Collection of J.K. Brown and Eric Diefenbach

Die Enteignung (The Kop in Blue), 2001
Mixed media on paper
24 3/8 x 28 3/8 (62 x 72)
Hort Family Collection

Head from Top, 2001
Mixed media on paper
11 3/4 x 12 3/4 (30 x 32.5)
Ilene Kurtz-Kretzschmar and Ingo Kretzschmar

Hopeless reparation 2 (leaving), 2001
Mixed media on paper
26 5/8 x 19 1/4 (65 x 49)
Collection of Patricia and Morris Orden

Mr Horror comes to town, 2001
Mixed media on paper
10 1/4 x 8 1/2 (26 x 21.5)
Private collection

*747 delivering a piece of land of my hometown
(maybe they won't let it in)*, 2001
Mixed media on paper
9 x 11 3/4 (22.8 x 30)
Collection of Jeanne Greenberg-Rohatyn

Some miles under the ground, 2003
Graphite and gouache on paper
5 1/8 x 7 1/2 (13 x 19)
Collection of Morris Orden

Cut Eye, 2004
Mixed media on paper
9 1/4 x 7 1/8 (25.4 x 18)
Collection of Morris Orden

The Scene, 2004
Mixed media on paper
9 1/2 x 10 3/4 (24 x 27)
Collection of J.K. Brown and Eric Diefenbach

Under the garden, 2004
Mixed media on paper
5 1/8 x 7 1/2 (13 x 19)
Courtesy Gavin Brown's Enterprise, New York

*Untitled (Mental Map:
St. Gallen projection)*, 2004
Watercolor and graphite on paper
4 7/8 x 7 3/8 (12.4 x 18.7)
The Judith Rothschild Foundation, New York;
Contemporary Drawings Collection

STEVE DiBENEDETTO (b. 1958)

Paintings:

Charley Don't Surf, 1998–99
Oil on canvas
24 x 18 (61 x 45.7)
Baumgartner Gallery, New York

Apocalypse Brown, 1999
Oil on canvas
20 x 26 (50.8 x 66)
Collection of Burt Aaron

Dose, 1999
Oil on canvas
11 x 14 (27.9 x 35.6)
Collection of Daniel and Brooke Neidich;
courtesy Derek Eller Gallery, New York

New Amnesia, 2001
Oil on canvas
48 x 60 (121.9 x 152.4)
Collection of Burt Aaron

Octocopter, 2001–03
Oil on canvas
48 x 60 (121.9 x 152.4)
Collection of Paul Rickert;
courtesy Daniel Weinberg Gallery, Los Angeles

Diagram, 2002
Oil on canvas
24 x 19 3/4 (61 x 50.2)
Private collection;
courtesy Derek Eller Gallery, New York

Reverb, 2003
Oil on canvas
14 x 11 (35.6 x 27.9)

Collection of Richard and Cindy Plehn;
courtesy Derek Eller Gallery, New York

Visionary Diagram, 2003
Oil on canvas
15 3/4 x 11 3/4 (40 x 29.8)
Collection of Dr. Ron Low;
courtesy Derek Eller Gallery, New York

Breakup, 2003–04
Oil on canvas
48 x 60 (121.9 x 152.4)
Private collection;
courtesy Nolan/Eckman Gallery, New York

Codex (Ruins in Reverse), 2004–05
Oil on canvas
84 x 142 3/8 (213.4 x 361.6)
courtesy the artist

Drawings:
Disappearance, 2003
Colored pencil on paper
30 1/8 x 22 1/2 (76.5 x 57.2)
Collection of Geoff Wall and Ron Platt

Darkopter, 2004
Colored pencil on paper
22 1/2 x 30 1/8 (57.2 x 76.5)
The Judith Rothschild Foundation, New York;
Contemporary Drawings Collection

The Wizard, 2004
Colored pencil on paper
22 1/2 x 30 1/8 (57.2 x 76.5)
Collection of Morris Orden

Oztopus, 2004–05
Colored pencil on paper
30 1/8 x 22 1/2 (76.5 x 57.2)
Collection of the artist;
courtesy Nolan/Eckman Gallery, New York

Phased, 2004–05
Colored pencil on paper
22 1/2 x 30 1/8 (57.2 x 76.5)
Courtesy Derek Eller Gallery, New York

Rotation, 2004–05
Colored pencil on paper
22 1/2 x 30 1/8 (57.2 x 76.5)
Courtesy Derek Eller Gallery, New York

CARROLL DUNHAM (b. 1949)
Paintings:
Green Planet, 1996–97
Mixed media on canvas
84 x 66 (213.4 x 167.6)
Collection of Rachel and Jean-Pierre Lehmann

Solar Eruption, 2000–01
Mixed media on canvas
84 x 100 (213.4 x 254)
Collection of Sally and John Van Doren;
courtesy Greenberg Van Doren Gallery,
New York

Mesokingdom Fourteen (Edge of Night), 2002
Mixed media on canvas
96 x 93 (243.8 x 236.2)
Collection of Phil Schrager, Omaha

Region One, 2005
Mixed media on canvas
120 x 108 (304.8 x 274.3)
Courtesy the artist and Gladstone Gallery, New York

Drawings:
Untitled (1/20/02), 2002
Graphite on paper
6 1/4 x 8 1/4 (15.9 x 21)
Collection of Alvin Hall

Untitled (1/20/02), 2002
Graphite on paper
6 1/4 x 8 1/4 (15.9 x 21)
Collection of Alvin Hall

Untitled (1/20/02), 2002
Graphite on paper
6 1/4 x 8 1/4 (15.9 x 21)
Collection of Alvin Hall

12/18/03, 2003
Urethane and synthetic polymer on paper
30 1/2 x 21 1/8 (77.5 x 53.7)
Collection of the artist;
courtesy Nolan/Eckman Gallery, New York

Untitled, 2003
Ink and graphite on paper, thirteen parts
Dimensions variable
Collection of the artist;
courtesy Nolan/Eckman Gallery, New York

1/5/04, 2004
Urethane and synthetic polymer on paper
40 1/2 x 49 (102.9 x 124.5)
Collection of Melva Bucksbaum and Raymond Learsy

ATI MAIER (b. 1962)
Paintings:
Six Moon Red, 2002
Ink and wood stain on paper
7 1/2 x 7 1/2 (19 x 19)
Collection of the artist;
courtesy Pierogi, Brooklyn, New York

Blue Horses, 2003
Ink and wood stain on paper
7 1/2 x 7 1/2 (19 x 19)
Collection of the artist;
courtesy Pierogi, Brooklyn, New York

Boy Meets Girl, 2003
Ink and wood stain on paper
7 1/2 x 7 1/2 (19 x 19)
Collection of the artist;
courtesy Pierogi, Brooklyn, New York

Happy Day, 2003
Ink and wood stain on paper
7 1/2 x 7 1/2 (19 x 19)
Collection of the artist;
courtesy Pierogi, Brooklyn, New York

Le Vent Nous Portera, 2003
Ink and wood stain on paper
23 5/8 x 47 1/4 (60 x 120)
Private collection

The Other, 2003
Ink and wood stain on paper
23 5/8 x 84 (60 x 213.4)
Collection of Clifford Diver

Stellar Wind, 2003
Ink and wood stain on paper
7 1/2 x 7 1/2 (19 x 19)
Collection of the artist;
courtesy Pierogi, Brooklyn, New York

Sunshine and Starman, 2003
Ink and wood stain on paper
7 1/2 x 7 1/2 (19 x 19)
Collection of the artist;
courtesy Pierogi, Brooklyn, New York

Come, 2004
Ink and wood stain on paper
7 1/2 x 7 1/2 (19 x 19)
Collection of the artist;
courtesy Pierogi, Brooklyn, New York

The Day After, 2004
Ink and wood stain on paper
7 1/2 x 7 1/2 (19 x 19)
Collection of the artist;
courtesy Pierogi, Brooklyn, New York

Drop Your Gun, 2004
Ink and wood stain on paper
23 5/8 x 23 5/8 (60 x 60)
Geraldine Bergmeier Collection,
Halle/Saale, Germany; on permanent
loan to Museum der bildenden
Künste Leipzig, Leipzig

Flowers, 2004
Ink and wood stain on paper
7 1/2 x 7 1/2 (19 x 19)
Collection of the artist;
courtesy Pierogi, Brooklyn, New York

More, 2004
Ink and wood stain on paper
23 5/8 x 47 1/4 (60 x 120)
Collection of Carlo Bronzini Vender;
courtesy Pierogi, Brooklyn, New York

Phast, 2004
Ink and wood stain on paper
23 5/8 x 23 5/8 (60 x 60)
Collection of Jed and Jamie Kaplan

Quiet Stars, 2004
Ink and wood stain on paper
23 5/8 x 47 1/4 (60 x 120)
Collection of Sandro Rumney

West, 2004
Ink and wood stain on paper
7 1/2 x 7 1/2 (19 x 19)
Collection of the artist;
courtesy Pierogi, Brooklyn, New York

Cloud Watch, 2005
Ink and wood stain on paper
7 1/2 x 7 1/2 (19 x 19)
Collection of the artist;
courtesy Pierogi, Brooklyn, New York

Dark Matter, 2005
Ink and wood stain on paper
7 1/2 x 7 1/2 (19 x 19)
Collection of the artist;
courtesy Pierogi, Brooklyn, New York

Deep Space, 2005
Ink and wood stain on paper
7 1/2 x 7 1/2 (19 x 19)
Collection of the artist;
courtesy Pierogi, Brooklyn, New York

Lila, 2005
Ink and wood stain on paper
7 1/2 x 7 1/2 (19 x 19)
Collection of the artist;
courtesy Pierogi, Brooklyn, New York

Mind, 2005
Ink and wood stain on paper
7 1/2 x 7 1/2 (19 x 19)
Collection of the artist;
courtesy Pierogi, Brooklyn, New York

Stranger, 2005
Ink and wood stain on paper
7 1/2 x 7 1/2 (19 x 19)
Collection of the artist;
courtesy Pierogi, Brooklyn, New York

Sunspots, 2005
Ink and wood stain on paper
23 5/8 x 23 5/8 (60 x 60)
Collection of the artist;
courtesy Pierogi, Brooklyn, New York

Visit, 2005
Ink and wood stain on paper
7 1/2 x 7 1/2 (19 x 19)
Collection of the artist;
courtesy Pierogi, Brooklyn, New York

JULIE MEHRETU (b. 1970)

Painting:
The Seven Acts of Mercy, 2004
Ink and synthetic polymer on canvas
114 x 252 (289.6 x 640.1)
Collection of Dennis and Debra Scholl, Miami Beach;
courtesy The Project, New York and Los Angeles

Drawing:
[Not yet titled], 2005
Ink and graphite on canvas on wall
Dimensions variable
Courtesy the artist and The Project, New York
and Los Angeles

MATTHEW RITCHIE (b. 1964)

Paintings:
The Eighth Sea, 2002
Oil and felt-tip pen on canvas
99 x 121 (251.5 x 307.3)
Private collection; courtesy Andrea Rosen Gallery,
New York

The Measures I, 2005
Oil and felt-tip pen on canvas
Approximately 100 x 84 (254 x 213.4)
Courtesy Andrea Rosen Gallery, New York

The Measures II, 2005
Oil and felt-tip pen on canvas
Approximately 100 x 84 (254 x 213.4)
Courtesy Andrea Rosen Gallery, New York

The Measures III, 2005
Oil and felt-tip pen on canvas
Approximately 100 x 84 (254 x 213.4)
Courtesy Andrea Rosen Gallery, New York

The Measures IV, 2005
Oil and felt-tip pen on canvas
Approximately 100 x 84 (254 x 213.4)
Courtesy Andrea Rosen Gallery, New York

[Not yet titled], 2005
Synthetic polymer and felt-tip pen on wall
Dimensions variable

Sculpture:
The Universal Cell, 2004

Powder-coated aluminum, stainless
steel, and gypsum
132 x 150 x 150 (335.3 x 381 x 381)
Private collection, New York;
courtesy Andrea Rosen Gallery, New York

ALEXANDER ROSS (b. 1960)

Paintings:
Untitled, 2002
Oil on canvas
65 1/4 x 96 1/4 (165.7 x 244.5)
Collection of Sr. Leopoldo Villarreal Fernandez

Untitled, 2004
Oil on canvas
96 x 85 (243.8 x 215.9)
Collection of Dominique Lévy
and Dorothy Berwin

Untitled, 2004
Oil on canvas
68 x 120 1/2 (172.7 x 306.1)
The Nelson-Atkins Museum of Art, Kansas City,
Missouri (Purchase: acquired through the generosity
of the William T. Kemper Foundation—Commerce
Bank, Trustee) 2004.39

Untitled, 2004
Oil on canvas
68 x 80 (172.7 x 203.2) (shaped)
Collection of Gerard Droege

Untitled, 2005
Oil on canvas
65 1/4 x 96 1/4 (165.7 x 244.5)
Collection of the artist;
courtesy Feature Inc., New York

Drawings:
Untitled, 2002
Synthetic polymer over gouache on paper
59 1/2 x 51 3/4 (151.1 x 131.4)
Collection of Scott London

Untitled, 2002
Ink and graphite over synthetic polymer on paper
22 1/2 x 18 3/8 (57.2 x 46.7)
Private collection

Untitled, 2002
Watercolor, colored pencil,
and graphite over synthetic polymer on paper
22 1/2 x 20 (57.2 x 50.8)
Collection of Jeffrey Peabody

Untitled, 2004
Watercolor and graphite over
synthetic polymer on paper
30 1/2 x 23 (77.5 x 58.4)
Private collection;
courtesy Kevin Bruk Gallery, Miami

TERRY WINTERS (b. 1949)

Paintings:
Blue Sequences, 2005
Oil on canvas
93 1/2 x 121 (237.5 x 307.3)
Collection of the artist;
courtesy Matthew Marks Gallery, New York

Coding, 2005
Oil on canvas
76 1/2 x 99 (194.3 x 251.5)

Collection of the artist;
courtesy Matthew Marks Gallery, New York

Display Linkage, 2005
Oil on canvas
102 x 132 (259.1 x 335.3)
Collection of the artist;
courtesy Matthew Marks Gallery, New York

Drawings:
Untitled (1), 2004
Graphite on paper
22 1/2 x 30 (57.2 x 76.2)
Collection of the artist;
courtesy Matthew Marks Gallery, New York

Untitled (12), 2004
Graphite on paper
22 1/2 x 30 (57.2 x 76.2)
Collection of the artist;
courtesy Matthew Marks Gallery, New York

Untitled (13), 2004
Graphite on paper
22 1/2 x 30 (57.2 x 76.2)
Collection of the artist;
courtesy Matthew Marks Gallery, New York

Untitled (2 of 4), 2004
Graphite on paper
22 1/2 x 30 (57.2 x 76.2)
Private collection;
courtesy Matthew Marks Gallery, New York

Prints:
Turbulence Skins, 2004
Selections from a series of forty lithographs
on vellum; text by Ben Marcus
14 x 11 (35.6 x 27.9) each
Whitney Museum of American Art, New York;
purchase, with funds from the Print Committee
2005.21.1–9

The Influencing Machine, 2005
Lithographic trial proof with graphite additions;
text by Ben Marcus
30 x 41 1/2 (76.2 x 105.4)
Collection of the artist

ARTISTS' CHRONOLOGIES

■ FRANZ ACKERMANN

Born 1963 in Neumarkt St. Veit, Germany

1984–88 Akademie der Bildenden Künste, Munich

1989–91 Hochschule für Bildende Kunst, Hamburg

Lives and works in Berlin

Selected One-Artist Exhibitions

2005 *Nonstop with HHC*, Gavin Brown's Enterprise, New York

2004 *Travelantitravel*, Neugerriemschneider, Berlin

2003 *Franz Ackermann. Eine Nacht in den Tropen*, Kunsthalle Nürnberg, Nuremberg (catalogue)

Naherholungsgebiet, Kunstmuseum Wolfsburg, Wolfsburg, Germany (catalogue)

2002 *Transatlantic* (with Rupprecht Geiger), *26a Bienal de São Paulo: Território Livre*, Fundação Bienal de São Paulo; Städtische Galerie im Lenbachhaus und Kunstbau München, Munich (catalogue)

Eine Nacht in den Tropen, Kunsthalle Basel, Basel (catalogue)

Mai 36 Galerie, Zurich

Museo Nacional Centro de Arte Reina Sofia, Madrid (catalogue)

Franz Ackermann: The Waterfall, Museum of Contemporary Art, Chicago

Basel Public, Nordtangente, Basel

Franz Ackermann: Seasons in the Sun, Stedelijk Museum Amsterdam (catalogue)

2001 Gavin Brown's Enterprise, New York

Mercato 1/Mercato 2, Galleria Giò Marconi, Milan

2000 *B.I.T. (Back in Town—Di ritorno in città)*, Castello di Rivoli Museo d'Arte Contemporanea, Turin (catalogue)

Galeria Camargo Vilaça, São Paulo

Helicopter VIII (die Reiseterrassen von Basel), Kunsthalle Basel, Basel

Welt I . . . and no one else wanted to play, Meyer Riegger Galerie, Karlsruhe, Germany

1999 *Off*, Kasseler Kunstverein, Kassel, Germany (catalogue)

Trawler, Mai 36 Galerie, Zurich

Works on Paper, Inc., Los Angeles (catalogue)

1998 *Das Haus am Strand und wie man dorthin kommt*, Meyer Riegger Galerie, Karlsruhe, Germany

Songline, Neuer Aachener Kunstverein, Aachen, Germany (catalogue, in the form of a set of fifty postcards)

Pacific, White Cube, London

1997 *Unexpected*, Gavin Brown's Enterprise, New York

5%, Galleria Giò Marconi, Milan

Mai 36 Galerie, Zurich

Mental Maps, Portikus, Frankfurt am Main (catalogue)

Unerwartet, Städtische Galerie Nordhorn, Nordhorn, Germany (catalogue)

1996 Neugerriemschneider, Berlin

1995 Gavin Brown's Enterprise, New York

Thomas Solomon's Garage, Los Angeles

Selected Group Exhibitions

2004 *Global World/Private Universe*, Kunstmuseum St. Gallen, St. Gall, Switzerland (catalogue)

Treasure Island, 10 Jahre Sammlung Kunstmuseum, Kunstmuseum Wolfsburg, Wolfsburg, Germany

Champs de vision, Musée des Beaux-Arts, Rouen

Werke aus der Sammlung Boros, Museum für neue Kunst, Zentrum für Kunst und Medientechnologie, Karlsruhe, Germany (catalogue)

2003 *Berlin-Moskau/Moskau-Berlin 1950–2000*, Berliner Festspiele; Nationalgalerie, Staatliche Museen zu Berlin, die Kulturstiftung des Bundes; the Ministry of Culture of the Russian Federation; the Stas Namin Center, Moscow (organizers) (catalogue); traveled to: Martin-Gropius-Bau, Berlin; State Historical Museum, Moscow (2004)

Sogni e Conflitti. La dittatura dello spettatore, Biennale di Venezia, Venice

Un-built Cities, Bonner Kunstverein, Bonn (catalogue)

Heißkalt. Aktuelle Malerei aus der Sammlung Scharpff, Hamburger Kunsthalle, Hamburg; Staatsgalerie Stuttgart, Stuttgart (2004) (catalogue)

Outlook International Art Exhibition, Hellenic Culture Organization SA; Cultural Olympiad, Athens (catalogue)

Painting Pictures: Malerei und Medien im digitalen Zeitalter, Kunstmuseum Wolfsburg, Wolfsburg, Germany (catalogue)

Die Sehnsucht des Kartografen, Kunstverein Hannover, Hannover, Germany (catalogue)

GNS (Global Navigation System), Palais de Tokyo, Paris (catalogue)

Supernova: Art of the 1990s from the Logan Collection, San Francisco Museum of Modern Art (catalogue)

Away from Home, Wexner Center for the Arts, The Ohio State University, Columbus (catalogue)

2002 *Centre of Attraction: The 8th Baltic Triennial of International Art*, Contemporary Art Centre, Vilnius, Lithuania (catalogue)

25 Bienal de São Paulo: Iconografias Metropolitanas, Fundação Bienal de São Paulo

Psychodrome 02, Fundació Joan Miró, Barcelona

Reverberator, Houldsworth Gallery, London

Drawing Now: Eight Propositions, The Museum of Modern Art, New York (catalogue)

Kopfreisen: Jules Verne, Adolf Wölffli und andere Grenzgänger, Seedamm Kulturzentrum, Pfäffikon, Switzerland; Kunstmuseum Bern, Bern (catalogue)

2001 *Form Follows Fiction*, Castello di Rivoli Museo d'Arte Contemporanea, Turin (catalogue)

Comfort: Reclaiming Place in a Virtual World, Cleveland Center for Contemporary Art (catalogue)

Tempted to pretend—Versuchung, Verheißung, Täuschung, Kunsthaus Kaufbeuren, Kaufbeuren, Germany (catalogue)

Casino 2001: 1st Quadriënnale voor Hedendaagse Kunst, Stedelijk Museum

voor Actuele Kunst, Ghent, Belgium (catalogue)

Hybrids, Tate Liverpool (catalogue)

Painting at the Edge of the World, Walker Art Center, Minneapolis (catalogue)

2000 *Glee: Painting Now*, The Aldrich Museum of Contemporary Art, Ridgefield, Connecticut (catalogue); traveled to: Palm Beach Institute of Contemporary Art, Lake Worth, Florida (2001)

Malkunst, pittura d'oggi a Berlino, Fondazione Mudima, Milan (catalogue)

Re_public, Grazer Kunstverein, Graz, Austria; traveled to: Expo 2000 Hannover; Steirischer Herbst 2K, Graz

LKW Lebenskunstwerke—Kunst in der Stadt 4, Kunsthaus Bregenz, Bregenz, Austria (catalogue)

City-Index: Recherchen im urbanen Raum, Kunsthaus Dresden, Dresden (catalogue)

DAAD: Weltwärts, Kunstmuseum Bonn, Bonn

Close Up, Kunstverein Freiburg im Marienbad, Freiburg, Germany; Kunsthaus Baselland, Basel; Kunstverein Hannover, Hannover, Germany (2001) (catalogue)

1999 *Mirror's Edge*, Bildmuseet, Umeå Universitet, Umeå, Sweden (catalogue); traveled to: Vancouver Art Gallery (2000); Castello di Rivoli Museo d'Arte Contemporanea, Turin (2000); Tramway, Glasgow (2001)

Carnegie International, Carnegie Museum of Art, Pittsburgh (catalogue)

Drawn from Artists' Collections, The Drawing Center, New York (catalogue)

Officina Europa, Galleria d'Arte Moderna di Bologna, Bologna (catalogue)

Frieze, The Institute of Contemporary Art, Boston (catalogue)

Dream City, Kunstverein München, Munich (catalogue)

1997 *Kunstpreis der Böttcherstraße in Bremen*, Bonner Kunstverein, Bonn (catalogue)

Time Out, Kunsthalle Nürnberg, Nuremberg (catalogue)

Atlas Mapping— Künstler als Kartographen. Kartographie als Kultur, Offenes Kulturhaus Linz, Linz, Austria; Kunsthaus Bregenz/Magazin 4, Bregenz, Austria (1998) (catalogue)

Heaven: Private View, P.S.1 Contemporary Art Center, Long Island City, New York

■ STEVE DiBENEDETTO

Born 1958 in Bronx, New York

1980 BFA, Parsons School of Design, New York

Lives and works in New York

Selected One-Artist Exhibitions

2003 *Recent Paintings*, Daniel Weinberg Gallery, Los Angeles

2002 Derek Eller Gallery, New York

2001 Baumgartner Gallery, New York

2000 Baumgartner Gallery, New York

Galerie Rolf Ricke, Cologne

1998 Marella Arte Contemporanea, Sarnico, Italy

1997 Galerie Rolf Ricke, Cologne

RealiArteContemporanea, Brescia, Italy

1995 Marella Arte Contemporanea, Sarnico, Italy (catalogue)

Selected Group Exhibitions

2004 *Beat the Reaper!*, Allston Skirt Gallery, Boston

Earthly Delights, Sandra and David Bakalar Gallery, Massachusetts College of Art, Boston

Surface Tension, Chelsea Art Museum, New York

I Was in the House When the House Burned Down, Fredericks Freiser Gallery, New York

Under the Sun, Greener Pastures Contemporary Art, Toronto

Colored Pencil, KS Art, New York

Endless Love, DC Moore Gallery, New York

Curious Crystals of Unusual Purity, P.S.1 Contemporary Art Center, Long Island City, New York

Drawing out of the Void, Vestry Arts, Inc., New York (catalogue)

Pencil Me In, Geoffrey Young Gallery, Great Barrington, Massachusetts

Pickup Lines, Geoffrey Young Gallery, Great Barrington, Massachusetts

2003 *Invitational Exhibition of Painting and Sculpture*, The American Academy of Arts and Letters, New York

Twentieth Anniversary Exhibition, Gavin Brown's Enterprise, New York

Drawings, Derek Eller Gallery, New York

The Melvins, Anton Kern Gallery, New York

Before and after Science, Marella Arte Contemporanea, Milan

Unforeseen: Four Painted Predictions, PICA (Portland Institute for Contemporary Art), Oregon

Abstract per Se, Red Dot, New York

Giverny, Salon 94, New York

Inside Scoop, Geoffrey Young Gallery, Great Barrington, Massachusetts

The New Topography, Geoffrey Young Gallery, Great Barrington, Massachusetts

2002 *The Empire Strikes Back*, ATM Gallery, New York

Paintings, Gavin Brown's Enterprise, New York

Landscape, Derek Eller Gallery, New York

Desire, Galleria d'Arte Moderna, Bologna (catalogue)

Einfach Kunst. Sammlung Rolf Ricke, Neues Museum, Nuremberg

Transcendent and Unrepentant, Rosenwald-Wolf Gallery, The University of the Arts, Philadelphia

On Paper, Daniel Weinberg Gallery, Los Angeles

Ballpoint Inklings, Geoffrey Young Gallery, Great Barrington, Massachusetts; KS Art, New York (2003)

Need to Know Basis, Geoffrey Young Gallery, Great Barrington, Massachusetts

2001 *Best of the Season: Selected Highlights from the 2000–2001 Manhattan Exhibition Season*, The Aldrich Museum of Contemporary Art, Ridgefield, Connecticut

Luck of the Drawn, Geoffrey Young Gallery, Great Barrington, Massachusetts

Waiting List, Geoffrey Young Gallery, Great Barrington, Massachusetts

2000 *Drawings and Photographs: An Exhibition to Benefit the Foundation for Contemporary Performing Arts*, Matthew Marks Gallery, New York

To Detail, Geoffrey Young Gallery, Great Barrington, Massachusetts

1999 *Another Place*, Joseph Helman Gallery, New York

Another Country: The Constructed Landscape Part 2, Lawrence Rubin

Greenberg Van Doren Fine Art, New York

Kill All Lies, Luhring Augustine, New York

Post-Hypnotic, University Galleries, Illinois State University College of Fine Arts, Normal (catalogue); traveled to: The McKinney Avenue Contemporary, Dallas; Contemporary Arts Center, Cincinnati; Atlanta College of Art Gallery (2000); Chicago Cultural Center (2000); SECCA (Southeastern Center for Contemporary Art), Winston-Salem, North Carolina (2000); Tweed Museum of Art, University of Minnesota Duluth (2001); Philharmonic Center for the Arts, Naples, Florida (2001)

1998 *Dijon/le consortium.coll*, Centre Georges Pompidou, Paris (catalogue)

Pulse: Painting Now, Rare, New York

Paper View, Geoffrey Young Gallery, Great Barrington, Massachusetts

1997 *In-Form*, Bravin Post Lee Gallery, New York

They Came Here First!, Center on Contemporary Art, Seattle; traveled to: Bumbershoot Arts Festival, Seattle

Dissolution: Made in the USA, Laurent Delaye Gallery, London

Gnarleyand, Feature Inc., New York

1996 *Pre-Millennium Tensions*, Marella Arte Contemporanea, Sarnico, Italy

1995 *Altered States: American Art in the 90s*, Forum for Contemporary Art, St. Louis (catalogue)

The Joy of Painting, Here Arts Center, New York

New York—Positionen aktueller Malerei, Kunstverein Museum Schloß Morsbroich, Leverkusen, Germany

Pittura/Immedia: Malerei der 90er Jahre aus den USA und Europa, Neue Galerie Graz, Graz, Austria

Now Is the Time, Tony Shafrazi Gallery, New York

■ CARROLL DUNHAM

Born 1949 in New Haven, Connecticut

1972 Trinity College, Hartford, Connecticut

Lives and works in New York

Selected One-Artist Exhibitions

2004 c/o—Atle Gerhardsen, Berlin

He, She, and It, Gladstone Gallery, New York

Recent Drawings, Nolan/Eckman Gallery, New York

Carroll Dunham: Composite Image Paintings, Daniel Weinberg Gallery, Los Angeles

2003 *Personal Distance: New Paintings*, Baldwin Gallery, Aspen

White Cube, London (catalogue)

2002 *Meso-kingdom, The Search for Orgone*, c/o—Atle Gerhardsen, Berlin

Zeichnungen, Galerie Fred Jahn, Munich

Mesokingdom (Paintings), Metro Pictures, New York

Carroll Dunham: Paintings, New Museum of Contemporary Art, New York (catalogue)

Carroll Dunham: Drawings 1985–2002, Nolan/Eckman Gallery, New York

2001 *Carroll Dunham: New Paintings*, Gagosian Gallery Los Angeles, Beverly Hills

Recent Prints and Related Works, Galerie Fred Jahn Studio, Munich

The Search for Orgone, Nolan/Eckman Gallery, New York

2000 c/o—Atle Gerhardsen, Oslo

1999 Metro Pictures, New York

Carroll Dunham: Falk Visiting Artist, Weatherspoon Art Gallery, The University of North Carolina at Greensboro

1998 *Pink Planets*, c/o—Atle Gerhardsen, Oslo

Land and Houses: Two Sequences of Drawings, Nolan/Eckman Gallery, New York (catalogue)

Carroll Dunham: Integrated Paintings, White Cube, London

1997 Metro Pictures, New York

1996 *Zeichnungen*, Galerie Fred Jahn, Munich

Recent Drawing, Nolan/Eckman Gallery, New York

Carroll Dunham: Paintings and Drawings, Santa Barbara Contemporary Arts Forum (organizer) (catalogue); traveled to: Guild Hall Museum, Easthampton, New York; Santa Barbara Contemporary Arts Forum; Forum for Contemporary Art, St. Louis (1997)

1995 *Carroll Dunham: Selected Paintings, 1990–1995*, Barbara and Steven Grossman Gallery, School of the Museum of Fine Arts, Boston (catalogue)

Selected Group Exhibitions

2004 *Fabulism*, Joslyn Art Museum, Omaha (catalogue)

Fifth International Biennial. Disparities and Deformations: Our Grotesque, SITE Santa Fe (catalogue)

Articles and Waves, Geoffrey Young Gallery, Great Barrington, Massachusetts

Pencil Me In, Geoffrey Young Gallery, Great Barrington, Massachusetts

2003 *Drawings*, Metro Pictures, New York

We Love Painting: Contemporary American Art from the Misumi Collection, Museum of Contemporary Art, Tokyo

Funny Papers: Cartoons and Contemporary Drawings, Daniel Weinberg Gallery, Los Angeles

Inside Scoop, Geoffrey Young Gallery, Great Barrington, Massachusetts

The New Topography, Geoffrey Young Gallery, Great Barrington, Massachusetts

2002 *Bildnis und Figur: Zeichnungen und Druckgraphiken*, Galerie Fred Jahn Studio, Munich

New York Renaissance: Masterworks from the Whitney Museum of American Art, Whitney Museum of American Art, New York (organizer) (catalogue); traveled to: Palazzo Reale, Milan

Ballpoint Inklings, Geoffrey Young Gallery, Great Barrington, Massachusetts

Need to Know Basis, Geoffrey Young Gallery, Great Barrington, Massachusetts

2001 *Under Pressure: Prints from Two Palms Press*, Alexandra Muse and Pamela Auchincloss/Arts Management, New York (organizers), Lyman Allyn Museum of Art at Connecticut College, New London (catalogue); traveled to: Schick Art Gallery, Skidmore College, Saratoga Springs, New York; Pollock Gallery, Southern Methodist University, Dallas; Chautauqua Center for the Visual Arts, New York; University Gallery, University of Massachusetts at Amherst (2002); Arthur A. Houghton Jr. Gallery, The Cooper Union, New York (2003); Sonoma Museum of Visual Art, Santa Rosa, California (2003)

Some Options in Abstraction, Carpenter Center for the Visual Arts, Harvard University, Cambridge, Massachusetts

American Art from the Goetz Collection, Munich, Galerie Rudolfinum, Prague (catalogue)

Locating Drawing, Lawing Gallery, Houston

Pop and Post-Pop: Works on Paper, Texas Gallery, Houston

Luck of the Drawn, Geoffrey Young Gallery, Great Barrington, Massachusetts

2000 *Superorganic Hydroponic Warfare*, Derek Eller Gallery, New York

Arbeiten auf Papier, Galerie Michael Hasenclever, Munich

00, Barbara Gladstone Gallery, New York (catalogue)

Figure in the Landscape, Lehmann Maupin, New York

Open Ends, The Museum of Modern Art, New York (catalogue, *Modern Contemporary: Art at MoMA since 1980*)

End Papers: Drawings 1890–1900 and 1900–2000, Neuberger Museum of Art, Purchase College, State University of New York (catalogue)

The Figure: Another Side of Modernism, Newhouse Center for Contemporary Art, Staten Island, New York

Useful Indiscretions, Geoffrey Young Gallery, Great Barrington, Massachusetts

1999 *Art at Work: Forty Years of The Chase Manhattan Collection*, The Museum of Fine Arts, Houston; Contemporary Arts Museum Houston (catalogue); traveled to: Queens Museum of Art, New York (2000)

Examining Pictures, Whitechapel Art Gallery, London; Museum of Contemporary Art, Chicago (catalogue); traveled to: Hammer Museum, University of California, Los Angeles (2000)

The American Century: Art and Culture 1900–2000. Part 2, 1950–2000, Whitney Museum of American Art, New York (catalogue)

What Big Is, Geoffrey Young Gallery, Great Barrington, Massachusetts

1998 *Pop Surrealism*, The Aldrich Museum of Contemporary Art, Ridgefield, Connecticut (catalogue)

The New Surrealism, Pamela Auchincloss Project Space, New York

Codex USA: Works on Paper by American Artists, Entwistle, London

Painting: Now and Forever, Part 1, Pat Hearn Gallery, New York, and Matthew Marks Gallery, New York

Young Americans 2: New American Art at the Saatchi Collection, The Saatchi Gallery, London (catalogue)

Paper View, Geoffrey Young Gallery, Great Barrington, Massachusetts

1997 *Project Painting*, Basilico Fine Arts, New York, and Lehmann Maupin, New York (catalogue)

Abstract Painting, Carrie Haddad Gallery, Hudson, New York

Genius Loci: Hail Corn, Geoffrey Young Gallery, Great Barrington, Massachusetts

1996 *Addison Gallery of American Art: 65 Years*, Addison Gallery of American Art, Phillips Academy, Andover, Massachusetts (catalogue)

Pratiques Abstraites, Galerie Thaddaeus Ropac, Paris

Nuevas Abstracciones, Museu d'Art Contemporani de Barcelona; Museo Nacional Centro de Arte Reina Sofía, Madrid (catalogue); traveled to: Palacio de Velázquez, Madrid; Kunsthalle Bielefeld, Bielefeld, Germany

Thinking Print: Books to Billboards, 1980–95, The Museum of Modern Art, New York (catalogue)

Field Days, Cerulean Embankments, Geoffrey Young Gallery, Great Barrington, Massachusetts

96 Works on Paper, Geoffrey Young Gallery, Great Barrington, Massachusetts

1995 *1995 Biennial Exhibition*, Whitney Museum of American Art, New York (catalogue)

■ ATI MAIER

Born 1962 in Munich
1981–82 School of Visual Arts, New York
1981–82 Purchase College, State University of New York
1983–87 Hochschule für Angewandte Kunst, Vienna
Lives and works in Brooklyn, New York

Selected One-Artist Exhibitions

2003 *The Return*, Pierogi, Brooklyn, New York (catalogue)

2002 Dogenhaus Galerie Leipzig, Leipzig (catalogue)

1999 *Neue Arbeiten*, Dogenhaus Galerie Leipzig, Leipzig

1998 *Homesteads*, John Berggruen Gallery, San Francisco (catalogue)

1997 Galerie Agathe Nisple, St. Gall, Switzerland

1996 *Playgrounds*, Dogenhaus Galerie Berlin; Dogenhaus Galerie Leipzig

1995 Galerie Agathe Nisple, St. Gall, Switzerland

Selected Group Exhibitions

2004 *Public Notice: Painting in the Sculpture Park*, The Fields Sculpture Park at the Art Omi International Arts Center, Ghent, New York

Hier und jetzt, Galerie Anita Beckers, Frankfurt

Vacation Nation, Pierogi, Brooklyn, New York

Uncharted Territory: Subjective Mapping by Artists and Cartographers, Julie Saul Gallery, New York

First Happiness, University Art Museum, University at Albany, State University of New York (brochure)

2003 *Drawing on Landscape*, Gallery Joe, Philadelphia

In Heat, Pierogi, Brooklyn, New York

Pierogi Presents! The Best of Brooklyn Comes to Boston, Bernard Toale Gallery, Boston

Drawn 2, Barry Whistler Gallery, Dallas

2002 *Action at a Distance*, Galerie der Bezirksgemeinschaft Überetsch-Unterland, Neumarkt, Italy

Summer Drawing Show, Gallery Joe, Philadelphia

The Force, Gale Gates et al., Brooklyn, New York

Boiled or Fried, Pierogi, Brooklyn, New York

Summer Sweets, Barry Whistler Gallery, Dallas

2001 *Taking Stock at Gallery Joe*, Gallery Joe, Philadelphia

Markers: An Outdoor Banner Event of Artists and Poets for Venice Biennale 2001, International Artists' Museum; Municipality of Venice; La Biennale di Venezia, Italy (catalogue)

Gather and Tell, The Mexican Cultural Institute of New York (brochure)

Raum Hoch Drei, Wittgenstein-Haus, Vienna

2000 *Solitude in the Museum*, Akademie Schloß Solitude, Stuttgart (non-exhibiting); Musée d'art Moderne, Saint-Étienne, France; Staatsgalerie Stuttgart, Stuttgart

1998 *Sound*, Refusalon, San Francisco

1997 *Record: Six German Artists*, John Berggruen Gallery, San Francisco, in co-operation with Dogenhaus Galerie Leipzig/Berlin, Leipzig and Berlin (catalogue)

1996 *Ice Breakers*, Dogenhaus Galerie Berlin, Berlin

JULIE MEHRETU

Born 1970 in Addis Ababa, Ethiopia

1990–91 Université Cheikh Anta Diop, Dakar, Senegal

1992 BA, Kalamazoo College, Michigan

1997 MFA, honors, Rhode Island School of Design

Lives and works in New York

Selected One-Artist Exhibitions

2005 *Drawings*, The Project, New York

Currents 96: Julie Mehretu, Saint Louis Art Museum (brochure)

2004 *Julie Mehretu/Matrix 211: Manifestation*, Berkeley Art Museum, University of California (brochure)

Déjà-vu, Carlier | Gebauer, Berlin (brochure)

2003 *Julie Mehretu: Drawing into Painting*, Walker Art Center, Minneapolis (catalogue); traveled to: Palm Beach Institute of Contemporary Art, Lake Worth, Florida; Albright-Knox Art Gallery, Buffalo, New York (2004); CalArts Gallery at REDCAT, Valencia, California (2004)

2002 *Julie Mehretu: Renegade Delirium*, White Cube, London

2001 *Hudson (Show)Room Exhibition: Julie Mehretu*, ArtPace, San Antonio

The Project, New York

1999 *Module* (with Amy Brock), Project Row Houses, Houston

1998 *Recent Work*, Barbara Davis Gallery, Houston

1995 *Ancestral Reflections*, Archive Gallery, New York; Hampshire College Art Gallery, Amherst, Massachusetts

Selected Group Exhibitions

2004 *Firewall*, Ausstellungshalle zeitgenössische Kunst Münster, Münster, Germany (catalogue)

Back to Paint, C and M Arts, New York

Carnegie International, Carnegie Museum of Art, Pittsburgh (catalogue)

26a Bienal de São Paulo: Território Livre, Fundação Bienal de São Paulo

Africa Remix. Zeitgenössische Kunst eines Kontinents, Museum Kunst Palast, Düsseldorf; Hayward Gallery, London (2005); Centre Pompidou, Paris (2005); Mori Art Museum, Tokyo (2006) (catalogue)

2004 Biennial Exhibition, Whitney Museum of American Art, New York (catalogue)

2003 *Social Strategies: Redefining Social Realism*, Pamela Auchincloss/Arts Management, New York (organizer) (catalogue); traveled to: University Art Museum, University of California, Santa Barbara; University Art Galleries, Illinois State University, Normal; Richard E. Peeler Art Center at DePauw University, Greencastle, Indiana; Schick Art Gallery, Skidmore College, Saratoga Springs, New York (2004); The Newcomb Art Gallery, Tulane University, New Orleans (2004)

I Moderni/The Moderns, Castello di Rivoli Museo d'Arte Contemporanea, Turin (catalogue)

Project 244: MetaScape, The Cleveland Museum of Art (brochure)

Splat Boom Pow! The Influence of Cartoons in Contemporary Art, Contemporary Arts Museum Houston (catalogue); traveled to: The Institute of Contemporary Art, Boston; Wexner Center for the Arts, The Ohio State University, Columbus (2004)

Outlook International Art Exhibition, Hellenic Culture Organization SA; Cultural Olympiad, Athens (catalogue)

8. Uluslararasý Istanbul Bienali, Istanbul Kültür Sanat Vakfi (catalogue)

Prague Biennale 1, National Gallery Veletrzni Palac

Ethiopian Passages: Dialogues in the Diaspora, National Museum of African Art, Smithsonian Institution, Washington, DC

GNS (Global Navigation System), Palais de Tokyo, Paris (catalogue)

2002 *Busan Biennale 2002: Contemporary Art Exhibition*, Busan Metropolitan Art Museum, Busan, South Korea

Centre of Attraction: The 8th Baltic Triennial of International Art, Contemporary Art Centre, Vilnius, Lithuania (catalogue)

Terra Incognita: Contemporary Artists' Maps and Other Visual Organizing Systems, Contemporary Art Museum St. Louis

Stalder—Solakov—Mehretu, Kunstmuseum Thun, Thun, Switzerland (catalogue)

Urgent Painting, Musée d'Art Moderne de la Ville de Paris, Paris (catalogue)

Drawing Now: Eight Propositions, The Museum of Modern Art, New York (catalogue)

Out of Site: Fictional Architectural Spaces, New Museum of Contemporary Art, New York (catalogue); traveled to: Henry Art Gallery, University of Washington, Seattle

Wallow, The Project, New York

2001 *The Americans: New Art*, Barbican Gallery, London (catalogue)

Third Annual Altoids Curiously Strong Art Collection, New Museum of Contemporary Art, New York; traveled to: Consolidated Works, Seattle; The Lab, San Francisco; Los Angeles Contemporary Exhibitions; Art Center/South Florida, Miami; DiverseWorks, Houston

Casino 2001: 1st Quadriënnale voor Hedendaagse Kunst, Stedelijk Museum voor Actuele Kunst, Ghent, Belgium (catalogue)

For the Record: Julie Mehretu, Senam Okudzeto, and Nadine Robinson, The Studio Museum in Harlem, New York

Freestyle, The Studio Museum in Harlem, New York (catalogue)

Painting at the Edge of the World, Walker Art Center, Minneapolis (catalogue)

2000 *Architecture and Memory*, CRG Gallery, New York

Selections Fall 2000, The Drawing Center, New York

Architecture and Memory, Lawrence Rubin Greenberg Van Doren, New York

Cinco continentes y una ciudad/Five Continents and a City: International Painting Exhibition, Museo de la Ciudad de México, Mexico City (catalogue)

Glenn Brown, Julie Mehretu, Peter Rostovsky, The Project, New York

Greater New York: New Art in New York Now, P.S.1 Contemporary Art Center, Long Island City, with The Museum of Modern Art, New York (catalogue, online and CD-ROM)

1999 *Texas Draws*, Contemporary Arts Museum Houston (catalogue)

Sheer Abstraction, Barbara Davis Gallery, Houston

The Stroke, Exit Art, New York

Core 1999, The Glassell School of Art, The Museum of Fine Arts, Houston (catalogue)

Material, Process, Memory, The Jones Center for Contemporary Art, Austin (brochure)

Hot Spots: Los Angeles, Houston, Miami, Weatherspoon Art Gallery, The University of North Carolina at Greensboro (brochure); traveled to: Pittsburgh Center for the Arts

1998 *Millennium Fever*, DiverseWorks, Houston

Core 1998, The Glassell School of Art, The Museum of Fine Arts, Houston (catalogue)

■ MATTHEW RITCHIE

Born 1964 in London
1983–86 BFA, Camberwell School of Art, London
1982 Boston University, Boston
Lives and works in New York

Selected One-Artist Exhibitions

2005 *The God Impersonator*, The Fabric Workshop and Museum, Philadelphia

2004 *Matthew Ritchie: The Two-Way Shot*, Mario Diacono, Boston

2003 *Matthew Ritchie: After the Father Costume*, c/o—Atle Gerhardsen, Berlin

Matthew Ritchie: Proposition Player, Contemporary Arts Museum Houston (catalogue); traveled to: Mass MoCA (Massachusetts Museum of Contemporary Art), North Adams (2004)

2002 *Games of Chance and Skill*, Massachusetts Institute of Technology, Albert and Barrie Zesiger Sports and Fitness Center, Cambridge (permanent installation, brochure and artist's book)

Andrea Rosen Gallery, New York

2001 *Concentrations 38. Matthew Ritchie: The Slow Tide*, Dallas Museum of Art (artist's book)

Matthew Ritchie: The Family Farm, White Cube, London

2000 *Matthew Ritchie: The Fast Set*, Museum of Contemporary Art, North Miami (artist's book)

Parents and Children, Andrea Rosen Gallery, New York

1999 *The Working Group*, c/o—Atle Gerhardsen, Oslo

1998 *The Gamblers: It's Time to Play*, Basilico Fine Arts, New York (catalogue); traveled to: Galeria Camargo Vilaça, São Paulo; Mario Diacono, Boston (brochure)

Matthew Ritchie Pinturas, Paço Imperial, Rio de Janeiro

1997 *Omniverse*, Nexus Contemporary Art Center, Atlanta

1996 *The Hard Way, Chapter 1*, Galerie Météo, Paris (catalogue); *Chapter 2*, Basilico Fine Arts, New York; *Chapter 3*, c/o—Atle Gerhardsen, Oslo; www.adaweb.com

1995 *Working Model*, Basilico Fine Arts, New York

Selected Group Exhibitions

2004 *Monument to Now: The Dakis Joannou Collection*, DESTE Foundation for Contemporary Art, Athens

26a Bienal de São Paulo: Território Livre, Fundação Bienal de São Paulo

Fabulism, Joslyn Art Museum, Omaha (catalogue)

In Situ: Installations and Large-Scale Works in the Permanent Collection, Museum of Contemporary Art, North Miami

Drawing a Pulse, Jean Paul Slusser Gallery, University of Michigan School of Art and Design, Ann Arbor

Modus Operandi, Space in Progress, Thyssen-Bornemisza Art Contemporary, Vienna

Encounters in the 21st Century: Polyphony—Emerging Resonances, Twenty-first Century Museum of Contemporary Art, Kanazawa, Japan

2003 *Maleriet Tørker Aldri . . . Refleksjoner over Malerier i Astrup Fearnley Samlingen*, Astrup Fearnley Museet for Moderne Kunst, Oslo

Painting Pictures: Malerei und Medien im digitalen Zeitalter, Kunstmuseum Wolfsburg, Wolfsburg, Germany (catalogue)

Hands Up, Baby, Hands Up! 160 Jahre Oldenburger Kunstverein—160 Arbeiten auf Papier, Oldenburger Kunstverein, Oldenburg, Germany

GNS (Global Navigation System), Palais de Tokyo, Paris (catalogue)

2002 *(The World May Be) Fantastic*, Biennale of Sydney (catalogue)

Reality Check: Painting in the Exploded Field, Selections from the Vicki and Kent Logan Collection, CCAC Wattis Institute for Contemporary Arts, San Francisco (catalogue)

Sprawl, Contemporary Arts Center, Cincinnati

Reverberator, Houldsworth Gallery, London

Flights of Reality, Kettle's Yard, University of Cambridge, United Kingdom (catalogue); traveled to: Turnpike Gallery, Greater Manchester, United Kingdom

Urgent Painting, Musée d'Art Moderne de la Ville de Paris, Paris (catalogue)

Drawing Now: Eight Propositions, The Museum of Modern Art, New York (catalogue)

Exposition collective, Palais de Tokyo, Paris

Once upon a Time: Fiction and Fantasy in Contemporary Art, Selections from the Whitney Museum of American Art, Whitney Museum of American Art, New York (organizer); traveled to: New York State Museum, Albany

2001 *Form Follows Fiction*, Castello di Rivoli Museo d'Arte Contemporanea, Turin (catalogue)

All Systems Go, Contemporary Arts Museum Houston (catalogue)

Pictures, Patents, Monkeys, and More . . . On Collecting, Independent Curators International, New York (organizer) (catalogue); traveled to: Western Gallery, Western Washington University, Bellingham; John Michael Kohler Arts Center, Sheboygan, Wisconsin; Akron Art Museum; Fuller Museum of Art, Brockton, Massachusetts (2002); Institute of Contemporary Art, University of Pennsylvania, Philadelphia (2002); South Bend Regional Museum of Art, Indiana (2002); Pittsburgh Center for the Arts (2003)

Selections from the Permanent Collection, Museum of Contemporary Art, North Miami

Collaborations with Parkett: 1984 to Now, The Museum of Modern Art, New York (catalogue)

Futureland, Museum van Bommel van Dam, Venlo, Netherlands; Städtisches Museum Abteiberg, Mönchengladbach, Germany (catalogue)

The Mystery of Painting, Sammlung Goetz, Munich (catalogue)

010101: Art in Technological Times, San Francisco Museum of Modern Art (catalogue)

The World according to the Newest and Most Exact Observations: Mapping Art and Science, The Tang Teaching Museum and Art Gallery, Skidmore College, Saratoga Springs, New York (catalogue)

2000 *Faith: The Impact of Judeo-Christian Religion on Art at the Millennium*, The Aldrich Museum of Contemporary Art, Ridgefield, Connecticut (catalogue)

Museum—Sommerutstillingen 2000, Astrup Fearnley Museet for Moderne Kunst, Oslo

00, Barbara Gladstone Gallery, New York (catalogue)

Drawing Spaces, Rhona Hoffman Gallery, Chicago (brochure)

HyperMental: Wahnhafte Wirklichkeit 1950–2000. Von Salvador Dalí bis Jeff Koons, Kunsthaus Zürich, Zurich; Hamburger Kunsthalle, Hamburg (2001) (catalogue)

Figure in the Landscape, Lehmann Maupin, New York

Unnatural Science: An Exhibition, Mass MoCA (Massachusetts Museum of Contemporary Art), North Adams (catalogue)

Vision Machine, Musée des Beaux-Arts de Nantes, Nantes, France (catalogue)

Celebrating Modern Art: The Anderson Collection, San Francisco Museum of Modern Art (catalogue)

1999 *Best of the Season: Selected Work from the 1998–99 Manhattan Exhibition Season*, The Aldrich Museum of Contemporary Art, Ridgefield, Connecticut

Mythopoeia: Projects by Matthew Barney, Luca Buvoli, Matthew Ritchie, Cleveland Center for Contemporary Art (brochure and artist's book)

Cyber/Cypher, Mario Diacono, Boston (brochure)

Drawn by . . . , Metro Pictures, New York

Continued Investigation of the Relevance of Abstraction, Andrea Rosen Gallery, New York

Mondo immaginario: Projektionen und Pigmente, Shedhalle, Zurich

Conceptual Art as Neurobiological Praxis, Thread Waxing Space, New York

1998 *Codex USA: Works on Paper by American Artists*, Entwistle, London

Exploiting the Abstract, Feigen Contemporary, New York

Painting: Now and Forever, Part 1, Pat Hearn Gallery, New York, and Matthew Marks Gallery, New York

Parallel Worlds, SECCA (Southeastern Center for Contemporary Art), Winston-Salem, North Carolina

Hindsight, Whitney Museum of American Art, New York

1997 *Project Painting*, Basilico Fine Arts, New York, and Lehmann Maupin, New York (catalogue)

In-Form, Bravin Post Lee Gallery, New York

The Body of Painting, Mario Diacono, Boston (brochure)

New Work: Drawings Today, San Francisco Museum of Modern Art

1997 Biennial Exhibition, Whitney Museum of American Art, New York (catalogue)

1996 *A Scattering Matrix*, Richard Heller Gallery, Santa Monica (catalogue)

Between the Acts, Icebox, Athens (catalogue); traveled to: c/o—Atle Gerhardsen, Oslo

1995 *A Vital Matrix*, Domestic Setting, Los Angeles (catalogue)

■ ALEXANDER ROSS

Born 1960 in Denver, Colorado

1983 Massachusetts College of Art, Boston

Lives and works in New York and the Berkshires, Massachusetts

Selected One-Artist Exhibitions

2005 Feature Inc., New York

2003 *New Paintings*, Kevin Bruk Gallery, Miami

Feature Inc., New York

2002 Feature Inc., New York

Alexander Ross: Recent Paintings, Daniel Weinberg Gallery, Los Angeles

2001 Kevin Bruk Gallery, Miami

2000 Feature Inc., New York (catalogue)

1999 Mary Boone Gallery, New York

1998 Feature Inc., New York

Selected Group Exhibitions

2004 *Invitational Exhibition of Painting and Sculpture*, The American Academy of Arts and Letters, New York

Drawing 2 (Selected), G-module, Paris

Colored Pencil, KS Art, New York

Endless Love, DC Moore Gallery, New York (brochure)

Abstract Reality, Sead Gallery, Antwerp

Fifth International Biennial. Disparities and Deformations: Our Grotesque, SITE Santa Fe (catalogue)

About Painting, The Tang Teaching Museum and Art Gallery, Skidmore College, Saratoga Springs, New York

2003 *Nature Boy*, Elizabeth Dee Gallery, New York

Mighty Graphitey, Feature Inc., New York

Online, Feigen Contemporary, New York

Giverny, Salon 94, New York

2002 *Exhibition of Work by Newly Elected Members and Recipients of Honors and Awards*, The American Academy of Arts and Letters, New York

Invitational Exhibition of Painting and Sculpture, The American Academy of Arts and Letters, New York

Miss Univers, Art : Concept, Paris

Everybody Knows This Is Nowhere, Kevin Bruk Gallery, Miami

Print Publisher's Spotlight: Solo Impression, Barbara Krakow Gallery, Boston

Painting and Illustration, Luckman Gallery, California State University, Los Angeles

Plotting; A Survey Exhibition of Artist Studies, Carrie Secrist Gallery, Chicago (catalogue)

On Paper, Daniel Weinberg Gallery, Los Angeles

Ballpoint Inklings, Geoffrey Young Gallery, Great Barrington, Massachusetts; KS Art, New York (2003)

Phenomena, Geoffrey Young Gallery, Great Barrington, Massachusetts

2001 *Painting/Not Painting*, White Columns, New York

Synth, White Columns, New York

Luck of the Drawn, Geoffrey Young Gallery, Great Barrington, Massachusetts

2000 *Alex 8*, Kevin Bruk Gallery, Miami

Superorganic Hydroponic Warfare, Derek Eller Gallery, New York

Grok Terence McKenna Dead, Feature Inc., New York

Hairy Forearm's Self-Referral, Feature Inc., New York

Drawing, Stephen Friedman Gallery, London

00, Barbara Gladstone Gallery, New York (catalogue)

M du B, F, H & g, Montreal

Almost Something: Depictive Abstraction, Catherine Moore Fine Art, New York

Greater New York: New Art in New York Now, P.S.1 Contemporary Art Center, Long Island City, with The Museum of Modern Art, New York (catalogue, online and CD-ROM)

Paper Trail Pt. 2, Shaheen Modern and Contemporary Art, Cleveland

ANP City Projects, Cokkie Snoei, Rotterdam

7 Young American Artists, Wetterling Gallery, Stockholm

Useful Indiscretions, Geoffrey Young Gallery, Great Barrington, Massachusetts

1999 *1999 Drawings*, Alexander and Bonin, New York

Drawings, Feature Inc., New York

Stephen Friedman Gallery, London

curious.parking@stupendous.strawberry, Galerie S & H De Buck, Ghent, Belgium

Cookie Snow Feature, Cokkie Snoei, Rotterdam

Pictorial Abstraction, Part 1, Temple Gallery, Tyler School of Art, Philadelphia

What Big Is, Geoffrey Young Gallery, Great Barrington, Massachusetts

1998 *WOp (Works on/of Paper)*, ANP, Antwerp

View (Three), Mary Boone Gallery, New York

Spectacular Optical, Thread Waxing Space, New York (catalogue); traveled to: Museum of Contemporary Art, North Miami; CU Arts Galleries, University of Colorado at Boulder (1999)

Art on Paper, Weatherspoon Art Museum, The University of North Carolina at Greensboro

1997 *Swamp Thing*, Salon 75, Brooklyn, New York

New American Talent: The Thirteenth Exhibition, Texas Fine Arts Association (organizer) (catalogue); traveled to: University of North Texas Art Gallery, Denton; Texas Fine Arts Association at CenterSpace, Austin (1998)

1996 *AbFab*, Feature Inc., New York

Alexander Ross, Michelle Lopez, Feature Inc., New York

1995 Mitchell Algus Gallery, New York

■ TERRY WINTERS

Born 1949 in Brooklyn

1971 BFA, Pratt Institute, Brooklyn, New York

Lives and works in New York and Columbia County, New York

Selected One-Artist Exhibitions

2004 *Terry Winters Paintings, Drawings, Prints 1994–2004*, Addison Gallery of American Art, Phillips Academy, Andover, Massachusetts (catalogue); traveled to: Museum of Contemporary Art, San Diego, Downtown (2005), Contemporary Arts Museum Houston (2005)

Terry Winters 1981–1986, Matthew Marks Gallery, New York (catalogue)

Terry Winters: Local Group/New Works on Paper, Pratt Manhattan Gallery, New York (catalogue)

2003 *Terry Winters: Paintings and Drawings*, Matthew Marks Gallery, New York

Turbulence Skins: Working Proofs, collaborative project between Terry Winters and Ben Marcus, LeRoy Neiman Gallery, Columbia University, New York

Terry Winters: Zeichnungen/Drawings, Staatliche Graphische Sammlung München, Pinakothek der Moderne, Munich (catalogue)

2002 Galerie Fred Jahn, Munich

Margo Leavin Gallery, Los Angeles

2001 *Set Diagram*, Lehmann Maupin, New York

Terry Winters/Drawings, Matthew Marks Gallery, New York (catalogue)

Terry Winters: Printed Works, The Metropolitan Museum of Art, New York (catalogue)

Terry Winters: Paintings, White Cube², London

2000 *Location Plan*, Susan Inglett Gallery, New York

Kunsthalle, Basel (catalogue)

1999 Fogg Art Museum, Harvard University, Cambridge, Massachusetts (brochure)

Terry Winters: Arbeiten auf Papier, Galerie Fred Jahn, Munich

Terry Winters Graphic Primitives, Matthew Marks Gallery, New York (catalogue)

Trisha Brown and Terry Winters: Works on Paper, collaborative project, Mass MoCA (Massachusetts Museum of Contemporary Art), North Adams

1998 *Prints by Terry Winters: A Retrospective from the Collection of Robert and Susan Sosnick*, The Detroit Institute of Arts

IVAM Centre del Carme, Valencia, Spain (catalogue); traveled to: Whitechapel Art Gallery, London (1999)

Terry Winters: Folio, Victoria and Albert Museum, London

Terry Winters: Graphic Primitives, White Cube, London

1997 Galerie Samia Saouma, Paris

Terry Winters: Early Works, Akira Ikeda Gallery, Tokyo

Terry Winters: Computation of Chains, Matthew Marks Gallery, New York (catalogue)

Terry Winters: Recent Works, School of the Museum of Fine Arts, Boston (catalogue)

1996 *Terry Winters Drawings 1996*, Galerie Lawrence Rubin, Zurich (catalogue)

Galerie Max Hetzler, Berlin

1995 *Terry Winters: Foundations and Systems*, Galerie Fred Jahn, Munich (catalogue)

Terry Winters: Drawings, Sonnabend Gallery, New York

Selected Group Exhibitions

2004 *Fresh: Works on Paper, a Fifth Anniversary Exhibition*, James Kelly Contemporary, Sante Fe

2003 *Visions and Revisions: Art on Paper since 1960*, Museum of Fine Arts, Boston

2002 *Trisha Brown: Dance and Art in Dialogue, 1961–2001*, Addison Gallery of American Art, Phillips Academy, Andover, Massachusetts (catalogue); traveled to: The Tang Teaching Museum and Art Gallery at Skidmore College, Saratoga Springs, New York (2003); Contemporary Arts Museum Houston (2003); New Museum of Contemporary Art, New York (2003); Henry Art Gallery, University of Washington, Seattle (2004)

Drawn from a Family: Contemporary Works on Paper, Colby College Museum of Art, Waterville, Maine (catalogue)

From Twilight to Dawn: Postmodern Art from the UBS PaineWebber Art Collection, Frist Center for the Visual Arts, Nashville (catalogue)

Premio Biella per l'incisione 2002, Museo del Territorio Biellese, Biella, Italy (catalogue)

The 177th Annual: An Invitational Exhibition, National Academy Museum, New York (catalogue)

New York Renaissance: Masterworks from the Whitney Museum of American Art, Whitney Museum of American Art, New York (organizer) (catalogue); traveled to: Palazzo Reale, Milan

2001 *Under Pressure: Prints from Two Palms Press*, Alexandra Muse and Pamela Auchincloss/Arts Management, New York (organizers), Lyman Allyn Museum of Art at Connecticut College, New London (catalogue); traveled to: Schick Art Gallery, Skidmore College, Saratoga Springs, New York; Pollock Gallery, Southern Methodist University, Dallas; Chautauqua Center for the Visual Arts, Chautauqua,

New York; University Gallery, University of Massachusetts at Amherst (2002); Arthur A. Houghton Jr. Gallery, The Cooper Union, New York (2003); Sonoma Museum of Visual Art, Santa Rosa, California (2003)

American Identities: A New Look, Brooklyn Museum of Art, New York

Thirty-five Drawings, Richard Gray Gallery, Chicago (catalogue)

Tenth Anniversary Exhibition: 100 Drawings and Photographs, Matthew Marks Gallery, New York (catalogue)

Works on Paper from Acconci to Zittel, Victoria Miro Gallery, London

Mythic Proportions: Painting in the 1980s, Museum of Contemporary Art, North Miami (catalogue)

Repetition in Discourse, The Painting Center, New York

2000 *An American Focus: The Anderson Graphic Arts Collection*, Fine Arts Museums of San Francisco, California Palace of the Legion of Honor (catalogue); traveled to: M.H. de Young Memorial Museum, San Francisco; Palm Springs Desert Museum, California (2001); Albuquerque Museum (2001)

Druckgraphische Trouvaillen, Galerie Franke, Stuttgart

Arbeiten auf Papier, Galerie Michael Hasenclever, Munich

00, Barbara Gladstone Gallery, New York (catalogue)

Paintings, I Love, Michael Hue-Williams Fine Art Limited, London

Hard Pressed: 600 Years of Prints and Process, International Print Center (organizer) (catalogue); traveled to: AXA Gallery, New York; Boise Art Museum (2001); Museum of Fine Arts, Santa Fe (2001); Naples Museum of Fine Art, Florida (2001)

Open Ends, The Museum of Modern Art, New York (catalogue, *Modern Contemporary: Art at MoMA since 1980*)

Lasting Impressions: Contemporary Prints from the Bruce Brown Collection, Portland Museum of Art, Maine (catalogue)

Celebrating Modern Art: The Anderson Collection, San Francisco Museum of Modern Art (catalogue)

1999 *To the Rescue: Eight Artists in an Archive*, American Jewish Joint Distribution Committee (organizer) (catalogue); traveled to: The International Center of Photography, New York; Contemporary Arts Museum Houston (2000); Miami Art Museum (2000); The Contemporary Jewish Museum, San Francisco (2000)

20 Years/20 Artists, Aspen Art Museum (catalogue)

American Paintings after 1950, Fogg Art Museum, Harvard University, Cambridge, Massachusetts

Art at Work: Forty Years of The Chase Manhattan Collection, The Museum of Fine Arts, Houston; Contemporary Arts Museum Houston (catalogue); traveled to: Queens Museum of Art, New York (2000)

The American Century: Art and Culture 1900–2000. Part II, 1950–2000, Whitney Museum of American Art, New York (catalogue)

1998 *Paper +: Works on Dieu Donné Paper*, The Gallery at Dieu Donné Papermill, New York (brochure)

Artists on Line for Acor, Gagosian Gallery, New York

Painting: Now and Forever, Part 1, Pat Hearn Gallery, New York, and Matthew Marks Gallery, New York

Master Drawings of the Twentieth Century, Mitchell-Innes and Nash, New York (catalogue)

Elements of the Natural: 1950–1992, The Museum of Modern Art, New York

Young Americans 2: New American Art at the Saatchi Gallery, The Saatchi Gallery, London (catalogue)

Von Baselitz bis Winters: Vermächtnis Bernd Mittelsten Scheid, Staatliche Graphische Sammlung München, Munich (catalogue)

1997 *Proof Positive: Forty Years of Contemporary American Printmaking at ULAE, 1957–1997*, The Corcoran Gallery of Art, Washington, DC; Universal Limited Art Editions, West Islip, New York (catalogue); traveled to: Sezon Museum of Art, Tokyo (1998); Kitakyushu Municipal Museum of Art, Japan (1998)

Spiders and Webs, Barbara Krakow Gallery, Boston

Eight Paintings, Luhring Augustine, New York

Icon/Iconoclast, Marlborough Chelsea, New York

The View from Denver: Amerikanische Gegenwartskunst aus dem Denver Art Museum, Museum Moderner Kunst Stiftung Ludwig Wien, Vienna (catalogue)

Views from Abroad: European Perspectives on American Art 3. American Realities, Whitney Museum of American Art, New York (catalogue)

1996 *Family Values: Amerikanische Kunst der achtziger und neunziger Jahre, Die Sammlung Scharpff in der Hamburger Kunsthalle*, Hamburger Kunsthalle, Hamburg (catalogue)

On Paper, Marlborough Gallery, New York (catalogue); traveled to: Galería Marlborough, Madrid

Nuevas Abstracciones, Museu d'Art Contemporani de Barcelona; Museo Nacional Centro de Arte Reina Sofía, Madrid (catalogue); traveled to: Palacio de Velázquez, Madrid; Kunsthalle Bielefeld, Bielefeld, Germany

Thinking Print: Books to Billboards, 1980–95, The Museum of Modern Art, New York (catalogue)

The Robert and Jane Meyerhoff Collection, National Gallery of Art, Washington, DC (catalogue)

1995 *Printmaking in America: Collaborative Prints and Presses, 1960–1990*, Mary and Leigh Block Gallery, Northwestern University, Evanston, Illinois (organizer) (catalogue); traveled to: The Jane Voorhees Zimmerli Art Museum, Rutgers, The State University of New Jersey, New Brunswick; Mary and Leigh Block Gallery, Northwestern University, Evanston, Illinois; The Museum of Fine Arts, Houston (1996); National Museum of American Art, Smithsonian Institution, Washington, DC (1996)

[Yamantaka Donation] An Exhibition to Benefit Tibet House of New York, Gagosian Gallery, New York

25 Americans: Painting in the 90s, Milwaukee Art Museum (catalogue)

Art Works: The PaineWebber Collection of Contemporary Masters, The Museum of Fine Arts, Houston (brochure); traveled to: The Detroit Institute of Arts; Museum of Fine Arts, Boston (1996); The Minneapolis Institute of Arts (1996); San Diego Museum of Art (1996); Center for the Fine Arts, Miami (1997)

Repicturing Abstraction: Basic Nature, Richmond Curatorial Project (organizer) (catalogue); traveled to: 1708 Gallery, Richmond, Virginia

1995 Biennial Exhibition, Whitney Museum of American Art, New York (catalogue)

Reinventing the Emblem: Contemporary Artists Re-create a Renaissance Idea, Yale University Art Gallery, New Haven, Connecticut (catalogue)

ARTISTS' BIBLIOGRAPHIES

■ **FRANZ ACKERMANN**

Selected books, exhibition catalogues, and brochures

Beccaria, Marcella. *Franz Ackermann: B.I.T.* Exhibition catalogue. Turin: Castello di Rivoli Museo d'Arte Contemporanea, 2000.

Coelewij, Leontine, and Gregor Jansen. *Franz Ackermann: Seasons in the Sun.* Exhibition catalogue. Amsterdam: Stedelijk Museum, 2002.

Friedel, Helmut, and Anuschka Koos. *Franz Ackermann/Rupprecht Geiger: Transatlantic. Bienal de São Paulo 2002.* Exhibition catalogue. Munich: Städtische Galerie im Lenbachhaus, 2002.

Grosenick, Uta, and Burkhard Riemschneider, eds. *Art Now.* Cologne: Taschen, 2001.

Kasseler Kunstverein; essay by Raimar Stange. *Franz Ackermann: Off.* Exhibition catalogue. Kassel, Germany: Kasseler Kunstverein, with Walther König, Cologne, 1999.

Lütgens, Annelie, ed.; essays by Michael Glasmeier, Annelie Lütgens, and Carmela Thiele. *Naherholungsgebiet.* Exhibition catalogue. Wolfsburg, Germany: Kunstmuseum Wolfsburg, 2003.

Molon, Dominic. "Franz Ackermann." In Thomas Bayrle et al., *Vitamin P: New Perspectives in Painting*, 16. London: Phaidon Press, 2002.

Pakesch, Peter, and Christina Végh. *Franz Ackermann: Kunsthalle Basel.* Exhibition catalogue. Basel: Kunsthalle Basel, 2001.

Portikus; essay by Harald Fricke. *Franz Ackermann: Mental Maps.* Exhibition catalogue. Frankfurt am Main: Portikus, 1997.

Seifermann, Ellen, and Raimar Stange. *Franz Ackermann: Eine Nacht in den Tropen.* Exhibition catalogue. Nuremberg: Kunsthalle Nürnberg, 2003.

Stange, Raimar. *Zurück in die Kunst.* Hamburg: Rogner und Bernhard bei Zweitausendeins, 2003.

Works on Paper, Inc. *Franz Ackermann.* Exhibition catalogue. Los Angeles: Works on Paper, Inc., 1999.

Selected articles and reviews

Ackermann, Franz. "Franz Ackermann: Dissolving into the Everyday." Interview by Wolf-Günter Thiel and Milena Nikolova. *Flash Art*, January–February 2001, 78–82.

———. "Metropolenstress o.ä." Interview by Eva Karcher. *Die Zeit* (Hamburg), May 8, 2002, 72.

———. "Schöne neue Urlaubswelt." Interview by Birgit Sonna. *Süddeutsche Zeitung* (Munich), April 6, 1999.

———. "Wish You Were Here." Translated by Michael Robinson. *Frieze* 44 (February 1999): 37–38.

Balkenhol, Bernhard. "Franz Ackermann: I Can't Remember." Review, Kasseler Kunstverein. *Fridericianum Magazin* 3 (Fall 1999): 22–24.

Beil, Ralf. "Atlas Mapping." Review, Offenes Kulturhaus Linz; Kunsthaus Bregenz/Magazin 4. *Kunstforum International* 141 (July–September 1998): 412–15.

Burger, Jörg. "Kaputt, dreckig und voller Ideen." *Die Zeit* (Hamburg), January 22, 2004, 53.

Christofori, Ralf. "In Bildern reisen." Review, Kunsthalle Basel. *Frankfurter Allgemeine Zeitung*, February 27, 2002, 51.

Clewing, Ullrich. "4. Art–Herbstsalon. Junge Kunst: Statt neuer Ideen am liebsten neue Bilder. Franz Ackermann: Reisen ins lilagelbe Blütenmeer." *Art*, October 1996, 56.

Conti, Tiziana. "Franz Ackermann." Review, Castello di Rivoli Museo d'Arte Contemporanea. *Tema Celeste* 83 (2001): 89.

Cotter, Holland. "Franz Ackermann." Review, Gavin Brown's Enterprise. *New York Times*, January 2, 1998, E2:41.

Decter, Joshua. "Ackermann Hallucinating Maps/Landkarten wie Halluzinationen." *Parkett* 68 (2003): 32–45.

———. "Franz Ackermann." Review, Thomas Solomon's Garage. *Artforum*, November 1995, 96–97.

Denk, Andreas. "Franz Ackermann: Songline." Review, Neuer Aachener Kunstverein. *Kunstforum International* 140 (April–June 1998): 390–92.

Flash Art. "Curating Painting: A Panel Discussion with Peter Pakesch, Douglas Fogle, and Lauri Firstenberg." November–December 2002, 59–61.

Fogle, Douglas. "The Occidental Tourist/Die Reisen des Franz Ackermann und der abendländische Tourismus." *Parkett* 68 (2003): 20–29.

Gleadell, Colin. "Smash Hits." *Art Review*, March 2004, 38, 40.

Heidenreich, Stefan. "Pflummis, springt auf diese Stadt!" *Frankfurter Allgemeine Zeitung*, January 2, 2001, BS3.

Heiser, Jörg. "Mirror's Edge." Review, Bildmuseet. *Frieze* 51 (March–April 2000): 106–07.

———. "Travelling Light." *Frieze* 66 (April 2002): 54–57.

Herzog, Samuel. "Opulent verpflegt von Insel zu Insel hüpfen." Review, Kunsthalle Basel. *Basler Zeitung* (Basel), January 19, 2002.

Hinrichsen, Jens. "Mit dem Pinsel um die Welt." Review, Kunstmuseum Wolfsburg. *Der Tagesspiegel* (Berlin), April 17, 2003, archiv.tagesspiegel.de/archiv/17.04.2003/531606.asp.

Johnson, Ken. "Franz Ackermann: 'Nonstop with HHC.'" Review, Gavin Brown's Enterprise. *New York Times*, January 7, 2005, E43.

Karcher, Eva. "Traumstadtsplitter." *Der Tagesspiegel* (Berlin), April 9, 1999.

Keil, Frank. "Der Kartograph." Review, Kunstmuseum Wolfsburg. *Frankfurter Rundschau*, May 23, 2003, 10.

Kotteder, Franz. "Entzauberung der Traumstadt." Review, Kunstverein München. *Süddeutsche Zeitung* (Munich), March 25, 1999.

Lapp, Axel. "Franz Ackermann." Review, Kunstmuseum Wolfsburg. *Art Review*, July–August 2003, 95.

Liebs, Holger. "Der Stadtraum—unendliche Weiten." Review, Städtische Galerie im Lenbachhaus und Kunstbau. *Süddeutsche Zeitung* (Munich), July 30, 2002, 14.

Meneguzzo, Marco. "Franz Ackermann." Review, Castello di Rivoli Museo d'Arte Contemporanea. *Artforum*, April 2001, 145.

Meschede, Friedrich. "Franz Ackermann: All the Places I've never been." *Kunstforum International* 137 (June–August 1997): 64–69.

Müller, Silke. "Ansichtskarten vom globalen Dorf." *Art*, May 2004, 16–29.

Neue Zürcher Zeitung (Zurich). "Im Sog eines fulminanten Bewusstseinsstroms—Franz Ackermann in der Galerie Mai 36." Review. June 27, 2002.

Pagel, David. "Patterns and Postcards." Review, Thomas Solomon's Garage. *Los Angeles Times*, July 27, 1995, F12.

Princenthal, Nancy. "Franz Ackermann at Gavin Brown's Enterprise." Review. *Art in America*, September 2001, 152–53.

Rauterberg, Hanno. "Amüsierte Selbstaufgabe." Review, Kunstmuseum Wolfsburg. *Die Zeit* (Hamburg), March 6, 2003, 46.

Ritchie, Matthew. "The New City." *Art/Text* 65 (1999): 74–79.

Sommer, Tim. "Selbst und Fremde." Reviews, Kunsthalle Nürnberg; Kunst-museum Wolfsburg. *Art*, April 2003, 81.

Stange, Raimar. "Adventures of Uncertainty." Review: Stedelijk Museum Amsterdam. *Modern Painters*, Winter 2002, 98–101.

_____. "Basel: Franz Ackermann in der Kunsthalle Basel." Review. *Das Kunst–Bulletin*, March 2002.

_____. "Ein utopischer Bürger?/A Utopian Citizen?" *Parkett* 68 (2003): 46–53.

_____. "Franz Ackermann." Review, Städtische Galerie Nordhorn. Translated by Michael Robinson. *Flash Art*, March–April 1998, 119.

_____. "Franz Ackermann im Neuen Aachener Kunstverein." Review. *Das Kunst-Bulletin*, January–February 1998, 36.

_____. "Street Drawing Man." *Das Kunst-Bulletin,* March 1997, 6–11.

_____. "Triviale Tropen." Review, Kunsthalle Basel. *Frankfurter Rundschau*, February 26, 2002.

Stoeber, Michael. "Die Sehnsucht des Kartografen." Review, Kunstverein Hannover. *Kunstforum International* 169 (March–April 2004): 247–50.

Tilmann, Christina. "Das grüne Leuchten." Review, Kunstmuseum Wolfsburg. *Der Tagesspiegel* (Berlin), March 1, 2003, archiv.tagesspiegel.de/archiv/01.03.2003/458834.asp.

Wilson-Goldie, Kaelen. "Abstractionism: The New Abstractionists." *Art and Auction*, July 2003, 92–97.

Wittneven, Katrin. "Die Metropole vergisst ihre Kinder." *Der Tagesspiegel* (Berlin), February 10, 2004, archiv.tagesspiegel.de/archiv/10.02.2004/968752.asp.

■ STEVE DiBENEDETTO

Selected books, exhibition catalogues, and brochures

Abreu, Miguel. *Drawing out of the Void*. Exhibition catalogue. New York: Vestry Arts, Inc., 2004.

Selected articles and reviews

Blair, Dike. "Artists on Artists: Steve DiBenedetto." *Bomb*, Spring 2003, 12–15.

Clarkson, David. "Now Is the Time." Review, Tony Shafrazi Gallery. *Flash Art*, October 1995, 49.

Coomer, Martin. "Dissolution: Made in the USA." *Time Out London*(?), Summer 1997(?).

Di Raddo, Elena. "Steve Di Benedetto." Review, Marella Arte Contemporanea. *Tema Celeste*, Winter 1995, 108.

Dunham, Carroll; introduction by Scott Rothkopf. "Artists Curate: Road Food." *Artforum*, October 2002, 132–37.

Franceschetti, Roberta. "Effetto virus. È arrivata l'arte postdigitale." *Arte*(?), July 1998(?), 80–85.

Henry, Max. "Hurly Burly." Gotham Dispatch. Review, Baumgartner Gallery. *Artnet.com*, May 2, 2000, http://artnet.com/magazine/reviews/henry/henry5–2–00.asp.

Johnson, Ken. "Another Place." Review, Joseph Helman Gallery. *New York Times*, September 10, 1999, E36.

_____. "Drawing out of the Void." Review, Vestry Arts, Inc. *New York Times*, April 30, 2004, E2:33.

_____. "Steve DiBenedetto." Review, Baumgartner Gallery. *New York Times*, April 13, 2001, E33.

_____. "Steve DiBenedetto." Review, Derek Eller Gallery. *New York Times*, November 1, 2002, E2:34.

Klein, Monika. "Sieben New Yorker Maler stellen in der Studiogalerie aus." Review, Kunstverein Museum Schloß Morsbroich. *Rheinische Post* (Düsseldorf), March 21, 1995.

Mahoney, Robert. "Landscape." Review, Derek Eller Gallery. *Time Out New York*, February 21–28, 2002, 51.

Rosin, Jessica. "Steve DiBenedetto. Derek Eller Gallery." Review. *Art on Paper*, January–February 2003, 77–78.

Saltz, Jerry. "Sleepers Awake." Review, Derek Eller Gallery. *New York Village Voice*, November 6–12, 2002, 57.

Schmerler, Sarah. "Steve DiBenedetto at Baumgartner." Review. *Art in America*, November 2000, 166.

Schwabsky, Barry. "Suddenly This Summer." *Art in America*, October 1999, 83–87.

Schwenke-Runkel, Ingeborg. "Knallbuntes aus New York." Review, Kunstverein Museum Schloß Morsbroich. *Kölner Stadt-Anzeiger* (Leverkusen, Germany), March 21, 1995.

Scott, Andrea K. "Steve DiBenedetto." Review, Baumgartner Gallery. *Time Out New York*, May 18–25, 2000.

Smith, Roberta. Art in Review. Review, Bravin Post Lee Gallery. *New York Times*, July 4, 1997, C24.

_____. "Kill All Lies." Review, Luhring Augustine. *New York Times*, July 9, 1999, E2:35.

_____. "Retreat from the Wild Shores of Abstraction." *New York Times*, October 18, 2002, E2:31.

_____. "Steve DiBenedetto." Review, Baumgartner Gallery. *New York Times*, May 19, 2000, E2:34.

Westdeutsche Zeitung (Düsseldorf). "Ein Kunstverein übt Senkrechtstart." Review, Kunstverein Museum Schloß Morsbroich. April 8, 1995.

_____. "Kunst im Schloß." Review, Kunstverein Museum Schloß Morsbroich. April 8, 1995.

Worman, Alex. "L.A. Confidential." Review, Daniel Weinberg Gallery. *Artnet.com*, December 2, 2003, artnet.com/magazine/reviews/worman/worman12–2–03.asp.

■ CARROLL DUNHAM

Selected books, exhibition catalogues, and brochures

Bomb. Speak Art!: The Best of Bomb Magazine's Interviews with Artists. Amsterdam: G+B Arts International, 1997.

Dunham, Carroll. *Carroll Dunham: Selected Paintings, 1990–95*. Exhibition catalogue. Boston: The Gallery, 1995.

Dunham, Carroll, and Mohammad Mottahedan, eds. *Once upon a Time in America: The Mottahedan Collection*. London: Christie's Books, 2000.

Joaquim Maria de Assis, Machado; illustrations by Carroll Dunham. *The Alienist*. Translated by Alfred Mac Adam. San Francisco: Arion Press, 1998.

New Museum of Contemporary Art; essays by Dan Cameron, A.M. Homes, Klaus Kertess, Lisa Phillips, and Sanford Schwartz, interview by Matthew Ritchie. *Carroll Dunham: Paintings*. Exhibition catalogue. New York: New Museum of Contemporary Art, in association with Hatje Cantz Verlag, Ostfildern-Ruit, Germany, 2002.

Nolan/Eckman Gallery. *Land*. Exhibition catalogue. New York: Nolan/Eckman Gallery, 1998.

Plous, Phyllis. *Carroll Dunham: Paintings and Drawings*. Exhibition catalogue. Santa Barbara: Santa Barbara Contemporary Arts Forum, 1996.

Roukes, Nicholas. *Artful Jesters: Innovators of Visual Wit and Humor*. Berkeley: Ten Speed Press, 2003.

Selected articles and reviews

Braff, Phyllis. "Power and Imagination in Original Work." Review, Guild Hall

Museum. *New York Times*, July 14, 1996, 13LI10.

Cameron, Dan. "Carroll Dunham." Review, Metro Pictures. *Artforum*, March 1998, 95.

Cotter, Holland. Art in Review. Review, Metro Pictures. *New York Times*, October 31, 1997, E35.

Del Re, Gianmarco. "Young Americans 2: Parts I and II." Review, The Saatchi Gallery. *Flash Art*, November–December 1998, 66.

Dunham, Carroll. "Artist's Interview, New York: Carroll Dunham. Taken Over by the Doodle." Interview by Adrian Dannatt. *The Art Newspaper*, May 2002, 31.

———. "For God's Sake." *New York Times Magazine*, September 19, 1999, 72–73.

Glueck, Grace. "Carroll Dunham—'The Search for Orgone.'" Review, Nolan/Eckman Gallery. *New York Times*, October 19, 2001, E39.

———. "City Sophistication Spends the Summer in Long Island." Review, Guild Hall Museum. *New York Times*, July 12, 1996, C24.

Goldberger, Paul. "The Art of His Choosing." *New York Times Magazine*, February 26, 1995, 30–39, 52, 55, 61–62.

Greene, David A. "Project Painting." Review, Basilico Fine Arts and Lehmann Maupin. *Frieze* 37 (December 1997): 90–91.

Gregg, Gail. "Blob Appeal." *Art News*, January 1999, 102–05.

Hirsch, Faye. "Dunham's Demonology." *Art in America*, January 2003, 66–73.

Homes, A.M. "The Best of 1998." *Artforum*, December 1998, 104–05.

Johnson, Ken. Art in Review. Review, Nolan/Eckman Gallery. *New York Times*, November 13, 1998, E2:40.

———. "Carroll Dunham—'Mesokingdom.'" Review, Metro Pictures. *New York Times*, May 17, 2002, E2:35.

Jones, Kristin M. "Carroll Dunham." Review, New Museum of Contemporary Art. *Frieze* 73 (March 2003): 90–91.

Kalina, Richard. "Dunham's Dystopia." *Art in America*, March 1998, 96–97, 99.

Kertess, Klaus. "Jack Bankowsky Talks with Klaus Kertess." Interview. *Artforum*, January 1995, 67–71, 104, 109.

Kimmelman, Michael. "Carroll Dunham." Review, Metro Pictures. *New York Times*, November 19, 1999, E2:41.

———. "Getting past the 80's: An Evolutionary Tale." Review, New Museum of Contemporary Art. *New York Times*, November 1, 2002, E2:31.

———. "How the Tame Can Suddenly Seem Wild." *New York Times*, August 2, 1998, 2:35.

Lambirth, Andrew. "Real Oil Painting Is Real Cool." Review, The Saatchi Gallery. *Independent* (London), April 28, 1998, 16.

Mac Adam, Alfred. "Carroll Dunham." Review, Nolan/Eckman Gallery. *Art News*, November 2001, 177.

Mahoney, Robert. "Carroll Dunham, 'Mesokingdom (Paintings).'" Review, Metro Pictures. *Time Out New York*, May 9–16, 2002.

McGee, John. "We Love Painting." Review, Museum of Contemporary Art. *Metropolis*, 2003, metropolis.japantoday.com/tokyo/464/art.asp.

Morgan, Robert C. "Carroll Dunham: Nouveau Musee d'art contemporain, New York." Review, New Museum of Contemporary Art. *Art Press* no. 290 (May 2003): 67–68.

Packer, William. "Not So Sweet Nothings from America." Review, The Saatchi Gallery. *Financial Times* (London), May 2, 1998, 7.

Perl, Jed. "War Stories." Review, Whitney Museum of American Art. *New Republic*, May 8, 1995, 27–30.

Ritchie, Matthew. "Carroll Dunham." Review, Sonnabend Gallery. *Flash Art*, May–June 1995, 113–14.

Schjeldahl, Peter. "One Man Show: Klaus Kertess's Biennial Moyen Sensuel." Review, Whitney Museum of American Art. *New York Village Voice*, April 4, 1995, 72.

Scott, Andrea K. "Carroll Dunham." Review, Metro Pictures. *Time Out New York*, November 25–December 2, 1999.

Searle, Adrian. "Monsieur le Patron." Review, The Saatchi Gallery. *Guardian* (Manchester), April 28, 1998, T010.

Sheets, Hilarie M. "An 'Art World Secret' Plumbs the Mysterious Id." *New York Times*, October 27, 2002, 2:33.

Sherman, Mary. "'Three Stooges' of Art Startlingly Refined." Review, Barbara and Steven Grossman Gallery. *Boston Herald*, November 5, 1995, 48.

Siegel, Katy. "Carroll Dunham." Review, Metro Pictures. *Artforum*, February 2000, 118.

Sirmans, Franklin. "The Paintings of Carroll Dunham." Review, New Museum of Contemporary Art. *Time Out New York*, January 9–16, 2003.

Smith, Dinitia. "Beside the Hudson, the Lure of Art." *New York Times*, October 10, 1997, E2:38.

Smith, Roberta. "Savoring a Medium Whose Bite Has Grown with Age." Review, The Museum of Modern Art. *New York Times*, June 21, 1996, C28.

Storr, Robert. "Slow Burn." *Artforum*, November 2002, 146–51.

Storr, Robert, with Carroll Dunham, Helmut Federle, Tim Griffin, Jutta Koether, Jonathan Lasker, Monique Prieto, Lane Relyea, Terry Winters, and Lisa Yuskavage. "Thick and Thin: A Roundtable." *Artforum*, April 2003, 174–79, 238–44.

Tallman, Susan. "Hot Pink Souls Ice: The Printed Work of Carroll Dunham." *Art on Paper*, March–April 2001, 44–53.

Temin, Christine. "Going Back to School in American Art History: The Addison Gallery Gets Straight A's for Its Anniversary Exhibit." Review, Addison Gallery of American Art. *Boston Sunday Globe*, June 23, 1996, B21.

———. "Raising Bad Taste to a Fine Art." *Boston Globe*, November 15, 1995, 85.

Turner, Grady T. "Abstracted Flesh: Pop Culture, Sex, and the Body in Abstract Art." *Flash Art*, January–February 1999, 66–69.

Valdez, Sarah. "Carroll Dunham." Review, New Museum of Contemporary Art. *Art News*, January 2003, 120.

Wolgamott, L. Kent. Reviews, Central: Omaha, Nebraska. Review, Joslyn Art Museum. *Art Papers*, May–June 2004, 53.

Wood, Eve. "Carroll Dunham." Review, Daniel Weinberg Gallery. *Flash Art*, May–June 2004, 140.

■ ATI MAIER

Selected books, exhibition catalogues, and brochures

Hunt, David. *Homesteads*. Exhibition catalogue. San Francisco: John Berggruen Gallery, 1998.

Russ, Sabine. *Ati Maier*. Exhibition catalogue. Leipzig: Dogenhaus Gallery, 2002 (Brooklyn: Pierogi, 2003).

Selected articles and reviews

Cotter, Holland. "Daniel Zeller and Ati Maier." Review, Pierogi. *New York Times*, December 19, 2003.

Fallon, Roberta. "Cup of Joe." Review, Gallery Joe. *Philadelphia Weekly*, February 12, 2003, 48.

Path 3: Echoes of a Countdown. "Ati Maier." October 21, 2000, www.crosspathculture.org/axb/maier.htm.

Russ, Sabine. "Ati Maier: Portfolio." *Grand Street* 71 (Spring 2003): 108–13.

Schmerler, Sarah. "Boiled or Fried." Review, Pierogi. *Time Out New York*, July 25–August 1, 2002, 54.

Schütte, Christoph. "UFOs und 'Pril'-Blumen: Malerei in der Galerie Anita Beckers." Review. *Frankfurter Allgemeine Zeitung*, April 3, 2004.

Sommer, Tim. "Lustiges Streunen im Bildgedächtnis." Review, Dogenhaus Galerie Leipzig. *Leipziger Volkszeitung*, October 10, 1999, 15.

Von Elzenbaum, Margit. "Ranghoh oder umgänglich?" Review, Galerie der Bezirksgemeinschaft Überetsch-Unterland. *Kultur am Wochenende* (Neumarkt, Italy), September 14–15, 2002, 9.

■ JULIE MEHRETU

Selected books, exhibition catalogues, and brochures

Conrads, Martin. *Déjà-vu*. Exhibition brochure. Berlin: Carlier | Gebauer, 2004.

Fogle, Douglas, and Olukemi Ilesanmi. *Julie Mehretu: Drawing into Painting*. Exhibition catalogue. Minneapolis: Walker Art Center, 2003.

Zuckerman Jacobson, Heidi. *Julie Mehretu/Matrix 211: Manifestation*. Exhibition brochure. Berkeley: University of California, Berkeley Art Museum, 2004.

Selected articles and reviews

Anton, Saul. "Glenn Brown, Julie Mehretu, Peter Rostovsky." Review, The Project. *Time Out New York*, June 15–22, 2000.

Berwick, Carly. "Julie Mehretu." *Elle Décor*, June–July 2003, 64–67.

———. "Ten Artists to Watch. Julie Mehretu: Excavating Runes." *Art News*, March 2002, 95.

Chua, Lawrence. "Julie Mehretu." *Black Book*, December 2002(?), 50–54.

Cotter, Holland. "Glenn Brown, Julie Mehretu, Peter Rostovsky." Review, The Project. *New York Times*, June 23, 2000, E33.

Dewan, Shaila. "Bugs to Beauty: Mehretu Maps out Identity at Barbara Davis Gallery." Review. *Houston Press*, July 30–August 5, 1998, 53.

Dumbadze, Alexander. "Julie Mehretu and Amy Brock." Review, Project Row Houses. *New Art Examiner*, September 1999, 62.

———. "Julie's World." *Branna*, Winter 2002.

Gaines, Malik. "Aftershocks." *Artext*, Summer 2002, 36–37.

Goneconti, Danielle. "Layering Chaos: Julie Mehretu at The Project." Review. *Museo* 5 (Spring 2002): www.columbia.edu/cu/museo/5/5/mehretu/index.htm.

Griffin, Tim. "Exploded View: Julie Mehretu's Paintings Detonate at The Project." Review. *Time Out New York*, December 6–13, 2001, 61.

———. "For the Record: Julie Mehretu, Senam Okudzeto, and Nadine Robinson." Review, The Studio Museum in Harlem. *Time Out New York*, September 13–20, 2001.

Harris, Susan. "Julie Mehretu at The Project." Review. *Art in America*, March 2002, 122.

Herbstreuth, Peter. "Explosionen in Zeitlupe." Review, Carlier | Gebauer. *Der Tagesspiegel* (Berlin), February 21, 2004.

Hirsch, Faye. "Full-Throttle Abstract." *Art in America*, June–July 2004, 170–01, 193.

Holmes, Pernilla. "Julie Mehretu." Review, White Cube. *Art News*, December 2002, 282–83.

Hoptman, Laura. "Crosstown Traffic: Laura Hoptman on Julie Mehretu." *Frieze* 54 (September–October 2000): 104–07.

Huntington, Richard. "Technical Ecstasy: Young Painter Julie Mehretu Creates Complex Abstracts Anchored in Architecture and Real Life." *Buffalo (New York) News*, January 30, 2004, G22.

Knight, Christopher. "A Terrible Beauty: Feeling Explodes on Julie Mehretu's Canvases in Studies of 9/11 and Our Modern Age." Review, CalArts Gallery at REDCAT. *Los Angeles Times*, June 2, 2004, E1.

Mehretu, Julie, Matthew Ritchie, and Barnaby Furnas. "Painting Platform in NY." Interview by Lauri Firstenberg. *Flash Art*, November–December 2002, 70–75.

Sirmans, Franklin. "Mapping a New, and Urgent, History of the World." *New York Times*, December 9, 2001, 41.

Sjostrom, Jan. "Painter's Show at PBICA: A Cultural Whirlwind on Canvas." Review, Palm Beach Institute of Contemporary Art. *Palm Beach Daily News*, September 29, 2003, 3.

Stange, Raimar. "Berlin: Julie Mehretu bei Carlier | Gebauer." Review. *Das Kunstbulletin*, March 2004.

Wilson-Goldie, Kaelen. "Abstractionism: The New Abstractionists." *Art and Auction*, July 2003, 92–97.

Worth, Alexi. "Julie Mehretu." Review, The Project. *Artforum*, February 2002, 129.

■ MATTHEW RITCHIE

Selected books, exhibition catalogues, and brochures

Contemporary Arts Museum Houston. *Matthew Ritchie: Proposition Player*. Exhibition catalogue. Houston: Contemporary Arts Museum Houston, 2003.

Galerie Météo. *Matthew Ritchie: The Hard Way*. Exhibition catalogue. Paris: Galerie Météo, 1996.

Gamwell, Lynn. *Exploring the Invisible: Art, Science, and the Spiritual*. Princeton, New Jersey: Princeton University Press, 2002.

Harris, Jane. "Matthew Ritchie." In Thomas Bayrle et al., *Vitamin P: New Perspectives in Painting*, 282–83. London: Phaidon Press, 2002.

Kandel, Susan. "Matthew Ritchie." In *Cream: Contemporary Art in Culture*, 348–51. London: Phaidon Press, 1998.

Marcoci, Roxana, Diana Murphy, and Eve Sinaiko, eds. *New Art*. New York: Henry N. Abrams, 1997.

Marcus, Ben, and Matthew Ritchie. *The Father Costume*. Sebastopol, California: Artspace Books, 2002.

Ritchie, Matthew. *The Big Story*. Artist's book. Cleveland: Cleveland Center for Contemporary Art, 1999.

———. *Incomplete Projects 01: The Fast Set*. Artist's book. Miami: Museum of Contemporary Art, 2000.

———. *Incomplete Projects 02: Slow Tide*. Artist's book. Dallas: Dallas Museum of Art, 2001.

———. *Incomplete Projects 03: Sea State One*. Artist's book, published for Artists Space. New York: Two Palms Press, 2001.

———. *Incomplete Projects 04: The Bad Need*. Artist's book, published for *Parkett* 61. Zurich: Parkett Editions, 2001.

———. *Incomplete Projects 05: Games of Chance and Skill*. Artist's book. Cambridge, Massachusetts: Massachusetts Institute of Technology, 2003.

Ritchie, Matthew; with essay by Helen Molesworth. *Matthew Ritchie*. Exhibition catalogue. New York: Basilico Fine Arts, 1998.

Weintraub, Linda. *In the Making: Creative Options for Contemporary Art*. New York: Distributed Art Publishers, 2003.

Whitney Museum of American Art. "Matthew Ritchie." In *American Visionaries: Selections from the Whitney Museum of American Art*, 255. New York: Whitney Museum of American Art, 2001.

Selected articles and reviews

Bayliss, Sarah. "The Informers." *World Art*, no. 13 (May 1997): 66–68.

Berman, Jenifer. "Matthew Ritchie." *Bomb*, Spring 1997, 60–65.

Blumenthal, Ralph. "An Art Show from before the Big Bang." Review, Contemporary Arts Museum Houston. *New York Times*, January 20, 2004, E1.

Brown, Cecily. "Painting Epiphany: Happy Days Are Where, Again?" *Flash Art*, May–June 1998, 76–79.

Cash. "Big Bang in Farbe." May 26, 2000, 85.

Cotter, Holland. "Matthew Ritchie." Review, Basilico Fine Arts. *New York Times*, November 15, 1996, C21.

———. "Matthew Ritchie." Review, Andrea Rosen Gallery. *New York Times*, November 24, 2000, E2:36.

Cullum, Jerry. "Matthew Ritchie: Omniverse." Review, Nexus Contemporary Art Center. *Atlanta Journal-Constitution*, November 28, 1997, Q07.

Drolet, Owen. "Matthew Ritchie." Review, Basilico Fine Arts. *Flash Art*, Summer 1995, 128.

———. "Matthew Ritchie." Review, Basilico Fine Arts. *Flash Art*, January–February 1997, 98–99.

Dunham, Carroll; introduction by Scott Rothkopf. "Artists Curate: Road Food." *Artforum*, October 2002, 132–37.

Ellis, Patricia. "Matthew Ritchie: That Sweet Voodoo That You Do." *Flash Art*, November–December 2000, 88–91.

Forrest, Jason. "Matthew Ritchie: Omniverse: Nexus Contemporary Art Center, Atlanta." Review. *Art Papers*, July–August 1998, 39–40.

Galison, Peter, and Caroline Jones. "Theories and the Dead." *Parkett* 61 (2001): 148–52.

Gilmore, Jonathan. "Matthew Ritchie." Review, Andrea Rosen Gallery. *Tema Celeste* 83 (2001): 94.

Glueck, Grace. "Creative Souls Who Keep the Faith or Challenge Its Influence." Review, The Aldrich Museum of Contemporary Art. *New York Times*, April 21, 2000, E2:39.

Gupta, Anjali. "Matthew Ritchie." Review, Contemporary Arts Museum Houston. *Tema Celeste*, May–June 2004, 96.

Heartney, Eleanor. "Matthew Ritchie at Basilico Fine Arts." Review. *Art in America*, April 1997, 114.

Jones, Ronald. "Continued Investigation of the Relevance of Abstraction." Review, Andrea Rosen Gallery. *Frieze* 47 (June–August 1999): 102–03.

Joo, Michael. "The Wheel of Life." Review, Basilico Fine Arts. *Performing Arts Journal* 57 (September 1997): 77–79.

Kahn, Joseph P. "Mr. Universe: Matthew Ritchie Sets up a Show at Mass MoCA That's Out of This World." Review. *Boston Globe*, April 11, 2004, N1.

Kalina, Richard. "Matthew Ritchie at Basilico Fine Arts." Review. *Art in America*, July 1995, 85–86.

Kastner, Jeffrey. "An Adventurer's Map to a World of Information." *New York Times*, October 15, 2000, 2:37.

———. "The Weather of Chance: Matthew Ritchie and the Butterfly Effect." *Art/Text* 61 (May–July 1998): 54–59.

Kelley, Tina. "For Patients, Welcome Relief from Four Bare Walls." *New York Times*, May 17, 2002, B5.

Marcus, Ben. "The Least You Need to Know about Radio." *Parkett* 61 (2001): 162–66.

McDonough, Tom. "Matthew Ritchie at Basilico Fine Arts." Review. *Art in America*, May 1999, 159.

Ohlin, Alix. "Inexact Science." Review, Contemporary Arts Museum Houston. *Art Papers*, July–August 2004, 28–33.

Princenthal, Nancy. "The Laws of Pandemonium." *Art in America*, May 2001, 144–49.

Rabinowitz, Cay Sophie. "Not Two, Not Three, Not Even Four Dimensions." *Parkett* 61 (2001): 138–45.

Richard, Frances. "Matthew Ritchie." Review, Andrea Rosen Gallery. *Artforum*, January 2003, 136.

Ritchie, Matthew. "Cosmic Strip." *New York Times Magazine*, September 19, 1999, 100.

———. "Matthew Ritchie." Interview by Daniel Pinchbeck. *Art Newspaper*, November 1998, 71.

Ritchie, Matthew, Julie Mehretu, and Barnaby Furnas. "Painting Platform in NY." Interview by Lauri Firstenberg. *Flash Art*, November–December 2002, 70–75.

Saltz, Jerry. "Matthew Richie, 'The Hard Way.'" Review, Basilico Fine Arts. *Time Out New York*, November 7–14, 1996, 40.

———. "Out There." Review, Andrea Rosen Gallery. *New York Village Voice*, November 28, 2000, 79.

Schaffner, Ingrid. "Matthew Ritchie." Review, Basilico Fine Arts. *Artforum*, March 1997, 93.

Schjeldahl, Peter. "Painting Rules." Review, Basilico Fine Arts and Lehmann Maupin. *New York Village Voice*, September 30, 1997, 97.

Schwabsky, Barry. "Matthew Ritchie." Review, Andrea Rosen Gallery. *Artforum*, January 2001, 137.

Sheets, Hilarie M. "Baffled, Bewildered—and Smitten: How to Stop Worrying and Love the Art You Don't Understand." *Art News*, September 2000, 130–34.

Siegel, Katy. "Matthew Ritchie." Preview, Contemporary Arts Museum Houston. *Artforum*, September 2003, 81.

Silver, Joanne. "Show Mixes Symbols, Sensation." Review, Mario Diacono. *Boston Sunday Herald*, February 2, 1997, 44.

Sischy, Ingrid. "Gotta Paint!" *Vanity Fair*, February 2000, 140–47.

Smith, Dan. "Matthew Ritchie." Review, White Cube. *Art Monthly*, December 2001–January 2002, 41–42.

Smith, Roberta. Art in Review. Review, Basilico Fine Arts. *New York Times*, March 10, 1995, C20.

———. "Cracking the Same Mold with Different Results." Review, Andrea Rosen Gallery. *New York Times*, November 15, 2002, E2:38.

Stange, Raimar. "Augen wie Billardkugeln." Review, c/o—Atle Gerhardsen. *Der Tagesspiegel* (Berlin), May 10, 2003.

Wei, Lilly. "The Cosmos according to Matthew Ritchie." *Art News*, Summer 2004, 148–51.

Wilson-Goldie, Kaelen. "Abstractionism: The New Abstractionists." *Art and Auction*, July 2003, 92–97.

———. "Matthew Ritchie's Matrix: An Artist Re-creates the World in Seven Steps." *Black Book*, Summer 2000, 56–58.

Wolgamott, L. Kent. Reviews, Central: Omaha, Nebraska. Review, Joslyn Art Museum. *Art Papers*, May–June 2004, 53.

Yablonsky, Linda. "Matthew Ritchie, 'The Gamblers.'" Review, Basilico Fine Arts. *Time Out New York*, November 26–December 3, 1998.

Zimmermann, Mark. "Colloquial Arabesques." Review, Basilico Fine Arts. *PAJ: A Journal of Performance and Art*, 21.2 (1999): 71–75.

■ ALEXANDER ROSS

Selected books, exhibition catalogues, and brochures

Feature Inc. *Alexander Ross*. Exhibition catalogue. New York: Feature Inc., 2000.

Selected articles and reviews

Cotter, Holland. Art in Review. Review, Mary Boone Gallery. *New York Times*, April 23, 1999, E2:35.

Heartney, Eleanor. "Alexander Ross at Feature." Review. *Art in America*, July 1998, 96.

Lin, Jeremy. "Cellular One." *surface*, no. 19 (1999): 176, 188.

Ocana, Damarys. "Tales of Suspense." Review, Kevin Bruk Gallery. *Street Weekly*, December 26, 2003–January 1, 2004, 60.

Peaker, Carol. "Year Zero." Review, Stephen Friedman Gallery. *Canadian Art*, Summer 1999, 70.

Richard, Frances. "Alexander Ross." Review, Feature Inc. *Artforum*, March 2001, 144–45.

Saltz, Jerry. "Sleepers Awake." Review, Feature Inc. *New York Village Voice*, November 6–12, 2002, 57.

Scott, Andrea K. "Alexander Ross." Review, Mary Boone Gallery. *Time Out New York*, April 29–May 6, 1999.

Smith, Roberta. "Alex Ross." Review, Feature Inc. *New York Times*, December 1, 2000, E35.

Storr, Robert. "The Art of Alexander Ross: Warts and All." *Artforum*, September 2003, 184–87, 251, 254.

Viveros-Fauné, Christian. "Green Machine." *New York Press*, April 7, 1999, 22.

■ TERRY WINTERS

Selected books, exhibition catalogues, and brochures

Duncan, Andrea. "Inside—Outside—Permutation: Science and the Body in Contemporary Art." In *Strange and Charmed: Science and the Contemporary Visual Arts*, edited by Siân Ede, 144–63. London: Calouste Gulbenkian Foundation, 2000.

Enright, Robert. *Peregrinations: Conversations with Contemporary Artists*. Winnipeg: Bain and Cox, 1997.

Galerie Fred Jahn; essay by Michael Semff. *Terry Winters: Foundations and Systems. Fifty New Drawings by Terry Winters*. Exhibition catalogue. Munich: Verlag Fred Jahn, 1995.

IVAM Centre del Carme; Whitechapel Art Gallery; essays by Ronald Jones and Enrique Juncosa. *Terry Winters*. Exhibition catalogue. Valencia, Spain: IVAM Centre del Carme, 1998.

Kalman, Tibor. *Chairman: Rolf Fehlbaum*. Frankfurt am Main: Rat für Formgebung, 1997.

Kunsthalle Basel. *Terry Winters*. Exhibition catalogue. Basel: Kunsthalle Basel, 2000.

Lambert, Susan. *Prints: Art and Techniques*. London: V and A Publications, 2001.

Matthew Marks Gallery; interview by Adam Fuss. *Terry Winters: Computation of Chains*. Exhibition catalogue. New York: Matthew Marks Gallery, 1997.

Matthew Marks Gallery; essays by Ronald Jones and John Rajchman. *Terry Winters: Graphic Primitives*. Exhibition catalogue. New York: Matthew Marks Gallery, 1999.

Norden, Linda. *Terry Winters: Fogg Art Museum, Harvard University*. Exhibition brochure. Cambridge, Massachusetts: Fogg Art Museum, 1999.

Prose, Francine. *Terry Winters: Local Group/New Works on Paper*. Exhibition catalogue. New York: Pratt Manhattan Gallery, 2004.

Riemschneider, Burkhard, and Uta Grosenick, eds.; with essays by Lars Bang Larsen, Christopher Blase, Yilmaz Dziewior, Jean-Michel Ribettes, Raimar Stange, Susanne Titz, Jan Verwoert, and Astrid Wege. *Art at the Turn of the Millennium*. Cologne: Benedikt Taschen Verlag, 1999.

Rosenthal, Nan. *Terry Winters: Printed Works*. Exhibition catalogue. New York: The Metropolitan Museum of Art, 2001.

Rothkopf, Scott. *Terry Winters/Drawings*. Exhibition catalogue. New York: Matthew Marks Gallery, 2001.

Seidner, David. "Terry Winters." In *Artists at Work: Inside the Studios of Today's Most Celebrated Artists*, 146–53. New York: Rizzoli International Publications, 1999.

Semff, Michael, ed. *Ein Bildhandbuch: Staatliche Graphische Sammlung München*. Munich: Staatliche Graphische Sammlung, 2002.

Shiff, Richard. *Terry Winters 1981–1986*. Exhibition catalogue. New York: Matthew Marks Gallery, 2004.

Sojka, Nancy; with essay by Richard H. Axsom. *Terry Winters Prints: 1982–1998. A Catalogue Raisonné*. Detroit: The Detroit Institute of Arts, 1999.

Starobinski, Jean; etchings by Terry Winters. *Perfection, le chemin, l'origine/Perfection, Way, Origin*. English translation by Richard Pevear. Bay Shore, New York: Universal Limited Art Editions, 2001.

Tallman, Susan. *The Contemporary Print: From Pre-Pop to Postmodern*. London: Thames and Hudson, 1996.

Weinberg, Adam D., ed.; essays by Richard Shiff, Rachel Teagle, and Adam D. Weinberg. *Terry Winters: Paintings, Drawings, Prints 1994–2004*. Exhibition catalogue. New Haven: Yale University Press, in association with Addison Gallery of American Art, Andover, Massachusetts, 2004.

Whitney Museum of American Art. "Terry Winters." In *American Visionaries: Selections from the Whitney Museum of American Art*. New York: Whitney Museum of American Art, 2001.

Winters, Terry. *Intersections and Animations: Fifty Drawings*. Dome Editions, 1998(?).

———. *Ocular Proofs: Terry Winters*. New York: Grenfell Press, 1995.

———. "Terry Winters." In *Inside the Studio: Two Decades of Talks with Artists in New York*, edited by Judith Olch Richards, 122–25. New York: Independent Curators International, 2004.

———. *Terry Winters: Recent Works*. Exhibition catalogue. Boston: School of the Museum of Fine Arts, 1997.

Winters, Terry; with essay by Gabriele Lutz. *Terry Winters Drawings 1996*. Exhibition catalogue. Zurich: Galerie Lawrence Rubin, 1996.

Winters, Terry; with essays by Michael Semff and Harry Cooper. *Terry Winters: Zeichnungen/Drawings*. Exhibition catalogue. Munich: Staatliche Graphische Sammlung München, 2003.

Selected articles and reviews

Anderson, Jack. "Exploring Austerity and Then Excitement." Review, Trisha Brown Dance Company (set painted by Terry Winters). *New York Times*, December 10, 2002, E5.

Brennan, Michael. "Terry Winters." Review, Matthew Marks Gallery. *Brooklyn Rail*, December 2003–January 2004, 12.

Brillembourg, Carlos. "Terry Winters, The Anti-Collaboration: A Painter and an Architect." Review, Lehmann Maupin. *Bomb*, Summer 2001, 18.

Brown, Cecily. "Painting Epiphany: Happy Days Are Where, Again?" *Flash Art*, May–June 1998, 76–79.

Cotter, Holland. "A Critic's Dozen to Catch at the Biennial." Review, Whitney Museum of American Art. *New York Times*, March 12, 1995, H37.

_____. "Terry Winters: Drawings." Review, Sonnabend Gallery. *New York Times*, May 12, 1995, C23.

Cumming, Laura. "He'd Start One Drawing with His Right Hand Just as His Left Hand Was Finishing Another. Who'd Have Thought He Took LSD?" Review, Whitechapel Art Gallery. *Observer* (London), March 7, 1999, 9.

Falkenstein, Michelle. "Performance Anxiety." *Art News*, May 2000, 51.

Gladstone, Valerie. "Filling the Stage with Her Inventions." New York Times, April 30, 2000, 2:8.

Glueck, Grace. "Terry Winters." Review, Matthew Marks Gallery. *New York Times*, December 12, 2003, E45.

Häntzschel, Jörg. "Kristalle, Schwämme, Nervenstränge; Die Münchner Pinakothek der Moderne zeigt erstmals Papier-Arbeiten von Terry Winters." Review, Staatliche Graphische Sammlung München. *Süddeutsche Zeitung* (Munich), August 8, 2003, 13.

James, Merlin. New York: Recent Painting [Exhibits]. Review, Matthew Marks. *Burlington Magazine*, January 1998, 65–67.

Johnson, Ken. "For Those in Search of Calm, an Armory Full of Modernists." Review, National Academy Museum. *New York Times*, February 22, 2002, E38.

_____. "Terry Winters: 'Graphic Primitives.'" Review, Matthew Marks Gallery. *New York Times*, June 11, 1999, E31.

Kastner, Jeffrey. "An Energetic Imagist Who Dances with Chance." *New York Times*, August 19, 2001, 2:29.

Kimmelman, Michael. "Terry Winters." Review, Matthew Marks Gallery. *New York Times*, October 31, 1997, E35.

Kisselgoff, Anna. "Cunningham Celebrates in a Fugue for Sixteen Dancers." Review, Merce Cunningham Dance Company (set painted by Terry Winters). *New York Times*, July 26, 2002, E1:3.

_____. "It Takes Two to Jitterbug, Sometimes More." Review, Trisha Brown Company. *New York Times*, May 11, 2000, E1.

Kuspit, Donald. "Terry Winters." Review, Sonnabend Gallery. *Artforum*, November 1995, 88.

McDonough, Tom. "Terry Winters at Lehmann Maupin and Matthew Marks." Review. *Art in America*, June 2001, 125–26.

Packer, William. "Artists' Journeys into Space." Review, Whitechapel Art Gallery. *Financial Times* (London), March 9, 1999, 20.

Princenthal, Nancy. "Perfect like a Hedgehog: The Printed Works of Terry Winters." Review, The Metropolitan Museum of Art. *Art on Paper*, September–October 2001, 50–56.

Rubinstein, Raphael. "Nine Lives of Painting." *Art in America*, September 1998, 90–99.

Russell, John. "Making Pen and Ink Seem Passé: The Proliferation of New Ways to Draw." Review, Barbara Gladstone Gallery. *New York Times*, August 18, 2000, E33.

Sachs, Brita. "Man hört den Morast blubbern." Review, Staatliche Graphische Sammlung München. *Frankfurter Allgemeine Zeitung*, July 11, 2003, 35.

Schjeldahl, Peter. "The Redeemer." Review, Matthew Marks Gallery. *New York Village Voice*, October 28, 1997, 93.

Schwabsky, Barry. "Terry Winters." Review, Matthew Marks Gallery. *Artforum*, February 1998, 92–93.

Searle, Adrian. "Who Needs Drugs, When You Can Paint like This?" Review, Whitechapel Art Gallery. *Guardian* (London), February 23, 1999, 10.

Storr, Robert, with Carroll Dunham, Helmut Federle, Tim Griffin, Jutta Koether, Jonathan Lasker, Monique Prieto, Lane Relyea, Terry Winters, and Lisa Yuskavage. "Thick and Thin: A Roundtable." *Artforum*, April 2003, 174–79, 238–44.

Temin, Christine. "An Abstract Winters Tale." Review, School of the Museum of Fine Arts. *Boston Globe*, March 5, 1997, F5.

_____. "Winters Weaves Beautiful, Tangled Orbs." *Boston Globe*, October 20, 2004.

Winters, Terry. "Implications, Images, and Signs." *New Observations* 110 (January 1996): 29.

_____. "In Conversation with Terry Winters." Interview by Peter Eleey. *Brooklyn Rail*, October–November 2001, 27–28.

Worth, Alexi. "Terry Winters." Review, Matthew Marks Gallery. *Art News*, November 1997, 229.

Yablonsky, Linda. "Terry Winters." Review, Matthew Marks Gallery. *Time Out New York*, December 17–24, 1998.

_____. "Terry Winters, 'Printed Works.'" Review, The Metropolitan Museum of Art. *Time Out New York*, August 2–9, 2001.

Whitney Museum of American Art Staff, April 1, 2005

Jay Abu-Hamda, Randy Alexander, Adrienne Alston, Ronnie Altilo, Martha Alvarez-LaRose, Basem D. Aly, Callie Angell, Xavier Anglada, Marilou U. Aquino, Bernadette Baker, Wendy Barbee, Harry Benjamin, Jeffrey Bergstrom, Lana Bittman, Hillary Blass, Richard Bloes, Julie Brooks, Meghan Bullock, Douglas Burnham, Ron Burrell, Garfield Burton, Pablo Caines, Meg Calvert-Cason, Andrew Cappetta, Gary Carrion-Muriyari, Howie Chen, Julie Chill, Ivy Chokwe, Kurt Christian, Ramon Cintron, Lee Clark, Ron Clark, Maggie Clinton, Melissa Cohen, Deborah Collins, Rhys Conlon, Arthur Conway, Lauren Cornell, Heather Cox, Stevie Craig, Sakura Cusie, Heather Davis, Nathan Davis, Evelyn De La Cruz, Donna De Salvo, Christine DeFonce, Chiara DeLuca, Anthony DeMercurio, Neeti Desai, Eduardo Diaz, Eva Diaz, Apsara DiQuinzio, Gerald Dodson, Elizabeth Dowd, Anita Duquette, Tara Eckert, Adrienne Edwards, Bridget Elias, Alvin Eubanks, Altamont Fairclough, Jeanette Fischer, Mayrav Fisher, Rich Flood, Carter Foster, Samuel Franks, Murlin Frederick, Annie French, Ted Gamble, Donald Garlington, Arianne Gelardin, Filippo Gentile, Larissa Gentile, Stacey Goergen, Kimberly Goldsteen, Jennifer Goldstein, Lena Goldstein, Mark Gordon, Pia Gottschaller, Elizabeth M. Grady, Suzana Greene, Patricia Guadagni, Peter Guss, Joann Harrah, Collin Harris, Barbara Haskell, Todd Hawkins, K. Michael Hays, Barbara Hehman, Dina Helal, Carlos Hernandez, Karen Hernandez, Jennifer Hersch, Thea Hetzner, Nicholas S. Holmes, Tracy Hook, Henriette Huldisch, Wycliffe Husbands, Chrissie Iles, Stephany Irizzary, Carlos Jacobo, Ralph Johnson, Lauren Kash, Chris Ketchie, Wynne Kettell, David Kiehl, Anna Knoell, Tom Kraft, Margaret Krug, Tina Kukielski, Diana Lada, Joelle LaFerrara, Raina Lampkins-Fielder, Sang Soo Lee, Monica Leon, Suellen Leonard, Vickie Leung, Lisa Libicki, Kelley Loftus, Jennifer MacNair, Carol Mancusi-Ungaro, Joel Martinez, Sandra Meadows, Graham Miles, Dana Miller, Shamim M. Momin, Victor Moscoso, Maureen Nash, Chris Neal, Colin Newton, Carlos Noboa, Darlene Oden, Richard O'Hara, Meagan O'Neil, Nelson Ortiz, Carolyn Padwa, Christiane Paul, Angelo Pikoulas, Marcelle Polednik, Kathryn Potts, Linda Priest, Vincent Punch, Elise Pustilnik, Christy Putnam, Suzanne Quigley, Elizabeth Randall, Michael Raskob, Bette Rice, Kristen Richards, Emanuel Riley, Felix Rivera, Jeffrey Robinson, Georgianna Rodriguez, Justin Romeo, Joshua Rosenblatt, Matt Ross, Amy Roth, Jan Rothschild, Jane Royal, Carol Rusk, Doris Sabater, Angelina Salerno, Warfield Samuels, Stephanie Schumann, Julie Seigel, David Selimoski, Joan Simon, Frank Smigiel, G.R. Smith, Stephen Soba, Karen Sorensen, Barbi Spieler, Carrie Springer, Mark Steigelman, Emilie Sullivan, Elisabeth Sussman, Mary Anne Talotta, Kean Tan, Tami Thompson-Wood, Phyllis Thorpe, Joni Todd, Robert Tofolo, James Tomasello, Lindsay Turley, Makiko Ushiba, Ray Vega, Eric Vermilion, Cecil Weekes, Adam D. Weinberg, Monika Weiss, John Williams, Rachel de W. Wixom, Sylvia Wolf, Sarah Zilinski

INDEX

Page numbers in italics refer to illustrations.

AUTHORS' BIOGRAPHIES

Elisabeth Sussman is curator and Sondra Gilman Curator of Photography at the Whitney Museum of American Art, where she has organized several major exhibitions, including the *1993 Biennial Exhibition*. For the San Francisco Museum of Modern Art she co-organized, with Renate Petzinger of the Museum Wiesbaden, a retrospective on Eva Hesse (2002) that received the International Art Critics Association First Prize for the best monographic exhibition outside New York in 2001 and 2002. She is the author of many publications, including *Lisette Model* (2001).

Caroline A. Jones teaches contemporary art and theory in the history, theory, and criticism section of the department of architecture at the Massachusetts Institute of Technology, Cambridge. Producer/director of two documentary films and curator of many exhibitions, her books include such major museum publications as *Modern Art at Harvard* (1985), *Bay Area Figurative Art, 1950–1965* (1990), and the award-winning *Machine in the Studio: Constructing the Postwar American Artist* (1996/98).

Katy Siegel is associate professor of art history and criticism at Hunter College, CUNY, and a contributing editor at *Artforum*. She writes widely on modern and contemporary art and is author of *Abstract Expressionism* (forthcoming) and coauthor, with Paul Mattick, of *Art Works: Money* (2004).

Ben Marcus is the author of two works of fiction: *The Age of Wire and String* (1995) and *Notable American Women* (2002). He has collaborated with several artists, among them Matthew Ritchie, Terry Winters, and Helen Mirra. He directs the fiction program at Columbia University's School of the Arts, New York.

Tina Kukielski is senior curatorial assistant at the Whitney Museum of American Art, where she helped organize, among other important exhibitions, *The American Effect: Global Perspectives on the United States, 1990-2003* (2003) and *Tim Hawkinson* (2004). For Deitch Projects, New York, she co-curated *The Freedom Salon* (2004).

Elizabeth M. Grady is curatorial assistant at the Whitney Museum of American Art and adjunct professor of art history at the Fashion Institute of Technology, SUNY. For Vox Populi, Philadelphia, she is curating *Parts to the Whole* (2006). Her publications include "The Popular Opposition: Politicizing modern art in the National Gallery in Berlin," forthcoming in Julie Codell, ed., *The Political Economy of Art* (2005).

Full caption information for works exhibited in *Remote Viewing* may be found in "Works in the Exhibition."
If an image cited below appears elsewhere in the book, the page number is indicated in parentheses.

Page 6: Ben Marcus, *Peterson's Forensics*, 2005. Print from digital file, 48 x 168 in. (121.9 x 426.7 cm). Collection of the artist

All photographs of the artists in their studios are by Jerry L. Thompson, except Ackermann, by Jens Ziehe.
Artworks on those pages are noted from top/left:
Ackermann: *Faceland/White Crossing I*, 2001 (detail)
Die Enteignung (the Kop in Blue), 2001
DiBenedetto: Drawing fragment, 2004. Felt-tip pen on paper, 4 x 7 in. (10.2 x 17.8 cm). Collection of the artist
Detail from a work in progress
Dunham: *Untitled*, 2003 (detail)
Maier: *Quiet Stars*, 2004 (details, in progress)
Mehretu: *The Seven Acts of Mercy*, 2004 (details) (48–49, 50–51, 55)
Ritchie: *The Damned II*, 2004. Ink and graphite on polypropylene vellum, 42 x 36 in. (106.7 x 91.4 cm)
The Universal Cell, 2004
The Damned I, 2004. Ink and graphite on polypropylene vellum, 42 x 36 in. (106.7 x 91.4 cm)
Winters: *Vermilion*, 2005 (detail) (74–75)
Untitled (2 of 4), 2004

Vellum inserts:
Franz Ackermann, *White Crossing 1*, 2001. Wall drawing, dimensions variable. Collection of Martin and Rebecca Eisenberg
Steve DiBenedetto, *Dark Octopus*, 1998. Charcoal on paper,
22 1/2 x 30 in. (57.2 x 76.2 cm). Courtesy Derek Eller Gallery, New York
Carroll Dunham, *4/17/98*, 1998. Graphite on paper, 4 1/2 x 6 1/4 in. (11.4 x 15.9 cm). Collection of the artist
Ati Maier, *Sketch*, 2004 (detail). Mixed media on paper, 28 x 22 in. (71.1 x 55.9 cm). Collection of the artist; courtesy Pierogi, Brooklyn, New York
Julie Mehretu, *Untitled*, 2004. 25 3/4 x 40 in. (65.4 x 101.6 cm). Collection of Martin and Rebecca Eisenberg; courtesy The Project, New York and Los Angeles
Matthew Ritchie, *The Last Sea*, 2004 (detail). Wall drawing, dimensions variable
Alexander Ross, *Untitled*, 2004 (71)
Terry Winters, *Untitled (13)*, 2004

This catalogue was published on the occasion of the exhibition *Remote Viewing (Invented Worlds in Recent Painting and Drawing)*, organized by Elisabeth Sussman, curator and Sondra Gilman Curator of Photography, Whitney Museum of American Art, with the assistance of Tina Kukielski, senior curatorial assistant, and Elizabeth Grady, curatorial assistant.

This publication was produced by the Publications and New Media Department at the Whitney Museum of American Art, New York: Rachel de W. Wixom: head of publications and new media; *Editorial:* Thea Hetzner: associate editor; Jennifer MacNair: associate editor; *Design:* Makiko Ushiba: manager, graphic design; Anna Knoell, graphic design assistant; *Production:* Vickie Leung: production manager; *Rights and Reproductions:* Anita Duquette: manager, rights and reproductions; Joann Harrah, rights and reproductions assistant; Arianne Gelardin: publications assistant.

Editors: Jennifer Liese and Thea Hetzner
Catalogue design: Yolanda Cuomo Design, NYC
Design associate: Kristi Norgaard
Exhibition design associate: Astrid Lewis Reedy
Proofreaders: Thea Hetzner and Jennifer MacNair
Indexer: Susan G. Burke
Printing: Meridian Printing

Printed and bound in the United States

Photograph and reproduction credits:
All photographs of the artists in their studios are by Jerry L. Thompson,
except Ackermann, by Jens Ziehe.

In some cases, photographs of artworks have been provided by the owners.
The following applies to photographs for which additional acknowledgment is due:

Courtesy Gavin Brown's Enterprise, New York: 101; © Centre Georges Pompidou, Paris: 15; Geoffrey Clements: 98; courtesy James Cohan Gallery, New York: 90, 96 (bottom); Sheldan C. Collins: 15, 23, 24, 26-27, 91 (top); Anthony Cunha, courtesy Daniel Weinberg Gallery, Los Angeles: 86 (bottom); © 1998 D. James Dee, courtesy Pierogi, Brooklyn, New York: 97 (top); courtesy Derek Eller Gallery, New York: 97 (bottom); Jacques Faujour: 15; courtesy Gladstone Gallery, New York: 86 (top); courtesy Gorney Bravin and Lee, New York: 96 (top); Hester and Hardaway, courtesy Andrea Rosen Gallery, New York: 91 (bottom), 95; courtesy JPMorgan Chase Collection: 97 (middle); Erich Lessing/Art Resource, New York: 82 (top), 82 (bottom); courtesy The Project, New York and Los Angeles: 87 (top); courtesy Andrea Rosen Gallery, New York: 14, 87 (top), 94 (top), 94 (bottom), 99 (top), 99 (bottom), *Insert vi*; Steven Sloman: 72-73, 74-75, 78-79, 80; Oren Slor, courtesy Andrea Rosen Gallery, New York: 61, 62; Oren Slor, courtesy Feature, Inc., New York: 64, 66-67, 70, 71; courtesy Scala/Art Resource, New York: 89; Oren Slor, courtesy Feature Inc., New York: 93; courtesy JRR Tolkien Estate Limited: 12

Copyright credits:
© Alice Debord Archive: 15; © 1996 Carroll Dunham: 86 (top); Ben Marcus; © 1993 The Regents of the University of Minnesota, illustration by Bernard Cache for *The Fold: Leibniz and The Baroque*, by Gilles Deleuze, English translation, originally appeared in French as *Le Pli: Leibniz et le Baroque*, © 1988 Les Editions de Minuit, reprinted by permission of Georges Borchardt, Inc., for Les Editions: 91 (top); © Matthew Ritchie: 14, 56-57, 58-59, 60, 61, 62-63, 87 (top), 91 (bottom), 94 (top), 94 (bottom), 95, 99 (top), 99 (bottom), *Insert vi*; © Estate of Robert Smithson/Licensed by VAGA, New York, NY: 90; Reproduced with the kind permission of The JRR Tolkien Estate Limited © The JRR Tolkien Copyright Trust 2005, courtesy Marquette University Libraries: Tolkien manuscripts 3/1/24": 12

This book was composed in Trade Gothic, Franklin Gothic, and Adobe Caslon, and printed on French Paper Company, Newsprint Extra White 50# text, Scheufelen Job Parilux Silk, 115# text, and Glama Natural Clear, 24# text.